THE ART COLLECTOR'S HANDBOOK

A GUIDE TO COLLECTION MANAGEMENT AND CARE

HANDBOOKS IN INTERNATIONAL ART BUSINESS

Series Editors: Derrick Chong and Iain Robertson
Advisory Editor: Jos Hackforth-Jones

The art market is now a multi-billion-dollar industry employing hundreds of thousands of professionals worldwide. Working within the art market brings a specific set of challenges, which are distinct from those of the conventional business world. Aimed at art world professionals and those working within the many sectors of art business, as well as those preparing for careers in the commercial art world, the Handbooks in International Art Business provide a series of authoritative reference guides to the structure and working of the international art market, incorporating core topics such as Art Law and Ethics as well as guides to different market sectors.

The Handbooks are written by experts in their field, many of whom teach at, or are graduates of, the MA in Art Business at Sotheby's Institute of Art at its London and New York campuses. Sotheby's Institute of Art has pioneered the field of art business as both a professional and an academic discipline. Its MA in Art Business was established in 1999.

THE ART COLLECTOR'S HANDBOOK

A GUIDE TO COLLECTION MANAGEMENT AND CARE

Mary Rozell

Lund Humphries
in association with Sotheby's Institute of Art

First published in 2014 by Lund Humphries in association with Sotheby's Institute of Art

Lund Humphries
Wey Court East
Union Road
Farnham
Surrey GU9 7PT
UK

Lund Humphries
Suite 3–1
110 Cherry Street
Burlington
VT 05401-3818
USA

www.lundhumphries.com
Lund Humphries is part of Ashgate Publishing

Sotheby's Institute of Art
30 Bedford Square
Bloomsbury
London WC1B 3EE
UK

Sotheby's Institute of Art
570 Lexington Avenue, 6th Floor
New York
NY 10022
USA

British Library Cataloging in Publication Data. A catalogue record for this book is available from the British Library.

Library of Congress Cataloging-in-Publication Data. Library of Congress Number: 2013048018
Rozell, Mary.
 The art collector's handbook : a guide to collection management and care / by Mary Rozell.
 pages cm. -- (Handbooks in international art business)
 Includes bibliographical references and index.
 ISBN 978-1-84822-099-7 (hardcover : alk. paper) -- ISBN 978-1-84822-143-7 (ebook) -- ISBN 978-1-84822-142-0 (epub) (print) 1. Art as an investment. 2. Art--Collectors and collecting. I. Title.
 N8600.R69 2014
 707.5--dc23
 2013048018

ISBN: 978-1-84822-099-7
ISBN: 978-1-84822-143-7 (ebk – PDF)
ISBN: 978-1-84822-142-0 (ebk – ePub)

Series designed by Andrew Shoolbred
Set in ITC Charter
Printed in the United Kingdom by TJ International Ltd, Padstow, Cornwall

To Bill and my SALA

CONTENTS

ACKNOWLEDGMENTS

It takes a veritable village to complete a professional handbook such as this, and there are many individuals to thank.

As I am not an expert in many of the specialist areas covered in this volume, I had to rely on individuals who are. The following colleagues very generously committed to reading specific chapters and made critical contributions: Eric Kahan, Collector Systems; Heather Gray, Associate General Counsel, Sotheby's; Andrew Faintych and Jonathan Schwartz, Atelier 4 Fine Art Logistics; Glen Wharton, former Time-Based Media Conservator at the Museum of Modern Art and Clinical Associate Professor at New York University; Vivian Ebersman, Christiane Fischer, Amanda Rowley, and Erika Witler of AXA ART Insurance; and Andy Augenblick of Emigrant Bank Fine Art Finance. I am extremely fortunate to be able to call on these respected professionals and I am deeply grateful for their involvement.

Sincerest thanks are also due to those who reviewed my entire manuscript draft and offered unfiltered assessments: art advisor Alex Glauber, my co-pilot in the Sotheby's Institute of Art (SIA) Art Collecting course; fellow Hamiltonian and art advisor Chris Barton; and my husband Bill Adams whose commanding intelligence and work in the publishing field make him an editor nonpareil. These critiques were invaluable.

I would like to thank the other professionals and members of the field who have shared their knowledge, expanded my vision, made introductions, or otherwise added to this book: Katherine Hinds, Curator of the Martin Z. Margulies Collection; Bas Mühren, Research Department, Kröller-Müller Museum; Tanya Van Sant, ArtBase founder; Tasha Seren; Bettina and Donald Bryant, Jr.; THE EKARD COLLECTION; Elizabeth Szancer Kujawski; Tom Zoufaly, Art Installation Design, LLC; and Christiane Fischer, President and CEO of AXA ART Americas.

The following individuals graciously provided images which bring life to these pages: Suzanne Siano and Stephen Gaylor of Modern Art Conservation, New York; Elinor Kuhn and Erika Hoffmann, Hoffmann Sammlung Berlin; Katharina Grosse; The Martin Z. Margulies Collection;

AXA ART Insurance; Ernesto Neto; The Estate of Giorgio de Chirico; Deutsche Bank; The Singapore Freeport; and James Clar.

My student Avie Linden was a helpful and caring research assistant who worked on my footnotes and continued to check in on me long after her task was completed.

Other students have stimulated my work with their energy and ideas. Specifically, Erica Back's essay on the collector Nelson A. Rockefeller and Isa Castilla's research on private collector museums provided new insights; Matthew Foster's MA thesis on private collections with public access was instructive and sparked energizing discussions. Cristina Biaggi wrote an outstanding thesis on the conservation of contemporary art and was an early reader of my conservation chapter. Her warm and remarkable allegiance has buoyed me throughout the duration of this project and beyond.

Members of the Sotheby's Institute of Art—NY Art Business Faculty also contributed to getting this content into shape. Tom McNulty read two drafts of my chapter on valuation, offering excellent suggestions, catching countless typos, and providing enriching and enjoyable dialogue. Former Christie's auctioneer Barbara Strongin combed my chapters containing auction references and offered valuable comments with her usual efficiency and accuracy. Special appreciation is due to Judith Prowda for not only reviewing the entire manuscript, but putting the idea of this book out into the ether. Her regular pep talks and faithful support provided heartening reassurance.

I am also grateful to my colleague and sounding board, Kathy Battista, and to our capable and inspiring Director, Lesley Cadman, who has provided me with steadfast guidance, sustaining conversations, and unparalleled support on every front throughout my tenure at SIA. The NY Art Business program could not have evolved, nor could this book have been written, without her leadership.

I would particularly like to thank Jos Hackforth-Jones, Director of SIA—London and series Advisory Editor, who invited me to submit a proposal for this book in the first place, and whose kind and perfectly

phrased messages of encouragement always came across the ocean at the right time.

I am most indebted to our Program Coordinator par excellence, Amanda Olesen, who cheerfully researched resources and edited chapters, printed countless drafts and articles, made me tea, and basically did everything in her power to assist me with this undertaking—all the while keeping the wheels of the program running.

I am grateful to the exceptional team at Lund Humphries— commissioning editor Lucy Myers; Sarah Thorowgood, head of editorial and production; project manager Lucie Ewin; and freelance copy editor Abigail Grater—for their genial professionalism, infinite patience, and hard work which has made this daunting task a pleasant and gratifying project. I also thank series editors and colleagues Iain Robertson and Derrick Chong for their important input.

This work could not have been completed without the support of my family, Bill and Samuel Adams, and that of my cherished friends who have stood by me despite my absences during the course of this undertaking.

Lastly, my profound thanks go to all of the collectors and artists I have worked with over the years for granting me privileged access to their homes, storage spaces, and files, allowing me to develop intimate relationships with their incredible works of art. Spending time with you and your art has been the most edifying and rewarding education imaginable.

FOREWORD

There are high-minded, philanthropic, enlightened and very rational reasons to embark on forming a collection; there are also personal, emotional and passionate impulses that compel anyone involved in art to become attached to the objects that they collect and the collection itself. And it is the latter motivations that come to the fore in this book. It might almost be said that this volume explains the meaning of a collection in the post-enlightenment world.

There is the thrill of the purchase, the potential inconvenience of an inheritance, the many responsibilities that are part and parcel of a great or even modest cultural legacy. The reader benefits from the experience of Mary Rozell as both an art historian and an art lawyer who, with her lucid writing style, shares the insights she has gained advising collectors, artists, and foundations on private art collection management.

The central tenet of the book is the private art collector and the life cycle of art objects in the collection. The significance of posterity and the continuation of a life's work is encapsulated in the many superb bequests that become private museum trusts, such as the Wallace and Frick collections in London and New York.

The particular rationale of a private collection often differs greatly from that of great public museum, and in some ways takes us back to an earlier form of collecting, before the French Revolution, to an age of private enjoyment represented by the *Kunstkammer*.

In a sense, the appropriation of the word passion by the world of finance does scant service to the very real feelings that collectors invest in their collections. These assortments of wondrous goods remain very personal testimonies to taste.

Derrick Chong
Iain Robertson
London, February 2014

←——

PREFACE

There are now more collectors worldwide than ever before. Not only have emerging economic markets around the globe spawned new art markets, but the digital age offers unprecedented ease of discovering and collecting art, bringing in more participants at every level. Once an intimidating "closed" world of galleries and a few auction houses, globalization, technology and the international surge of art fairs have in many ways democratized the art business.

Few people wake up and decide they want to be an art collector. Rather, they tend to buy an artwork, and then another, and over time they find they own a constellation of items that comprise a meaningful collection. Or they may suddenly inherit works of art. Such individuals may not consider themselves to be "collectors" and yet they may one day discover that they are owners of a valuable art collection, perhaps even one that constitutes the majority of their net worth. Other individuals describe themselves as being "bitten by the collecting bug" or they explain their desire to collect as an "illness," an obsession, or an "unruly passion,"[1] and tend to build up a collection relatively quickly, rabid in their desire to own art. And more and more, individuals are putting together collections with art's investment potential in mind.[2]

No matter how one acquires art or for what purpose, there is more to art collecting than discovering a work at an art fair or gallery and finding the perfect place to hang it. Owning art (and, for that matter, relinquishing art) also requires thought, time, and, frequently, a significant sum of money. Depending on the circumstances, a collector can expect to spend 1 to 5 percent of the collection's value on maintenance annually.[3] Collectors must consider how to sustain the physical integrity of their artworks as well as how to protect themselves from potential liability and financial loss. In the case of larger collections, management can be a sizable burden or even a full-time job. Some collectors employ entire art departments consisting of curators, collection managers, registrars, and other assistants to address collection matters year round.

Managing a personal art collection requires conscientious stewardship and a kaleidoscopic approach. Myriad specialists—including conservators, installers, insurers, scholars, lighting and climate control specialists, and tax and estate planners—must be called upon to provide the necessary expertise and care. These professionals are indispensable to sound management, and cultivating trusted relationships with them can be both rewarding and educational. For optimal results, however, collectors themselves need to possess an awareness of fundamental art collection management principles and practice starting at the acquisition stage. A collector's wishes, needs, or priorities may not always be entirely in sync with a specialist's, and being able to ask the right questions and raise critical issues can be immensely beneficial.

When I was first hired to manage a significant art collection, I had an MA in Art History, a law degree with a practice specialization in art law, and years of experience working in both the commercial and non-profit art worlds, both in the US and in Germany. What I did not have was a road map for approaching this vast task, or anything more than superficial knowledge of those vital "back businesses" that keep the art world afloat: insurance, conservation, logistics, storage, etc. Similarly, when I initiated my professional practice course on art collecting at Sotheby's Institute of Art in 2010, I searched for applicable resources to share with my students. While there is some literature regarding managing museum collections,[4] as well as a plethora of useful articles, pamphlets, and online information, I could find no comprehensive overview on creating and maintaining art collections of all types geared towards the private individual collector. At the same time, the wealth of invaluable behind-the-scenes knowledge shared by respected experts who guest-lectured in my course—a hallmark of SIA education—merited an audience beyond the classroom.

This book thus aims to serve as a generalist reference for the individual art collector, providing an overview of the salient art collection subjects to consider while providing direction on best practice. The intent is to offer guidelines for those collectors just starting out while also providing more technical details that may be of use to the seasoned collector. The content should also serve as a resource for professionals in the field as well as for art business students.

The text traces the "life cycle" of an art collection, starting with an overview of the many issues to consider when initially purchasing a work of art. Part Two addresses how the scope and value of a collection—its essence—are determined and documented. In Part Three, the focus shifts to the various practical aspects of maintaining a collection during its "lifetime"—insurance, conservation, shipping, installation, framing, and storage—as well as the considerable costs associated therewith. Part

Four reflects on the private and public worth of collections, discussing how collectors can benefit economically, intellectually, and socially from their art. In Part Five, the book concludes with the theme of relinquishing one's art, outlining the means and strategies for parting with an art collection once the time comes.

Anyone who has worked in the art world or read the art press even fleetingly knows that matters involving art are often the subject of legal dispute, and that novel legal issues within this realm are forever surfacing. However, given the entrenched tradition of hand-shake deals and gentlemen's agreements in this largely unregulated business—as well as art's strong emotional value—such concerns are often overlooked in order to close a deal quickly or finish a transaction painlessly. While by no means a legal treatise, this book thus attempts to flag potential legal issues that may arise in the course of art collecting. Its content is crafted through the lens of the law as well as the premise that proper care and attention in the short term can prevent problems and future loss.

Finally, a few limitations and disclaimers are in order. The content of this volume is largely derived from my own experience working in the field, as well as from the expertise garnered from the numerous specialists, collectors, and clients with whom I have had the pleasure of collaborating. For reasons of discretion, many of the examples cited within this text must remain anonymous. In some cases referenced herein, while the substance is factual, certain identifying details have also been changed for privacy reasons.

Since I am licensed to practice law in the US and most of my current professional work on behalf of artists and collectors takes place there, the content of this book has a strong US focus. While some of these principles are similar in other parts of the world, other laws, customs, and practice are not; thus this advice should be taken in context.

It should also be noted that, while generalizations can be made about how galleries and other agents in the commercial art world operate, each individual enterprise has its own methods of doing business; hence, the general practices discussed in this book cannot be assumed to apply to all.

Also, it is important to clarify that all of the opinions expressed herein are my own and in no way represent those of Sotheby's auction house, a distinct entity from Sotheby's Institute of Art.

And finally, as collections and personal circumstances are always unique, experts should always be consulted before making important decisions regarding an individual art collection.

Mary Rozell
New York, February 2014

PART ONE
COLLECTION BUILDING

ACQUISITION

Acquiring art—whether from a dealer, through an auction house, directly from an artist or through some other method—is at the heart of collecting. Some acquisitions are made after years of searching for an object, while others are purchased on a whim. Either way, or depending upon the stakes, the process can be nerve-wracking or immensely satisfying. Usually, it's both.

Sound art collection management starts at the acquisition stage. Knowing from whom to buy what and at what price is a skill in itself, one that can be developed over time. While most art collectors do not collect solely for investment purposes, the majority will at least want to know how price relates to value and whether they are investing their money wisely. They will want to purchase something that will gain value over time—or at least not *lose* value.

Today, there are infinite opportunities to buy art. With the globalization of the 1990s and the introduction of the Internet, the art business has become an international, quasi-transitory affair. Not only do many galleries now have multiple branches in other cities (Gagosian Gallery being in the lead with shops and offices in at least 13 locations, from New York and Beverly Hills to Athens and Rome), a huge portion of art transactions are happening at art fairs, temporary gallery trade shows which span five to 12 days and take place in ever more cities around the globe. Auction houses, too, have expanded their reach, with Christie's and Sotheby's, both originally founded in London, now offering sales in far-flung venues such as Beijing and Dubai, and further broadening their businesses through private treaty sales and selling exhibitions. And online possibilities for viewing and buying art continue to grow.

MARKETS, SOURCES, APPROACHES

What to Collect?

Art collecting is deeply personal, a reflection of the self. It is not surprising, then, that individuals take different approaches towards building a

collection. Some begin with a particular theme or interest in mind: a certain movement, historical period, medium, geographical area, or a combination thereof which leads to a succession of discoveries and connections. Others seek to chronicle or preserve the production of a specific era or culture. Motivated by an ardent interest in his own Mexican culture, the painter Diego Rivera (1886–1957) amassed some 60,000 examples of pre-Hispanic pieces, now exhibited in Mexico City's Anahuacalli Museum which the artist himself designed. Still others buy work without any intended focus at all, acquiring individual pieces simply on the basis of what appeals to them visually or taps into their desire at a particular moment. As collector Jesse Price said when discussing how her eclectic collection was put together, "We just assume nothing has any relationship to anything."[5]

The American collector Ronald Lauder bought his first work of art, a drawing by Egon Schiele (1890–1918), at the age of 14 with his bar mitzvah money.[6] This was the beginning of a lifelong collecting passion for German and Austrian art and, eventually, the founding of a museum in New York devoted to this genre. At the same time, Mr. Lauder has indulged his rather disparate interests in medieval art and armor, French and Italian design from the 1920s to the 1950s, and works by modern masters such as Paul Cézanne, Pablo Picasso, and Constantin Brancusi, demonstrating how individual collecting often takes different avenues.

Tastes and interests evolve as well. One international couple began acquiring classic paintings of ice-skating scenes from Dutch masters in homage to their adopted home in the Netherlands, but eventually shifted their collecting focus to avant-garde contemporary art.

Some collectors concentrate on blue-chip works while others are inspired by emerging artists—younger artists who are not yet established in their careers and whose prices are usually lowest. In the 1990s, Charles Saatchi famously collected the work of emerging British artists fresh from Goldsmiths art school, almost single-handedly catapulting this edgy group—which would come to be known as the Young British Artists (YBAs)—into bona fide international art stars. Other collections are at least partially defined by budget and other constraints. The storied American collecting pair Herbert and Dorothy Vogel, he a postal clerk and she a librarian, purchased conceptual and minimal art on Herbert's modest salary—and only bought works small enough to take home in a taxi.[7] New collectors often start by purchasing less expensive prints and multiples, enabling even those with lower budgets to own a work by Rembrandt van Rijn (1606–69) or Louise Bourgeois (1911–2010). German Expressionist artists, who at the beginning of the 20th century revived the printmaking tradition of Albrecht Dürer from the 15th and 16th century, recognized that the print medium enabled bourgeois collectors to acquire innovative art of their time at affordable prices.

Collecting one individual artist's work in depth, often from different points in that artist's career, is sometimes referred to as vertical collecting. For a while, the colorful collector Jean Pigozzi liked to select 10 different works each of the emerging artists he collected for his "10 x 10" collection, thereby establishing a "position." He still likes to have multiple examples by each artist he collects, focusing his collection on young artists in order to support them, to buy works cheaply, and to hopefully maximize investment potential.[8] On the other hand, buying individual works from a broad number of different artists is sometimes referred to as horizontal collecting. Crossover collecting is a term used to describe collecting works from across periods from the ancient to the contemporary[9] and may be contrasted with niche collecting.

No matter where the specific interests lie and whether or not a collection will ultimately become a heterogeneous one, collectors can, and should, hone their eye by looking at art from all different periods and media as often as possible. The greatest collectors can evolve into connoisseurs in their own right, becoming just as knowledgeable and skilled as the dealers, curators, or other experts they work with—if not more so.

The American collecting pair Dorothy and Herb Vogel—a librarian and a postal clerk—put together one of the most important collections of minimal and conceptual art on their modest salaries.

Buying from Art Dealers

Most collectors start buying art from an art dealer (or gallerist),[10] who is in the business of selling art and usually specializes in certain artists or

types of art. Dealers typically have a space in which they keep inventory of art and stage exhibitions which are presented to the public. Up until recently, the majority of the art trade took place locally in bricks-and-mortar galleries, and it would be possible for a collector to be familiar with all of the art galleries in one geographical area. An individual would visit the gallery, look at the art, talk to the dealer, and sometimes purchase a work. Now, major art hubs such as London, New York, and Berlin each have hundreds and hundreds of galleries with many coming and going as markets boom and bust. And more and more, art is also being sold online.

Given this landscape, how can a new collector find a reputable dealer? To start, one can consult professional organizations for member listings such as, in the US, the Art Dealers Association of America (ADAA) or the New Art Dealers Alliance (NADA)—though by no means all countries have equivalents to these. The gallery roster of respected art fairs such as Art Basel, The Armory Show and Frieze whose participants are usually vetted, in some cases rigorously, is another good place to find galleries with interesting works to offer. Most cities with a critical mass of galleries also organize monthly or yearly open-house events where openings are held concurrently such as Gallery Weekend in Berlin in late spring or the Second Saturday Gallery Nights in the Wynwood Art District in Miami. After such initiations, the process is about engaging with dealers, following artists, and building relationships over time.

The Primary Market

When a dealer sells work that is on the market for the first time, work that is usually consigned to the dealer directly from an artist, he is operating in the primary market. In such situations, the artist and the dealer usually split the retail price paid by the buyer 50–50, but this percentage tends to shift in favor of the artist as prices rise. A collector sometimes has the opportunity to buy a work directly from an artist. If the artist is represented by a gallery, however, the collector should think twice about making such overtures. A reputable artist, if already associated with a gallery, will usually not make a direct sale which omits the dealer (but may arrange a discount through the dealer, see p. 23).

Access

All of this presupposes that a gallery is willing to sell to a buyer in the first place. Traditionally, and from a business perspective, it is the dealer's job to build the reputation and hence the market for an artist's work. This means that good dealers will be very knowledgeable about the artists, their history, the entire body of work and where to find it (e.g., whether the works are in private collections, public collections, and whether they are for sale). Good dealers strive to ensure that work

is spread around; they do not simply sell work, but rather place it in the right hands. Selling to the wrong party can result in a dealer losing control of an artist's market. The dealer will thus generally not sell to just anyone who happens to have the cash, and will most certainly not sell to a suspected speculator—someone who is perceived to be only out to make money by buying a work and flipping it at auction. Art buyers known to engage in such practices can quickly be blacklisted by a gallery, if not an entire gallery community. However global the art world is, it is in practice quite small; information about the particular interests and habits of collectors gets around.

Right of First Refusal
More and more frequently, as a condition to having access to the most desirable artists, top galleries are requiring collectors to sign a right of first refusal at the time of purchase, meaning that if a collector wants to sell a work sometime in the future to a third party, he or she must offer it back to the original gallery at the same price before consigning or selling it. The right of first refusal is thus a method dealers use to control markets of work by sought-after artists or as a safety net when dealing with new buyers who have not yet won the dealer's trust. This pre-emptive right is also imposed to prevent art buyers from selling works for a prescribed time period or even from ever selling the works at all. If such an agreement is signed by the buyer, it will most likely be enforceable, although there are still few court cases to substantiate this. (Most such claims settle out of court.)[11] Regardless, any collector who wants to continue to buy art from dealers and wishes to avoid legal headaches, fees, and other disruptions such as being assigned to a blacklist, should take such agreements seriously. Collectors should also be aware that the right of first refusal is a condition that it is not always negotiated or discussed; it may be buried in the terms of the purchase invoice—or it may simply be assumed (see p. 183).

"Blacklists"
Art buyers known to sell works quickly for profit may be blacklisted by certain galleries. Although almost never openly discussed in the guarded art world, artists, too, may have a say in how an artwork purchased through a gallery will be placed and may thus dictate who may *not* buy their work. In at least one rather sensational case, the well-known South African artist Marlene Dumas (1953–) allegedly blacklisted Miami collector Craig Robins after finding out he had sold one of her earlier works. When Robins attempted to buy a newer work, the dealer refused to sell it to him, supposedly per the wishes of the artist.[12]

The Secondary Market

Art dealers also engage in the secondary market, selling works that have already been sold before. While some dealers specialize in the secondary market, others sell such works as a back business to support the exhibitions and publications of their principal primary-market operations. (It can take years to make a profit when representing a new artist on the primary market.) Dealers are also active secondary-market buyers, investing in inventory and controlling the markets of the artists they represent. Some secondary-market dealers deal privately; they do not have a physical showroom or exhibition space, but rather sell from their own inventory and broker deals from a non-public space, usually a home or office.

Works on Approval

Established collectors are sometimes allowed to borrow a work they are considering purchasing from a dealer, receiving the artwork on approval (or "on spec") for a temporary period in order to make a decision. In such cases, the dealer sometimes organizes the transport or even the installation of the work in the potential buyer's home, providing the collector with the opportunity to seriously consider the piece in situ. This, by the way, was a successful tactic of the legendary art dealer Joseph Duveen, who would dispatch works that had never even been requested to clients' homes.[13] Duveen knew that having a work hanging on one's wall makes it harder to part with, and that the subsequent invoices sent would eventually get paid. Sometimes consignment agreements dictate the terms of such an arrangement, but—as is still common in the art world—often there is nothing more than a phone call. In either case, misunderstandings can, and do, arise. The collector should therefore make sure that all details are clear. For example, the dealer's art insurance should cover the work for the duration of the loan as the collector does not yet own the piece.

Discounts

Where a dealer has an existing relationship with a collector (or would like to build one) or when demand is low, he or she may offer a buyer a discount off the retail price, usually 10 percent but sometimes 15 percent. But in certain situations or in the case of special relationships, the artist and dealer may agree to offer a deeper discount to select parties including friends of the artist. They almost always do so for museums or well-known collectors whose very purchase may enhance the general value of the artist's body of work. In such cases, a discount of 20 percent is more the norm. Discounts do, however, very much depend on market climate or individual dealer practices. Low-priced work may be priced to sell with a discount already built in. Or, at the end of an art fair, discounts might also be extended to regular buyers. In most situations, it

is appropriate to ask if there might be any room on the price, but this is less advisable in the case of works by artists currently in great demand.

The Invoice

The terms of all gallery sales are included in the purchase invoice, or the bill of sale, which, for legal purposes, is the controlling document in such transactions. The collector should read the invoice carefully and always include a copy in the collection management system (see Chapter 2, "Collection Management Systems"). In addition to price and applicable sales tax, the invoice should include a detailed description of the artwork specifying medium, signatures, dimensions, and any edition numbers. Other details of the transaction, such as payment instructions and which party will be responsible for crating, shipping, and insurance, should also be clear in the document.

Invoices routinely stipulate that title to the artwork does not pass until the buyer has paid in full. However, in the US, the Uniform Commercial Code provides that title passes upon physical delivery of the goods, irrespective of when or even whether payment has been made.[14] At that point, unless otherwise agreed, the buyer will be responsible for all costs associated with the artwork.

Relationship Building

While dealers are in the business of building relationships with collectors, it behooves the collector, too, to take pains to build a relationship with the dealer. This usually begins by the collector asking questions about art and demonstrating genuine curiosity, knowledge, and a degree of seriousness. Making payments on time—whether that be paying cash immediately or never missing a deadline if paying in installments—is another way to become a valued client. After a strong relationship develops, a dealer may give the collector first dibs on an artist's new body of work or prime secondary-market material coming onto the market, hold a piece on reserve, or place a collector on a wait list for yet-to-be-created works by a desirable artist. Collectors sometimes even buy works of emerging artists who are just being introduced to a favored gallery's roster, a pledge of support for the gallery often pinned to the hope of being given priority when the most coveted works of more established artists later become available.

Individual Collections v. "Dealer" Collections

Once meaningful relationships with dealers are established, collectors should, however, try to avoid falling into the comfort zone of only buying art from the same trusted dealers. Collections populated only with works by artists represented by a few instantly recognizable galleries often fail to inspire, tending to reveal the hand of the dealer(s) more than the

individual journey of the collector. While dealers should guide, educate, and supply, it is up to the collector to keep an open mind, continually exploring new galleries and other possible horizons.

Art Fairs

When the Kunstmarkt Köln, now known as Art Cologne, was founded in the affluent Rhineland by Rudolf Zwirner and 17 other West German dealers in 1967 as a way of reinvigorating a flat market, the idea of such commercial cooperation among competitors was startlingly novel. Now there are almost 200 art fairs, and it is estimated that galleries do anywhere from 30 to 80 percent of their annual business at fairs.[15]

The propagation of art fairs and their effect on the art market is the subject of much debate. For the collector, buying at art fairs offers the advantage of one-stop shopping, the chance to see and compare the works offered by galleries from different geographic regions all in one spot. Depending on their interests and objectives, some collectors will focus their attention on the concurrent satellite fairs which are smaller, less established and generally less expensive, hoping to discover emerging artists at lower price points which will prove to be a smart investment in years to come. PULSE, SCOPE, and NADA are just a few of the satellite fairs that have piggybacked on Art Basel Miami Beach, setting up shop around the main event.

Given the overwhelming nature of art fairs with hundreds of galleries participating and countless ancillary events, it is always a good idea to do as much research as possible before a fair begins. Collectors should see which galleries are participating, decide which programs and artists might interest them, and develop a strategy as to where to focus their energy once they arrive. That being said, one of the joys of art fairs is the possibility of making new, serendipitous discoveries along the way.

In either case, potential buyers should take heed against making rash decisions in the heat of the moment. As art fairs can present a short window for deal-making and a competitive environment not entirely dissimilar to an auction salesroom, it is advisable to take a step back and to do some investigating before committing to a purchase. What are the public auction records for the artist, if any? Where does this work fit within the artist's body of work? A single appealing picture may not accurately represent the whole oeuvre, and eye-catching work is not always, in the end, interesting work. Most collectors, at some point, make what they might later consider to be a mistake.

Collectors looking for bargains in a robust market will also usually not find them at art fairs which tend to represent the apex of the retail art trade. One collector attending TEFAF (The European Fine Art Fair) in Maastricht excitedly put a 19th-century painting on hold, but her follow-up research yielded a sobering fact: the work had been "bought in"

at auction (see "Buying Art at Auction", below) the previous year when it failed to make its low estimate, a fraction of its price tag at the fair.

Nonetheless, most art fairs offer collectors exceptional educational opportunities worth investigating. In addition to the artworks on offer, the major fairs present days of content-rich programming to complement the mercantile nature of the event. This usually includes lectures and panels featuring artists and art-world professionals who speak on topics such as market trends, investment, and artistic practice. VIP programs offer tours of private collections, cultural points of interest within a given city, and various receptions. Most importantly, after the frenzy and mad socializing of the opening hours, the last few days of a quality art fair such as The Armory in New York or TEFAF can provide collectors with the occasion to have meaningful conversations with dealers and to learn a great deal about art. In fact, many collectors attend fairs primarily for researching and connecting, rather than seeking to make transactions.

Buying Art at Auction

Auction houses are the main arena of the secondary market (and have long been the predominant means of acquiring art in China). The vast majority of works sold at auction have had previous owners,[16] and those in the auction business like to say that the material they sell is the result of the three D's: Death, Divorce, and Debt—although seizing the opportunity to sell during robust market conditions has become another reason why works are put on the auction block.

Unlike acquiring art through a gallery, just about anyone who has a credit card can buy a work of art at auction; one generally does not need special relationships to succeed. Relatively speaking, the auction world is thus a more open marketplace with few barriers to entry—except cash. Estimates (the price range an auction house assigns based on what its experts believe the work will fetch—or sometimes on the low side, intentionally calculated to escalate bidding), hammer prices (the price of the winning bid before fees and taxes are added), and sales prices (the hammer price plus the auction-house premium) are public information.

All interested parties who are approved for credit-worthiness may register for a paddle—a numbered board with which to identify themselves to the auctioneer—and bid in person during the auction. While some collectors enjoy the thrill and competition of the salesroom and revel in the auction experience, others prefer to remain anonymous and appoint an art advisor or a trusted dealer to do their bidding for them.

Collectors may also submit written absentee bids with specified limits before the sale, or place a bid by phone, with an auction-house representative calling the client just moments before the specified lot comes

up. For the collector, the advantage of phone bidding is being able to hear some of the activity in the salesroom and feeling more connected to the action without having to be present. Some phone bidders are actually in the salesroom audience, making bids on their mobile phones rather than raising a paddle. More and more, however, online bidding is becoming popular, either through the auction house directly or via third-party companies that specialize in online auction bidding such as LiveAuctioneers or BIDnow. These allow visitors to participate in live auctions online and place bids in real time from anywhere in the world. Bidding online in the comfort of one's home offers collectors convenience and anonymity; at the same time, the collector misses the energy of the salesroom and the exact sense of the optimal moment to place a bid.

Most works sold at auction have a secret reserve—that is, the lowest price at which the auction house and the seller have agreed the piece can sell, which may equal or not exceed the low estimate. For example, even if a work has a published estimate of £12,000 to £15,000, if the actual reserve is £8,000, the work must reach that amount after the bidding starts or it will not be sold. If a work fails to receive a bid that meets the reserve, the work will be bought in (also referred to as "BI") and the lot will be considered passed. Collectors should note that works that are bought in are often sold privately by the auction house after the sale. Those interested in unsold material may contact the auction house with purchase inquiries and can often obtain a work in this way for a very good price. Smaller auction houses will sometimes offer unsold works of lesser value online in the days following the auction at a set price, usually just below the low estimate but sometimes for as little as half of that amount.

In all cases, buyers will pay a premium to the auction house (plus fees to any agents involved). Whereas a dealer takes a cut of all of his or her primary- and secondary- market sales, buyers at auction pay the auction house a commission based on the hammer price of the work. The commission rate can be as much as 25 percent.[17] If a consignment is particularly desirable, an auction house might waive or negotiate the seller's consignment fee—the amount a seller pays to place a work at auction—or even share some of the buyer's premium with the seller, but the buyer's premium is non-negotiable.An additional fee—usually another 1 percent of the hammer price added to the premium—will be charged when a third party such as LiveAuctioneers or BIDnow is involved in the transaction. All fees and other important terms will be outlined in the Conditions of Sale, which buyers should always peruse carefully before an auction purchase. The Conditions of Sale are included in the auction catalogue and can usually also be found online.

In general, buying at auction can be a good way to obtain value in sectors where there is no primary market. When attending an art fair such

as TEFAF, it is astonishing to see the gallery markups on artworks recently sold at auction. A Diego Velázquez (1599–1660) painting being offered by Otto Naumann for a "reasonable" $14 million at the 2013 fair had been purchased by the dealer for $4.7 million at Bonhams London a little over a year before. At the same fair, the London dealer Daniel Katz was selling an Egyptian Isis sculpture dating from approximately 664–525 BC for $7 million, a $3.3-million markup from its Christie's London sale price just five months earlier.[18] Why would a collector pay such inflated prices when he could have purchased the work himself for much less just months (or sometimes weeks) before? Perhaps because buying from a dealer provides some assurance of authenticity or includes restoration work, but the margins remain remarkable nonetheless.

The disadvantage of buying at auction is the need to rely on auction calendars as opposed to walking into a gallery or dealer's booth and being able to purchase something on the spot. There is also the uncertainty of actually succeeding in obtaining the work, especially if the collector feels that it is a "must have." Further, in the heat of the auction, there can be a temptation to overbid followed by buyer's remorse. This is especially true in a hyped bull market when it seems that lot after lot sells for amounts that exceed the high estimates. It is all too easy to get caught up in the context, especially when a work is so clearly desirable to (an)other bidder(s) in the room or on the phone, and a playful auctioneer applies public pressure. Stories abound in the art world of collectors paying inflated prices simply to best a rival on the auction floor. Prudent collectors should decide on their own personal bidding limit before an auction starts and be disciplined about sticking to it. Their limits should also take premiums into account as these are considered part of the purchase price. Other expenses such as taxes and shipping costs should likewise be factored into such decisions.

Unless such information enhances value and thus the sale, the provenance of lots offered at auction typically is not spelled out, but they are rather stated as being "property of an American/European/important collection." Due to confidentiality requirements with consignors, further details can be very hard to glean (although this may change in the future[19]).

Collectors should also be aware of the practice of chandelier bidding (also known as "consecutive bidding" or "off-the-wall" bidding in the UK), a practice whereby auctioneers pretend to spot bids in the salesroom when, in reality, there are no such bids; their theatrical gestures are aimed not at a live bidder, but rather at the chandelier on the ceiling or some other diversion. In most jurisdictions, auctioneers can legally create such fictitious bids up to the reserve price. A collector bidding on one side of the room may thus have the strange sense he is actually bidding against himself.

Skillful collectors take pains to learn what is on the market, scouring auction catalogues. Aside from Sotheby's and Christie's, some of the

most notable auction houses include Phillips (New York), Bukowskis (Stockholm), Beijing Poly International, China Guardian, Dorotheum (Vienna), Villa Grisebach (Berlin), Hauswedell & Nolte (Hamburg), Ketterer Kunst (Munich), Bonhams and Butterfields (London, San Francisco), Heritage (Dallas), Tajan (Paris), Artcurial (Paris) and Waddington's (Toronto), many of which have affiliates in other locations. Smaller, regional auction houses where prices are often lower should also not be overlooked. With most catalogues now available online, canvassing the greater market has become much easier for the collector, although the effect is that competition is ever greater. Stefek's—a modest auction house based in Grosse Pointe Farms, Michigan—traditionally catered almost exclusively to local clients, but now has a truly international business thanks to its online platform.

Buying Art Online

As everyone familiar with eBay knows, it is now possible to buy a huge range of artworks (of greatly varying quality) on the Internet. It is estimated that 10 percent of art sales now take place online.[20] Not only does the eBay emporium offer art from dealers, resellers, and artists, but there are now countless vendors of all kinds selling art directly online, including young artists and galleries who do not yet have other viable means to find an audience. There is a myth that online sales of artworks are made predominantly by novice collectors who are too intimidated to enter the closed gallery world, but this is not the case. The primary online art buyers are actually established collectors who know exactly what they are looking for.[21]

One of the greatest advantages of buying art online is that it saves time by providing a vast array of art with a touch of a finger and allowing quick price comparisons. Not all collectors can carve out time from their schedules to do gallery rounds or attend art fairs in far-off cities. One Google executive and entrepreneur looking for art for his London and Manhattan homes purchased a 5-by-7-foot (1.5-by-2.1-meter) oil painting of a zebra online from a Palm Beach gallery through 1stdibs—a portal which brings together the offerings of international dealers of antiques, design, and fine art—and continues to buy fine art and furnishings online simply because he has no time to hunt for art in person. Like 1stdibs, artnet, one of the earliest multi-faceted art businesses on the Web, allows collectors to search for available works offered by its member galleries online. Galleries themselves now have their own sophisticated websites which allow potential clients to view their inventory, if not make actual purchases online.

New online vendors with fresh concepts appear regularly and will continue to do so. Art*space* is an example of a successful online art sales

portal which offers editions of selected artists, and partners with other art institutions to sell for fundraising. Among other online activities, Paddle8 collaborates with art fairs to present featured artworks online before the fair opens, allowing collectors to research and make purchases before and after the public event in the privacy of their own home. And even Amazon, the world's largest online retailer, has officially entered the art market. Amazon Art was introduced in August 2013, providing potential art buyers with the opportunity to add Claude Monet's *L'Enfant à la tasse* (1868) to their shopping carts for $1.45 million during its first week of operation.[22]

Art is not just like any other chattel, however. As the reported results and ultimate demise of the much-hyped VIP Art Fair—the first online art fair, founded in 2010—demonstrated, the Internet still seems to be more of a portal for viewing and connecting buyers and sellers than becoming a primary medium of actual transactions. Although a 2013 study indicated that 64 percent of contemporary art collectors surveyed reported having purchased artwork online sight unseen through a website,[23] unless a buyer already has first-hand familiarity with the art being offered online (or in a printed catalogue, for that matter), most collectors still prefer to be able to see an artwork in person in order to examine condition and overall quality before committing to a purchase. The fact is, most art is unique—and its true character and condition can only be fully understood and appreciated in person.

Even if a collector has no interest in actually buying art online, many of these sites offer articles, interviews, and a wealth of other information to mine. As mentioned, innovative online art businesses such as Artsy, an "art genome project" described as "the Pandora of the art world," are materializing regularly and will continue to do so. It will be interesting to continue to watch how the Internet is opening new doors for collectors, both for the learning and buying opportunities offered.

Art Advisors

Some collectors choose to work with an art advisor to build their collections. Why work with an advisor when one of the pleasures of art collecting is the thrill of discovering art oneself? There are two reasons. The first is education. New collectors or established collectors with little time appreciate the shortcut that an advisor can offer. The art advisor does the research and the legwork, viewing art, talking to dealers, vetting values, flying to the fairs, and makes recommendations to the collector based on the collector's specific interests. The second reason to work with an advisor is access. Eager collectors who lack the relationships and credibility with important galleries engage the services of an advisor to

gain entrée. A reputable art advisor, while offering knowledge and access for the novice or time-deprived collector, can also provide tacit assurance to the dealer that the work is not going to just anybody.

One young collecting couple in Chelsea, New York, worked with an established art advisor to begin their collection. The advisor introduced the couple to many artists they would not have found on their own, and reassured dealers that the new collectors were legitimate. Without their relationship with the advisor, the couple simply would not have been able to buy many of the works in their collection. As the years went on, the couple became more educated about the market, becoming known as serious collectors in their own right. They no longer needed the advisor to acquire art, but continued to employ her as a valuable sounding board and discussion partner. One of the most valuable benefits a good advisor can offer is neutral advice.

Reputable advisors are upfront and clear about their fees. It is common practice for art advisors to charge the collector a percentage of the purchase price, usually 10 to 15 percent. Since an advisor with a gallery relationship is usually entitled to a discount of about the same amount (which the unconnected collector may not be), this is generally a fair trade-off; in theory, art advisors pass their discounts along to their clients so that the clients are able to pay them while still paying no more than retail for the work. Other art advisors will charge on a retainer basis for big-volume clients (and often manage the collection in addition to sourcing the artwork). Still others receive a salary or charge on an hourly or daily basis for their time. The most appropriate arrangement will depend on the situation.

No matter how they bill, advisors should be paid from one source only, preferably the client. Advisors who are given a discount by the dealer, do not disclose this to the client, and take a percentage fee from the client based on the retail price—a not-uncommon practice known as "double-dipping"—are unethical and their practices can reflect badly on the client who is paying them. A buyer should also be wary of an advisor who presents invoices without a detailed breakdown. Eager novice collectors, keen to work with an of-the-moment advisor (or someone who appears to be such), have been known to turn a blind eye to vague invoices, only to get burned. The key issue in such a relationship—and in just about all business relationships in the art world—is transparency. Like the best dealers, the best advisors are interested in establishing long-term relationships and helping to build meaningful collections, not making one-off deals solely to fill their pockets.

As with a handful of dealers in this unregulated business, there are a number of unscrupulous art advisors. In fact, since there are no required credentials and no certifying body, just about anyone can call themselves an

art advisor, and many individuals do just that. A collector should confirm that any advisor he is considering engaging has a solid reputation. Has the advisor been covered in the press? What is his or her educational and experiential background? Most advisors worth their salt have a background in art history as well as years of experience in the commercial art world under their belts, either in galleries or auction houses or both. If the advisor has not been recommended by a trusted fellow collector, one resource for finding a reputable art advisor is the US-based Association of Professional Art Advisors (APAA) whose members must be invited to apply for admittance.

Commissioning a Work of Art

Another way to acquire an artwork is to commission it directly from an artist. Where the artist is represented by a dealer, the dealer will normally broker the commission and take the usual fee. Sometimes one dealer will represent an artist while another dealer might represent commissions by that same artist. (For example, Richard Serra is represented by the Gagosian Gallery but Peter Freeman, Inc. represents commissioned works by the artist.) It is also sometimes possible to commission a work from an artist directly. In either case, the collector typically makes a non-refundable deposit which covers the artist's time and materials. The right to refuse the work if the final product is not to one's satisfaction should be negotiated, and there should always be a written commission agreement which outlines payment, delivery terms, and various rights to the commissioned work, including copyright.

Buying Art with Others

It is sometimes desirable to buy works of art together with others. The most common arrangement is for spouses or relatives to acquire works together as a couple or family, gaining satisfaction from pursuing a common interest together. It is also fairly customary for individuals to purchase art together for investment reasons (see Chapter 8, "Collective Investing," p. 165). Individuals chip in to buy works of art they may not be able to purchase on their own, each taking a share of the proceeds when the work is subsequently sold.

While perhaps not a common practice, others buy art together with acquaintances as more of a hobby, a way to learn and expand one's horizons in dialogue with others. One intrepid group of European friends created an informal collecting consortium, pooling their funds to purchase works of contemporary art, and taking turns selecting the acquisitions. Works in the joint collection would then be rotated among the group's members for display in their respective homes. Much like a book club, the

members of this group enjoyed being exposed to works of art they might not have chosen on their own and relished the adventure of exploring the contemporary art world without the weight of individual investment.

Individual collectors might also buy art together with the intention of donating a work of art in the future. In one case, when an important Abstract Expressionist work of art came on the market, a trio of New York collectors purchased the work jointly with the intention of eventually donating it to a local museum where they all served as trustees. In the interim, they would share the possession and enjoyment of the work.

One obvious issue that arises when art is shared is the question of who is entitled to possess the art—and for how long? Also, who manages and pays for transportation, insurance, and other expenses? In all cases when art is shared, it is important to clarify the ownership rights in writing and to ensure that any collection management system and all invoices accurately reflect this information. In case of divorce or other conflicts, the invoice will often be the controlling document.

After several years of joint collecting, the participants of the aforementioned European collecting group decided that their endeavor had run its course. It was time to sell. But what if more than one member wanted to keep the same piece? Who would be given first choice? And would they be free to sell the artworks expediently as they wished in order to close this chapter—or would the market not cooperate? Owning works of art together with others can carry its own risks, all of which should be discussed and clarified in writing.

RESTRICTIONS AND ADDITIONAL EXPENSES

Restrictions

Collectors should be aware that there can be restrictions placed on moving art, especially international transport, and any possible obstacles should be carefully investigated prior to purchase. Many countries have laws that protect their cultural heritage and prohibit export. One French collector was keen to buy a rare Renaissance silver tankard to gift to his brother for his 50th birthday. The sales specialist at the auction house in Stockholm pointed out a small notation in the auction catalogue: the Swedish government deemed the tankard to be a national treasure and export of the object was thus forbidden. In other words, the French collector was free to buy the tankard if he had the winning bid—but the tankard would have to remain in Sweden, defeating the purpose of the gift.

In the UK, certain cultural objects over 50 years old which are deemed to be of cultural significance to the nation may be temporarily

banned from export in order to give a UK buyer enough time to raise the funds needed to keep the work in the country. Such was the case when Raphael's *The Madonna of the Pinks* (*c.* 1506–7) was acquired by the National Gallery in London in 2004 after the Getty in Los Angeles had previously offered its owner, the Duke of Northumberland, £35 million for the picture and its export was barred.

Aside from export restrictions, the materials of an artwork itself may present issues. Certificates are required for export and import of objects made of endangered species such as ivory, whalebone, tortoiseshell, rhinoceros horn, etc. Even if a buyer successfully obtains an export license or certificate, that does not mean that an import license will be obtainable on the other end (and vice versa).

Some works may not be exported or sold at all. There are a number of federal restrictions on the trade of antiquities or Native American art and artifacts such as Anasazi pots, for example, making these difficult and controversial collecting fields. The US Bald and Golden Eagle Protection Act and the 1918 Migratory Bird Treaty Act make it a crime to possess, sell, purchase, barter, transport, import, or export a number of birds, dead or alive, and this includes bird parts such as feathers or nests. Thus, the dealer Ileana Sonnabend's heirs who inherited Robert Rauschenberg's masterwork *Canyon* (1959), a sculptural combine which contains a stuffed bald eagle, were unable to sell the work—even though tax authorities valued it at $65 million in 2012 for estate purposes.[24] (*Canyon* was eventually donated to New York's Museum of Modern Art (MoMA) in 2012 as part of the estate's settlement with the Internal Revenue Service (IRS).)

Taxes

Taxes and fees imposed on art purchases and transfers can be substantial, varying greatly from one jurisdiction to the next, and are often subject to change. Collectors must thus be vigilant about confirming which taxes might be due *before* they make the purchase—even if they have made such purchases many times over.

Sales Tax

One factor to always consider when acquiring art is sales tax, which varies in each jurisdiction. In the United States, in addition to auction-house commissions, broker fees, or a dealer's cut, a collector must pay local sales tax on each work of art purchased. (In the US, collectors buying strictly for investment purposes and classified as "investors" by the IRS—a very difficult standard to meet—do not have to pay sales tax when purchasing artworks.)[25]

In New York, for example, sales tax was set at 8.875 percent in 2013. In China and Europe, Value Added Tax (VAT), a consumption tax levied on the purchase price, is imposed. This rate starts at 15 percent, although some countries have a reduced tax for works of art. US collectors buying works at fairs or galleries while in Europe will not have to pay VAT, but will have to pay sales or use tax in their state of residence and are obligated to report such purchases on income tax returns. (A use tax is imposed on artworks that would have been subject to sales tax had they been purchased within the state.)[26]

Due to such cases and crackdowns by tax authorities, instigated by a notably aggressive campaign against violators by the Manhattan District Attorney's office in the early 2000s, however, this art-world practice has sharply declined. In fact, many jurisdictions, including New York, now require auction houses and galleries to impose state taxes when a client picks up a work they have purchased—even if the work is legitimately and permanently going out of state. Buyers should therefore do the math, weighing the costs of shipping out-of-state and not paying taxes against paying the taxes and avoiding shipping charges which can also be exorbitant.

It is important to note that sales tax is also imposed in destination jurisdictions where the vendor also does business. For example, Sotheby's auction house is required by law to add Connecticut sales tax on works purchased in New York and shipped by carrier to Connecticut since Sotheby's is a registered business in that state. Collectors concerned about taxes should always check where an auction house is registered to do business, keeping in mind that this can change from time to time.

Not even major collectors are entitled to be informed of such changes, despite the significant impact these may have on their purchases. In one case, a collector routinely bought works from a New York auction house and had them shipped to his out-of-state address where the auction house was not registered for business. When the collector made a purchase of a lifetime from the same auction house one season, however, the invoice included unanticipated state taxes totaling hundreds of thousands of dollars. In a heated telephone exchange with the auction house, the incensed collector was told that the business had recently become registered in the destination state, something the collector would not have anticipated after so many years of similar transactions with the same auction house.

Collectors have long sought creative ways to avoid paying these not-insignificant levies. Shipping works to out-of-jurisdiction addresses in order to evade sales taxes used to be common practice. The question "Where would you like this work shipped?" posed by a gallery assistant preparing an invoice was a cue for the buyer to provide a non-taxable

out-of-state address even if the work was destined to remain in, or return to, the jurisdiction. In order to oblige the client and massage their own profits, some dealers even went to the trouble of shipping empty crates out of state while the actual artwork was secretly ferried to the local residence.

This very practice resulted in the spectacular fall of former Tyco CEO Dennis Kozlowski whose sales tax evasion on his art purchases led to the investigation which landed him in prison with over $100 million in restitution and owed taxes. Kozlowski regularly had dealers send invoices to his New Hampshire offices when the artworks were, in reality, being delivered to his Manhattan apartment—as blatantly evidenced by the dealer's memo to a shipping company: "Here is a list of the five paintings to go to NH (wink, wink). Please make cardboard boxes or use crates to match the piece count. Cheers & thanks."[27]

VAT and Import Duties

Some countries also require collectors to pay a sizable import duty when they purchase works abroad. In the case of China where VAT and import duty are around 23 percent but have been as high as 33 percent (compared to no levies in Hong Kong), this has led to trouble. (In March 2012, in a crackdown on dealers and collectors, a German art handler and a Chinese associate of shipping company Integrated Fine Art Solutions were imprisoned on charges of art smuggling, with the government claiming they undervalued imported art to avoid customs duties.)[28]

In certain circumstances where it has been recognized that heavy taxation impedes the art trade, such local and import taxes have been waived. In Brazil, for example, the organizers of the ArtRio and São Paulo's SP-Arte fairs persuaded government authorities to make art purchases at the fairs exempt from state taxes, but this was only for local residents and caused a great deal of confusion.[29] As art economies continue to develop, the issue of taxes and duties has become central, and such fees can be expected to change.

Artist's Welfare Tax and Artist's Resale Royalties (*Droit de Suite*)

Another tax to be aware of is artist's welfare tax, added at the time of purchase by some jurisdictions such as Germany to cover pensions and health insurance for living artists. Still other jurisdictions impose artist's resale rights, also known as *droit de suite*, when works by living artists are purchased. Following the UK's implementation of the EU's Artist's Resale Right Directive, art-market professionals in the UK are required to collect resale royalties on behalf of artists. As of 2013, buyers at Sotheby's London, for example, pay a 4 percent artist resale royalty on works with hammer prices up to €50,000.[30]

Ancillary Expenses

The substantial ancillary costs involved in art acquisitions including insurance, storage, shipping, framing, and installation should also not be overlooked. These costs, discussed at length in Chapters 4 to 6, often exceed 25 percent of the purchase price and should be considered at the acquisition stage.

DUE DILIGENCE

Caveat Emptor: An Opaque Marketplace

Collectors should be warned that the art world is not a transparent marketplace.[31] There is little regulatory oversight, and obtaining essential information about a work of art can be difficult.

The pitfalls in acquiring art are many. Countless collectors have been duped by the casual assurances of a seller, only to subsequently learn that the works they have purchased have issues with title, authenticity or condition which affect their value and make them difficult, if not impossible, to resell—problems they could have avoided if they had done research from the outset.

In the US, the Uniform Commercial Code (UCC)—a federal code of law which standardizes the law of sales and other commercial transactions within all 50 states of the US—offers some protection for buyers, requiring that dealers and auction houses warrant good title on the artworks they sell and imposing other implied and express warranties on a seller. Certain states such as New York provide further protection for art buyers such as creating dealer warranties with respect to the stated authorship of a work of art. Such warranties, however, can be limited or disclaimed by sellers, and there are inconsistencies in how these limitations are interpreted by courts.[32] Even if a collector can successfully prove that he has been defrauded by a seller, the remedies—such as rescinding a sale—are not always satisfactory for the collector.

In order to avoid such issues, collectors must be dogged in rooting out all pertinent information related to the artworks they consider acquiring. Facts provided about any work of art should never be taken at face value, and independent verification is critical. Due diligence—that is, asking the right questions and garnering information about a potential acquisition—is thus essential to the acquisition process. Collectors need to take meaningful measures to ensure that works of art they buy are (1) in good condition, (2) genuine, (3) have clear and unencumbered title, and (4) are appropriately priced. Due diligence can sometimes be done within minutes, but in the case of older, secondary-market works, it can take months or even years.

Provenance

The provenance of a work of art is the history of physical possession of the piece from the date the artist created the work to the present day. When buying an older work, a complete and unbroken provenance is crucial. Catalogues raisonnés—comprehensive, scholarly compilations of all known works of an artist—are critical tools for researching the provenance of a work. The International Foundation for Art Research (IFAR) provides free-of-charge access to electronic databases comprised of citations to both published catalogues raisonnés and catalogues in preparation. They can be searched separately or together and are regularly updated. Provenance is also provided in many auction catalogues and dealer information sheets. The Getty Provenance Index Databases are a rich resource that includes archival ownership records, sales catalogues, dealer stock books, artist payment records, and public-collection documentation. Lastly, the work of art itself should not be overlooked. The markings and tags on the backs of paintings and on the base of sculptures such as stamps, exhibition labels, and other indicators of an artwork's ownership and history, often provide valuable information.

As provenance information has been known to be manipulated or even completely fabricated, it should not, however, be taken at face value, but investigated in great detail. Collectors should personally check the catalogue raisonné and all relevant auction and exhibition catalogues. Scholars who have been named as supporting an attribution should be contacted, where possible, and experts themselves—some of whom are paid by the seller—should be researched. The College Art Association's Code of Ethics outlines such conflicts of interest and offers guidance.[33]

Condition

An artwork's condition directly affects its market value. Sometimes, condition issues are obvious. There is a tear in a canvas, paint loss, cracks, or fading. But other times, to the untrained eye, condition concerns are not so obvious and may even have been masked by a dishonest seller. Older works have histories; they may have been restored, reframed, or relined to the work's detriment.

Unless the sought-after work is fresh from the artist's studio, collectors should always request a condition report on prospective acquisitions. A reputable dealer or auction house will usually provide a detailed report for significant works, sometimes commissioned from a conservator at the time of consignment. Auction houses routinely provide brief reports for all lots in the catalogue but these can be vague. Lots sold "as is" make it clear the condition reports do not warranty anything

beyond that which is stated in the conditions of sale. Collectors should thus not hesitate to contact the sale expert directly to discuss condition. As poor restoration attempts also profoundly affect condition, a conservation history should also be requested.

While such experts are usually forthcoming about condition, it is always advisable to retain the services of an independent conservator when considering purchasing a significant work of art. Detailed condition reports in writing are all the more important when one is buying an artwork without having personally examined it, as is frequently the case

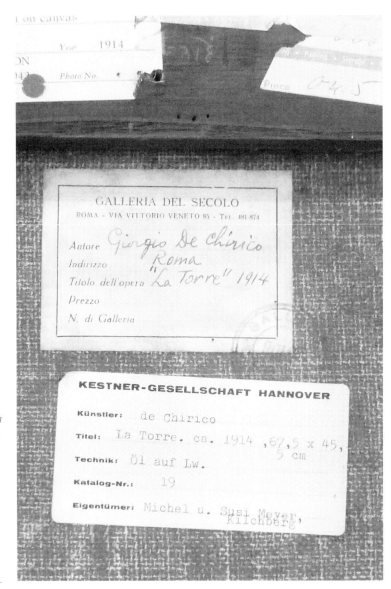

Detail, Giorgio De Chirico, *La Torre*, (1914), verso, Museo Soumaya, Mexico City. The markings and tags on the backs of paintings such as stamps, exhibition labels, and other indicators of an artwork's ownership and history, provide valuable information and should be preserved and documented.

with online purchases. They are also the best protection if questions about condition should arise in the future. Collectors should be aware, however, that condition reports and other documentation related to an artwork are sometimes fabricated to advance a fraudulent transaction.

Authenticity

As long as there has been an art market, there have been a plethora of fakes, with some forgers, such as the legendary Dutch Old Master counterfeiter Han van Meegeren, becoming renowned in their own right. More recently, Wolfgang Beltracchi, together with others in a German forgery ring, was jailed in 2011 after having created forgeries of artworks by some fifty Expressionist and modern artists. Over the course of more than two decades, Beltracchi and his cohorts made a fortune duping such prominent individuals as the collector Steve Martin, expert Werner Spies and dealer Richard Feigen.[34] And, as the art market explodes in China, faking Chinese artifacts, paintings, porcelains and bronzes has become an industry in itself,

Condition report from Sotheby's auction house. Collectors should request condition reports from dealers and auction houses before acquiring a work of art on the secondary market. In some cases, independent condition reports are advisable.

with one estimate stating that 80 percent of the lots at small and mid-size auction houses in that country are counterfeits.[35]

As discussed, while the US Uniform Commercial Code requires dealers and auction houses to guarantee the authenticity of the works they sell, and buying from reputable dealers and businesses is always wise, this is no absolute guarantee that works will be authentic. New York's "most venerable art gallery",[36] Knoedler, suddenly closed in 2011 after 165 continuous years of operation amid allegations of forgery of sold works by Abstract Expressionists Willem de Kooning, Franz Kline, Robert Motherwell, Barnett Newman, Jackson Pollock, Mark Rothko and Clyfford Still.[37] Collectors should note that in the case of deceased artists, sometimes a "perfect" provenance is actually the best clue that a work is a fake.

It is a fact that art which has been determined to be inauthentic often returns to the marketplace. In one situation, an auction purchase was rescinded when the buyer demonstrated that the work was inauthentic after the sale; that inauthentic work, however, was thereupon sold by the auction house to the underbidder.[38] With art values skyrocketing, scandals such as these—and perils for the collector—are bound to mushroom.

Establishing authenticity is no easy feat. Proof of authenticity is a matter of opinion which is by nature subjective, and it is not uncommon for experts themselves to disagree on whether or not a work is genuine. In some cases, authenticity simply cannot be definitively established. Furthermore, as scholarship and technology advance, opinions on authenticity and attribution can, and do, change over time.

Moreover, to make the issue of establishing authenticity even more challenging, it is now becoming difficult for collectors to obtain expert opinions. Most collectors seek such opinions before acquiring a work of art, and it has long been standard practice for art historians and other connoisseurs to provide such opinions as part of their vocation or even out of a sense of moral duty. Disturbingly, following a series of lawsuits wherein such experts have been targeted for providing opinions that were unfavorable or ultimately did not hold up, respected experts, authenticating bodies, and even catalogue raisonné authors are now declining to render their opinions. With certain art values going off the charts and opinions being able to literally make or break a fortune, the legal stakes are just too high to risk an error or purported error. Established scholars such as former chief MoMA curator John Elderfield as well as organizations like the Andy Warhol Foundation for the Visual Arts and the Roy Lichtenstein Foundation have all stopped authenticating works in order to avoid the debilitating costs of any potential litigation, and many fear that even more inauthentic works will find their way to the market due to this de facto censorship of qualified experts.[39]

Certificates of Authenticity

A certificate of authenticity—a document signed by the artist (or the artist's heirs, estate, or foundation) which avows the authorship or originality of the work—is one way to affirm authenticity. During the 1960s when art was becoming more conceptual and production methods were being re-thought, certificates gained importance, coming to represent not just an artwork's "deed, legal statement, and fiscal invoice," but the work itself, enabling even immaterial works of art to have a position in the market.[40] For works by contemporary artists such as Dan Flavin and Sol LeWitt, the value of the work lies not in the physical work itself, but in the certificate; without the certificate, the work has little or no value at all.

In one situation in France, an auction house sold a work by a prominent 20th-century artist, with the sale catalogue stating that work was accompanied by a certificate—although it had nver been provided. When the buyer tried to sell the work years later and sought the certificate from the auction house, he learned that it had burned in a warehouse fire. The estate of the artist refused to acknowledge the work without the certificate, leaving the collector with an object he was unable to sell.

In 2013, on the eve of a sale of contemporary art, an auction house realized that the consignor/collector of one of the items had not provided the certificate of authenticity. The frantic hunt to locate the certificate in the hours before the sale revealed that it was unclear whether the reputable art advisor who had originally purchased the work on behalf of the consigning collector had ever provided the certificate in the first place or whether the collector's staff had somehow subsequently lost it. The only evidence found was an ambiguous Post-it note in the advisor's files. The work had to be pulled from the sale, with the collector paying the penalty for doing so. Although the advisor might be found liable to the collector as agent and fiduciary if such a course of action were pursued here, this scenario underscores the need for collectors to be proactive about obtaining all relevant documentation from vendors and agents at the time of purchase and to archive them with care.

That being said, sometimes such documentation is bogus, as certificates of authenticity, too, are routinely fabricated for the purpose of making a sale. The market is flooded, for example, with limited-edition prints allegedly created by Picasso, Salvador Dalí, or Marc Chagall, and related certificates, which often bear a watermark and florid script. These should raise a red flag. Condition reports and exhibition histories, too, are routinely faked, so buyers should not be too easily swayed based on accompanying paperwork when a work's authenticity could be in question. Again, it is always best to acquire art from vetted, reputable sources and seek additional expert advice when necessary.

Title

Even experienced collectors who do their homework with respect to the provenance, condition, and authenticity of an artwork sometimes overlook the related issue of title. Legal title in a work of art—to be distinguished from provenance—is defined as the past and present full right of legal ownership in the work. In the vast majority of cases, a buyer obtains title to a work of art at the time of purchase. There are, however, a number of circumstances in which a good-faith buyer does not obtain clear and free title, and this can have dire consequences for the collector. Unlike real estate, there is no title registration for art, no means to do a lien search, and thus no way to verify proof positive that one has full legal title to one's artworks—even where a detailed provenance exists. An artwork may have been looted, stolen, or, more commonly, subject to liens and encumbrances. And while, in the US, one can do a UCC title search with respect to the latter, this is not foolproof.

Because of the general lack of transparency in the art business, with no means to register or check the title of a work of art, even collectors who exercise due diligence at the time of purchase have no guarantees that they actually own what they have purchased. As has been seen in the scores of Second World War era restitution cases towards the end of the 20th century and at the beginning of the 21st, individuals can lose their artworks after decades of presumed ownership or suddenly find themselves liable to third parties long after they have spent the proceeds of art they have sold.

Looted and Stolen Artworks

Since the early 1990s, artworks looted during the Nazi period have received a lot of attention as they resurface on the art market, with a spectacular single trove of some 1,400 artworks discovered in Munich in 2012. Some estimates say that a million artworks were looted by the Nazis, mostly from Jewish owners. The warning sign of looted property is typically a gap in provenance or one that includes the name of certain dealers, such as Karl Haberstock or Friedrich Welz, who were known to have sold Nazi-looted art.

Heirs to Nazi-confiscated artworks continue to make claims against private individuals and institutions alike. The US Customs Office famously seized Egon Schiele's *Portrait of Wally* (1912) from the Museum of Modern Art in 1998 while it was on loan there from the Leopold Collection of Vienna, when heirs to the Jewish art dealer Lea Bondi claimed rightful ownership (see color plate section). The painting subsequently sat in a warehouse while the parties fought out their rights to the picture in the court system over the next 13 years, ultimately settling.[41] Gustav Klimt's *Portrait of Adele Bloch-Bauer I* (1907) was also the subject of headlining litigation, with the Altmann

family eventually winning the portrait back from the Austrian government and selling it to Ronald Lauder for a record-breaking $135 million in 2006.

Additionally, according to some sources, stolen art is the largest international criminal activity behind drugs and arms trading, with billions of dollars' worth of art stolen annually.[42] Civil law countries including most of Europe tend to protect subsequent, innocent purchasers (i.e., a person who purchases property for value and without notice that it is stolen property) after a certain time period has lapsed. However, the common law in the US and the UK is not as friendly to subsequent buyers, since the original owner of a stolen work of art—unless barred by the statute of limitations or some other technicality—maintains the right to reclaim the piece. In the global marketplace, issues related to title are complicated by conflicting laws and choice-of-law questions.[43]

Where doubts exist, collectors should thus consult the Art Loss Register to determine if the piece has been reported as missing or stolen. Founded in 1991, the ALR database lists close to 400,000 works of art that have been reported stolen or missing. The ALR is regarded as the primary stolen-art database, with courts considering an ALR search to be an essential due-diligence step for collectors seeking to establish their rights of ownership. As many theft victims do not report theft, however, even a clean report from ALR cannot guarantee that a work is free from a claim by another party.

Liens and Encumbrances

While art theft makes great headlines, title-related issues with respect to art purchases are more commonly due to more mundane problems such as liens and encumbrances involving family or estate disputes, creditor's claims, unauthorized sales, and import/export violation. It is not unheard of for works to be consigned to dealers or auction houses by sellers who only have partial interest in a work. In one high-profile case, a former art dealer consigned Mark Tansey's *The Innocent Eye Test* (1981) to the Gagosian Gallery, which then sold it to a third party for $2.5 million. The consignor had forgotten, however, that the Metropolitan Museum of Art had a 31 percent ownership interest in the painting and that the remaining interest belonged to his mother.[44]

Moral Rights

In Europe as well as states like California and New York, *droit moral*, or moral rights laws, protect artists' rights in the integrity of their work. The right of of authorship (or right of paternity or attribution) gives the artist the right to claim or disclaim authorship. Further, under the Visual Artists Rights Act—known as "VARA"—which is US federal law, "the artist

shall have the right to prevent the use of his or her name as the author of the work of visual art in the event of a distortion, mutilation, or other modification of the work which would be prejudicial to his or her honor or reputation."[45]

In theory, if an artist disavows a work under these laws due to some physical change in the work, it is therefore possible that an unwitting collector could purchase an artwork that has little value at all. Sotheby's withdrew the silk-screen print on aluminum by Cady Noland entitled *Cowboys Milking* (1990) the day before its November 2011 sale on account of the fact that the artist had disavowed the work under VARA, claiming her reputation would be prejudiced if the work were sold in its restored condition. With the value of the silk screen—which had an estimate at $250,000–$350,000 and was similar to another piece by Noland which had achieved $6 million the previous day—suddenly deemed questionable, the consignor sued both the artist and the auction house for many millions of dollars.[46] This matter was ultimately resolved based on the auction house's contractual right to rescind the sale; thus, ambiguity remains as to whether an artist can actually legally disavow a work that has deteriorated.

Ascertaining Value at Time of Purchase

Due diligence also means not overpaying for artwork. How does the collector know whether the price for which the work is being offered is fair? Establishing prices for artworks is difficult, and pricing itself can sometimes seem completely arbitrary. Similar works by the same artists may sometimes be offered at different galleries or at the same art fair for very different prices. (If buying a work at a fair, a collector should consult the artist index of the fair catalogue to see if works by the artist are offered at multiple booths. If so, investigate and compare.)

While there are no public records of private gallery sales, online price databases such as artnet, Artprice, and Invaluable (formerly Artfact) provide past auction results, for a fee, of works by visual and decorative artists with an established body of work. This data can offer useful comparables. The caveat here is that such results do not disclose information about condition or other pertinent issues that may profoundly affect value (see Chapter 3, "Valuation Factors"). These databases are thus considered both a blessing and a curse, but can nonetheless be a helpful tool for the experienced collector.

In the case of new works by emerging artists, a collector will want to learn as much as possible about the artist. Has the artist had a show before? If so, where and when? What is his or her training and background? Who else is collecting the work—noted collectors, or

perhaps other artists who often have the best antennae for identifying promising work of quality? Lastly, how do prices for the artist's work relate to those for other artists at similar points in their careers, and how has the work been critically received?

Where applicable, the gallery should also be considered. What other artists does the gallery represent and where are their careers going? What is the gallery's reputation? What is the gallery's history? Does it show at fairs? Which ones? What about publications? Some galleries are so strong that their very association with an artist confers value on the artworks. As galleries almost always raise the prices of an artist's work each time the artist has a show with them (generally once every two years), buying a work of art from such a gallery can almost guarantee growing value— at least in the short term. In fact, some art advisors and investment-orientated collectors will make a point to buy an artist's work early on with the intention of selling it—sometimes back to the original gallery—in a few years' time for shorter-term profits. For this kind of return, a collector will need knowledge, experience, and—as with most investments—luck. But even a very strong gallery provides no guarantee that an artist's work will continue to gain value *in the long run*.

Following the Market

The best way for a collector to have a sense of value at the time of acquisition and not be taken by an unscrupulous dealer or advisor is to be an active follower of the market. This means going out to galleries and art fairs and asking about the prices for similar works, studying auction estimates and following sale results from auction houses and price databases. Due diligence means reading critical reviews of museum and gallery shows and engaging in discussions with experts and fellow collectors. Collectors of contemporary art should also attend biennales and other art festivals to note which artists are currently valued by curators.

Those collectors who steep themselves in the market, and read and see as much as they can about the artists that interest them, tend to take great satisfaction in doing so and usually make the savviest collectors in the long run, putting together the most admirable, valuable collections and becoming true experts themselves over time.

PART TWO

ESTABLISHING THE SCOPE AND VALUE OF A COLLECTION

INVENTORY MANAGEMENT

The first step in managing an art collection is knowing exactly what comprises it—and marshaling all related information into one accessible, secure, and comprehensive system. The number of collectors who don't have a grasp on the full scope of what they own is astonishing, especially considering that this can have significant consequences if disaster strikes or if the collector is suddenly no longer available. Much of the value, both emotional and financial, of a work of art is determined by the information connected to it: What is the work made of? Who made it? When was it conceived and executed? Where did it come from? How much did it cost? What does it mean? And it always helps to know where it is located. It can be extremely challenging, if not impossible, for successors, executors, and insurance companies to piece this information together when detailed records do not exist.

Moreover, where records do exist, they will not be much help unless they can be clearly identified with a particular piece. It is not uncommon for collectors to accumulate works that are similar, e.g., works by the same artist, works of similar aesthetic, furniture of a specific genre. Personal notations such as "the larger one purchased in Hong Kong" or "Grandfather's favorite painting" can be of little help to third parties trying to identify a work if the author is no longer in a position to elaborate. That's why identifiers—numbers assigned to both the object and its corresponding records—are essential for proper art collection management. (See later in this chapter, "Cataloguing Checklist," Accession (Inventory) Number, p. 60.) Collectors and those who care for collections should approach their record keeping and collection management with a level of detail and clarity such that, should they themselves be incapacitated, the records would be fully comprehensible to any party who may be called upon to step in and take charge at any moment.

Due to the organic nature of collecting, the lack of methodical inventory systems is understandable. Collectors generally don't start out with the goal of being a collector, equipped with the tools to manage this new undertaking. Rather, a painting is purchased one day at a gallery or a

friend's studio, and then another, and then another. Or someone inherits a few pieces and begins to add more. There are countless ways in which collections accrue. But where is the point where acquisitions become a collection? Is it three artworks? Or 30? And when is the moment where one stops to think "I now have a collection and I need to document it"?

Most commonly, a collector with the best intentions will process information related to their artworks in a piecemeal fashion: a gallery invoice will go into a file; a related exhibition catalogue will go onto the bookshelf; a JPEG image sent by the gallery will be saved on the computer. This kind of record keeping can go on for years, suddenly becoming a mass of information which only the owner can decode— that is, if he himself can remember or locate the details. Works are transferred to storage or gifted, documents disappear, files are erased, hardware is replaced, and memory starts to fade. In the case of older collections, even the most meticulous record keeping can be difficult to decipher by subsequent generations or owners.

COLLECTION MANAGEMENT SYSTEMS (CMSs)

Over the last decade, art collection management has been revolutionized by the advances of the digital age, making it much easier for collectors to manage, enjoy, and even utilize their collections. Software and now web-based systems, referred to collectively as collection management systems (CMSs), not only enable collectors to maintain a comprehensive overview of their collections, but can assist them with related decision making, bookkeeping and administration. Collectors now have the option of viewing their collections online at any time from just about any location, and they can search their inventory by location, artist, theme, value, or a host of other qualities. The CMS enables them to print colorful catalogues so that they can reference and admire their entire collections or share their works with others without ever leaving their armchairs. These days, the hardest decision may be which CMS to choose, and the greatest challenge staying on top of the rapidly evolving technology. Like art values, CMS technology can drastically change within a year. The examples discussed below, although vetted and thus far enduring, are therefore subject to change.

Paper Files

Even in the digital age with an optimal CMS in place, best art collection management practice includes maintaining parallel paper files to house original documentation. Ideally, each work of art in a collection

will have a corresponding archival paper file in which all original documentation is placed. This includes original invoices, shipping or conservation documents, certificates of authenticity, bills of lading, and all correspondence related to the artwork. Such original documentation can even prove to have value in its own right over time.

All of this original documentation should also be carefully scanned, the electronic copies being stored in the CMS. With most home printers now including scanning options, this process has become routinely feasible. Scans can be viewed at any time in the CMS, with the added bonus that the original files don't have to be accessed and can be better preserved.

In most cases when collections are formed, no one, including the collector, can surmise how long they will last. Collections exist for generations within families, yet meticulous documentation on paper can only last as long as the materials themselves. It is therefore always best to approach collection management with a long-term view, using archival standards. First, all staples, paper clips, and adhesives should be systematically removed before filing as they can erode paper over time. As everyday paper and folders contain acids which can accelerate the deterioration of documents, collectors should use only archival acid-free files to house collection documentation. Related ephemera should be stored in acid-free boxes which are available at specialty shops or can easily be ordered on the Internet. While more costly than materials obtained at your average office-supply store, they are relatively inexpensive in terms of the value of the protection they provide.

The fastidious documentation of one important collection put together in the 1960s before archival materials were readily available was seriously deteriorated by the end of the millennium. Staples were rusted, burning holes through valuable documents; adhesives had stained paper dark brown; and documents themselves were starting to crumble and could no longer withstand handling. Given that these included letters from some of the most important artists, dealers, and art-world personalities of the period including Jasper Johns, Leo Castelli, and Alfred Barr, this corrosion was a shame—even more so because the collector had been so diligent in compiling and organizing all this information in the first place.

As is often the case with older collections, one of the first steps in managing this collection was to rehouse it using archival materials. Harmful materials were delicately removed, old files were discarded and replaced with acid-free ones, and documents were scanned.[47] While extra handling and photocopying is not normally recommended for fragile documents, having accessible digital copies for future reference in this case was much preferable to the repeated touching of the originals, many of which were hand-typed on ultra-thin onion-skin paper.

Even with the highest archival standards, these original records are of course vulnerable to the elements and to fate. They should thus be kept in fireproof cabinets and should never be stored in basements that might be susceptible to mold or flooding. It is also recommended that such records (or at least a copy thereof) be stored off-site for protection in case of disaster. A safety deposit vault at a bank or secure art-storage facilities are good options, especially for certificates of authenticity which are usually irreplaceable.

CMS Options: Excel, Software, and Relational Databases

What are the collection management system options and how can a collector choose the right one? While there are many options and the choices are constantly evolving, the best choice will depend on the needs and budget of each individual collector. The following discussion is not meant to be a comprehensive analysis of all art collection management systems, but rather an overview to provide collectors with general information about the range of options that are currently available.

Many collectors start keeping track of their collections using Microsoft Excel as it provides a familiar system to store data in a customized fashion without great investment. But Excel is essentially a spreadsheet, a handy tool to store information which may suffice for collectors who require little more than a comprehensive overview of data related to their artworks. Even with all the incredible advances in CMS options, some stick with Excel despite its limitations for art collection management as that is the system they are accustomed to. At least one major internationally recognized collection is still managed solely with Excel because the curator started using it to manage the collection more than 20 years ago and feels it would be unwieldy to change. While most CMS providers who regularly provide data-importation services would beg to differ, Excel may indeed be adequate for static collections in which there is not much activity. But it is not always in the best interests of the collector.

A database, by contrast, allows collectors to take the same information and employ it in countless ways, offering a powerful and flexible instrument for collection management. Some of the first and most popular specialized collection management systems used in the art world such as Artsystems, founded in 1989, and ArtBase, founded in 1993, are software systems built in FileMaker Pro. A number of art businesses and collectors have also built on FileMaker Pro to devise custom CMSs which are specifically tailored to their individual needs.

Certain collection management software systems are favored by some niches in the art industry, but may not be the best for others.

For example, The Museum System, known as TMS, was specifically established in 1981 as a CMS for the Metropolitan Museum of Art. This software, which is expensive, tends to be preferred by larger institutions with extensive exhibition activity such as the Guggenheim, and may not be the perfect fit for an individual collector. Similarly, Artsystems and ArtBase are more orientated towards sales and tend to be the choice of commercial galleries, although there are many private collectors who rely on these recognized systems.

Modified versions of these software options are also available and continue to be developed. ArtBase, for example, offers two versions of out-of-the-box software: its AB Collector Program which is limited to 2,000 artworks and one user, as well as AB Artist which is designed for artists and has a monthly payment plan. Specialized and custom CMSs are also available for managing collections of wine and other collectibles.

What exactly do these software-based CMSs offer? While it would be impossible to detail the range of options here, ArtBase, a system that many art professionals swear by,[48] describes its system as "having all the contents of your file-cabinets, Rolodex, library, and storage racks right on your desktop, accessible at the touch of a button."[49] ArtBase and most other CMS software are relational databases, meaning that when one enters a piece of information in one place (e.g., an address in a mailing list), one never has to enter it again (in, for example, an invoice or loan form). These systems are capable of doing a lot of the work for their users, from automatically generating accession numbers, to resizing images, to calculating financials for tax, estate, and insurance purposes, to converting measurements and currencies. With the corresponding Apps, collectors can view their collections in vibrant color on their iPhone or iPad from any location. (The art world, while sometimes resistant to change, did not waste any time adapting on this front; almost overnight, it seems, dealers were relying on iPads to manage their inventory at art fairs.[50])

The most notable drawback to all of these systems is the general limitations that apply to all software. Namely, the user is tied to the physical software itself. That means if a collector is travelling or has more than one residence, it can be difficult to update information housed in a computer located elsewhere. Often collection managers who build a database do this on their own computers or do at least some of this work off-site (in their own homes, for example). Keeping the collector's database current has thus sometimes required continuous and tedious copying and updating, at the risk of discrepancies.

With options for remote access and other web tools, this CMS software restriction is, however, becoming less of an issue. One art collection manager who worked for a major international collector in New York was able to continue managing a collection dispersed in five countries when

she moved to Arizona in 2005. Initially, she connected to the collector's ArtBase CMS from her remote location in the desert using a VPN (virtual private network).[51] The VPN allowed her to access the computers in New York and import large batches of photos into the database. Since that time, technology and Internet services have advanced such that VPNs are largely outdated; the collection manager and her colleagues in New York, Paris, and Geneva now share a server over the Internet.

All computer records should always be backed up on an external hard drive (which can also be vulnerable to the elements or theft) or a web solution such as the Mac Time Machine system developed by Apple that works in the background, providing incremental backups of files that can be restored at a later date if needed.

CMS Options: Web-Based Systems

This is where the Cloud comes in. Web-based computing, or "working in the Cloud," means the delivery of computing as a service over the Internet rather than via a product like software. Cloud computing has changed our information framework and has the potential to radically transform art collection management. Concurrently, the iPad has changed the way collectors interface with their artworks. So it is not surprising that collection management, for some, is rapidly moving to Web-based systems. Examples of such systems include Collector Systems which is used by a number of Sotheby's preferred clients, as well as Artlogic which is based in London and lists Christie's Private Sales and the Victoria Miro Gallery as clients.[52]

The primary issue with storing information on the Web has been that of security—the cornerstone of any collection. There are strong differences of opinion about whether the Web has been tested enough to provide an effective and appropriate platform to manage a collection. But with banking, most major corporations, and the United States government already relying on Web-based systems for confidential transactions, this debate is quieting, if not moot. As mentioned, software CMSs are also not entirely secure; not only are they dependent on Internet service providers for non-enterprise-level firewalls, but users must rely on anti-virus, backups, and even the locks on their doors for security. The fact remains that data is always at risk.

The obvious advantage to cloud-based collection management systems is that collectors and their collection managers can all access and update the collection information at virtually any location. Moreover, it is now possible for arts professionals such as shippers, appraisers, and conservators to "talk to" a select part of a CMS in real time. For example, an invited shipper might be able to obtain needed dimensions or upload

a bill of lading directly to the CMS with an email alert automatically sent to the collector. The possibilities are wide open and continually developing.

All of this can happen, of course, provided that there is an Internet connection. Without an Internet connection, collectors cannot access their Web-based CMS if they had not previously downloaded it to their hard drive or iPad—and this, software CMS proponents argue, is the disadvantage of Web-based systems. Connectivity can be a concern particularly at art fairs where many users are trying to access the Internet at the same time, making access painfully slow. But with hotspots and Wi-Fi becoming so ubiquitous and with the addition of cellular networks, it is easy to imagine that connectivity may not be an issue for long.

The location of the actual server on which the data is stored does also make a difference; the Cloud is not one entity as sometimes imagined, but consists of different servers. If a collector is based in New York, data on a server across the ocean in London will take slightly longer to access than data stored locally. The location of the server(s) of any given CMS provider may be worth an inquiry.

Another important matter for collectors to consider when choosing a CMS is the question of where the collection data actually lives. What happens to data stored in the Cloud or in a software database if the companies providing these services cease to exist or a vendor relationship is severed? In the case of software, the collector's data would still be stored on his or her computer. But Web-based systems, where data is not physically stored in the collector's possession, present another scenario. This issue should be explored with any provider, and it may be wise to consider other backup methods.

Regardless of the type of CMS a collector chooses, a hard copy of all their data should always be maintained.

Reports

Irrespective of which type of CMS one chooses, the great advantage of these systems (which distinguishes them from Excel) is the capability of producing complex reports in a variety of formats. For example, if a collector wants to see all his or her Bessarabian rugs in storage in order to determine which one might work best in the new living room, he or she can pull up a fully illustrated report immediately, complete with all details such as dimensions and value, obviating the need for a trip to the warehouse. Collectors can just as easily create appraisal and location reports for insurance purposes, or search works by one artist, works of a particular medium, or art in a particular room. In fact, learning about the complex capabilities of all these CMS options—designed to service a vast range of needs—actually provides a highly interesting educational window on various aspects of the art business itself.

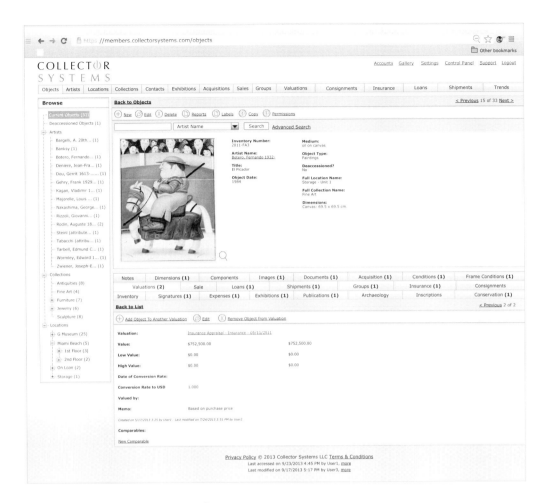

Individual object report from Collector Systems, a cloud-based collection management system (CMS).

Costs and Service

How much do these sophisticated collection management systems cost? Prices can range from a one-time cost of a couple hundred dollars for CMS software one can purchase online, to initial fees of several thousand dollars in addition to monthly individual user fees of hundreds of dollars. With the latter, a license is usually purchased for each user with sliding monthly fees applying for the more involved systems. Fees for Web-based systems like Collector Systems tend to be relatively modest monthly fees, but these, too, can up over time. (Collector Systems allows collection managers to access the CMS for free.)

For collections that are not particularly large or active, the more sophisticated systems may be overkill. In addition to the Excel and FileMaker Pro options, simple software options are readily available. While the tools and options offered are limited in comparison to the more elaborate CMSs, the functions they offer, including search and report abilities, may be

adequate for many collectors. Collectify and My Art Collection are currently among the many products available to instantly download inexpensively.

What these more modest out-of-the-box systems generally do not offer is unlimited service and software updates. With the rapid advances in technology and evolving complexities of the art business, most CMSs are updated every two or three years and those collectors with more basic systems will have to be proactive about updating their systems themselves.

Every collector and art entity has its own needs and approach to collection management, so research is always advisable. The best way to find the right CMS is to speak with trusted art-world associates and to spend time with the demos available on the companies' respective websites. Regardless of which kind of CMS might be best, exciting advances in technology and their impact on art collection management will surely be interesting for collectors to follow.

Apps aimed at collectors are also regularly introduced to the market. For example, Collectrium is a free App that automatically identifies registered artworks at participating art fairs when a photo is taken on an iPhone. Information about the work, the artist, and the gallery is assembled into a "collection" which can be shared via Facebook and Twitter or imported to a CMS. This is helpful when a collector is considering works for purchase or just wants a record of art with appeal.

CATALOGUING A COLLECTION

Once a CMS has been selected, the next step is to begin cataloguing the collection. What are the essential elements to be included in any art collection catalogue? The amount of information connected to an artwork—and the idea of pulling it all together for a CMS—can be daunting. Part of the obstacle for many collectors is feeling that they need to gather all the information related to each piece before they can begin the cataloguing process. This is not the case.

The first step is to simply identify all the works in a collection. When this information is kept in one easily accessible place, collectors can approach the cataloguing in phases, starting with the basics such as an image and location. The next phase might include importing the documentation, the next measuring, and so on. Things like provenance and exhibition histories may require research and can be done over time.

Cataloguing a collection demands that one pay attention to the details of each and every work. This process—examining, measuring, describing, researching—is an intimate one, and can be immensely satisfying for the collector. There is no better way of becoming the master of one's own collection.

Cataloguing Checklist

The essential components to be included in a collection catalogue are as follows:

- Type of Object
 What kind of object is it? This field refers to the artwork category such as painting, work on paper, sculpture, or installation. Most digital and Web-based CMSs have a drop-down menu here.

- Description
 A detailed visual description of the work, e.g., "Impressionist landscape with central setting sun on blue-violet background, abstract sail boat on left" or "Metal vase, decorated in black lacquer and applied with a diagonal chromed rib and matching flat circular rim." This field should also include detailed descriptions of frames and other materials, e.g., "modern 1.0″ wide x 1.0″ deep frame with a smooth, mat black finish."

- Artist
 The name of the artist, usually written last name first, e.g., Hoffmann, Josef. The CMS will often have two separate fields, as well as an "alternative name" field. Where there is no known artist, as in the case of most antiquities, the period or region is substituted, e.g., "Ancient Egyptian". Other times, it is appropriate to write "Unknown."

- Title
 The original title of the artwork, where applicable. While this seems relatively straightforward, sometimes it can be tricky. One single work of art may be referred to by different titles over the years, especially in the case of translations. Best practice thus dictates that if the original title was in French, the title should always remain in French. Translations are thus better added in parentheses or kept in "notes" sections of records.

 Sometimes, an artist changes the title of a work, inadvertently or not. An artwork might be exhibited under one title and years later consigned under another one. This can obviously create confusion over time. (Not all artists are particular about the titles of their works. When a French collector contacted Sigmar Polke in 2007 to obtain the title of one of the artist's paintings he had purchased in the 1960s, the artist responded, "Whatever you think." The collector and his dealer then made up a new title.)

 In the case of antiquities, titles are usually assigned by dealers, e.g., *Egyptian Bronze Seated Cat*.

- Signature

 Is there a signature or inscription? If so, how is it made and where is it? Is it printed or in script? Full name or just initials? Is it located on the front ("recto") of a picture or back ("verso")? Is it in ink or pencil or pigment—or is it engraved or stamped? Be specific. Examples: "signature, recto, lower right in pencil: 'M. Beckmann'"; "artist's stamp verso center."

- Dimensions/Weight

 Should always be included in both inches and centimeters. Some CMSs do an automatic conversion. Systems that have multiple dimension field are always a plus as it is important to record both framed and unframed dimensions. In the case of photography, there may be a difference between the print size and the image size; both should be recorded. In certain cases, it may also be desirable to include a crate size, an installation room size, etc.

- Medium

 What is the work made of? This field should be as descriptive as possible. Examples include: "photo-lithograph on thin off-white wove paper," "brush and ink on wove paper," "archival dyes on cloth with embroidery." Such information should be provided on a gallery invoice or in an auction catalogue. For example, a work made of recycled urban posters covered in inked stamps was described on the invoice as "ink on paper, collage."

 With respect to photography, as processes and papers used vary greatly, a precise description is critical: e.g., "chromogenic color print mounted with Diasec face," "gelatin silver print," or "Museo Silver Rag" (an archival gloss inkjet paper).

- Date

 When was the work created? Keeping dates in a consistent format is important. For example, a decision must be made whether to write "c." or "circa" or "c. 1950" or "1950s." If the date format is not consistent, then searching for dates becomes more difficult. (It looks cleaner on reports as well.)

- Edition

 In the case of multiples, prints, and photography, this is one of the most important pieces of information. A complete edition number includes both the specific edition number of the print as well as the size of the edition, e.g., "3/20"—and not simply "3." Artist's proofs ("AP") and other trial proofs should be noted, as well as plate numbers within a particular series, e.g., "Plate 75 from the cycle *Ecce Homo*".

- Catalogue Raisonné
 References from catalogues raisonnés should always be noted. This should include author, volume, and item reference number, e.g., "Dückers S. I,75."

- Purchase Price
 The purchase price—as well as date of purchase—should always be included in a CMS. The purchase price represents the price paid or the owner's tax basis in a work, but collectors will also want to make a note of any discount that may have been received as well as sales tax. Premiums added at auction sales are considered part of the purchase price.

 Note: purchase price is not the same as value.

- Vendor
 The exact place of purchase, whether it is an auction house, gallery, artist's studio, or private individual. The full address of the vendor should also be included.

- Provenance
 The ownership history of the item should also be included. As discussed in Chapter 1 (see p. 38), provenance is critical information about any work of art in the secondary market and affects its value. All known previous owners should be listed, starting with the earliest owner, e.g.:

 > Acquired from the artist;
 > Leo Castelli Gallery, New York;
 > De Pasquale Collection, New York;
 > Galerie Beyeler, Basel;
 > Acquired by the present owner in 1995.

- Value
 Includes all appraisals with corresponding dates as well as the type indicated (e.g., fair market value, insurance, estate—see Chapter 3, "What Kind of Value?", p. 68). It is a good idea like to include comparables in the notes in this section, whether that be current information obtained from a price database or pricing notes obtained directly on the market such as similar works seen at fairs or in a gallery. This information can be a valuable reference.

- Condition
 The general condition of the work should always be noted along iwth the date value was determined. Collectors should take the time to carefully observe each work of art themselves.

 Common basic terms to describe condition include "pristine," "excellent," "good," "fair," or "poor." Any holes, tears, smudges,

paint loss, foxing, chips, fading, etc. should be noted, along with the exact locations on the work. Such issues should be photographed and included in the conservation section of a database.

- Location
 This field refers to the actual physical location of the artwork, e.g., "Library, west wall, upper right." Location is not to be confused with "Status" which refers to whether a work is displayed, in storage, on loan, on consignment, at the conservator's, etc.

- Accession (Inventory) Number
 It is essential that each work in a collection be assigned an accession number. Collectors can devise their own systems, but it is recommended to start with the year of acquisition, such as 2012.001. If there are works belonging to different owners such as a father and son catalogued within one system, the accession numbers might distinguish the owners by starting with their respective initials: CRF.2010.014 and NRF.2010.003.

 The inventory number assigned should, where possible, also be marked somewhere on the corresponding artwork; the best place and means to do that will vary with the object. For paintings, the ideal option may be a pencil notation on the back of the frame or stretcher (never the canvas). For a marble sculpture, it may be an adhesive label on the underside of the base. (Some galleries and art-storage facilities are now using bar coding and microchips to inventory pieces, and certain CMS programs provide bar code technology for inventory purposes for an extra fee or no charge. However, this kind of a system is expensive and burdensome for individual collectors and can be invasive to the artwork.)

 The inventory number should also be included on all corresponding photographs and documentation. This includes exhibition catalogues and literature. Often catalogues are kept separately from collection records, usually on bookshelves in a library or living room. Over the years, collectors may amass hundreds of such publications. The corresponding inventory number of the object in question, along with relevant page numbers, should be included somewhere visible in the volume itself (e.g., the inside cover). Whatever system is chosen, it should be used consistently.

- Conservation History
 All documentation and notes pertaining to the object's conservation history should be included in the database. This includes scanned and digital condition reports, conservation invoices, and related images including detailed "before" and "after" treatment documentation.

In the case of light-sensitive works such as drawings and photographs, collectors should also keep a record of exposure history, noting the time frames that a work has been on display.

- Exhibition History
 The database should note the exhibition history of the object, as well as any corresponding catalogues and notations of their exact locations. The full title of the exhibition as well as dates and all venues should be included, e.g.:

 New York, Solomon R. Guggenheim Museum, *Six Painters and the Object*, March–June 1963.
 Fort Worth Art Museum; Washington, D.C., Hirshhorn Museum and Sculpture Garden; and New York, Metropolitan Museum of Art, *New York Painting and Sculpture: 1940–1970*, October 1969–February 1970, p. 216, no. 228 (illustrated).
 New York, Whitney Museum of American Art, Downtown Branch, *The Comic Art Show: Cartoons in Painting and Popular Culture*, July August 1983, p.69 (illustrated).
 New York, Gagosian Gallery, *Pop Art from the Tremaine Collection*, October–November 1985, p. 60 (illustrated in color).

- Artist Biography
 An artist's biography should always begin with the lifespan of the artist indicated in parentheses, e.g., "Sigmar Polke (13 February 1941—10 June 2010)." If taken from the Internet, the source should be cited. Conveniently, given the relational nature of most of the CMS databases, once a biography is included for one work, it will appear in the database for all other works by the artist in the collection.

- Bibliography/Literature
 All reviews and citations of the work. A gallery can usually provide this information, and contemporary artists usually keep current lists themselves if they do not have a gallery to do it for them. For example: "Matthias Winzen (ed.), *Thomas Ruff: Photography 1979 to the Present*, Cologne, 2001, no. 14, p. 192, illustrated in color."

- Images
 Color photographs of all works are a critical component of all art collection management systems. Most CMSs have the capacity to house multiple, if not indefinite, numbers of photographs for each work. Collectors should include images of signatures and inscriptions, damage, condition, or identifying marks, as well as installation shots, which can be helpful for insurance purposes. As the back (verso) of a work often includes vital information about the

piece such as exhibition labels, lot numbers, structural references and any additional inscriptions, these should be photographed as well. The frame should also be photographed; sometimes a frame can be more significant than the artwork itself.

At the time of acquisition, collectors should always ask the seller for whatever photographs they might have. (An image from a gallery website will generally be too small and will not suffice.) Most galleries will have high-resolution images of the works they offer which can be easily emailed to the collector for immediate upload to the CMS. Also, if a work is loaned for an exhibition, it is wise to ask the museum or gallery for any professional images of the artwork taken for catalogues, publicity, etc.

How good does a picture have to be? While any picture is better than no picture, print-quality 300 dpi images are generally recommended for the CMS; simple identification purposes do not demand high-resolution photographs. Lighting issues and flash reflections on glazing can cause glare and distortion. Sometimes, taking an adequate photograph will require small tricks such as lighting adjustments, using white paper as a backdrop to create a light source, or moving an artwork under natural light in order to take the shot.

Serious collectors may find that it is worthwhile to have all their artworks, or at least their most prized ones, professionally photographed. They may also be asked to do so by catalogue raisonné authors who usually don't have the funds to pay for the professional photographs needed for the project. Since inclusion in a catalogue raisonné enhances the value of the artwork, most collectors are inclined to oblige.

To protect the artworks, professional photography should be done on-site, but there is of course a premium for this kind of service and collectors have to weigh the cost versus the risk. Most photographers can bring the appropriate equipment and charge an hourly or daily rate. One major New York collector has a photographer return once a year to photograph new works. This is a high-end operation with a rate of close to $1,000 day, but significantly cheaper options are, of course, available. Some artist/photographers moonlight as commercial photographers, and often art galleries who regularly use these photographers themselves are willing to share their contact information and make recommendations.

The Importance of Consistency

Any CMS is only as good as the information entered into it. In order to maximize effectiveness, the consistency and accuracy of data input is

critical. If a collector enters a location of an artwork as "Foyer," but his administrator refers to that same location as "Hall," searches about artworks in that one location will not be productive. Likewise, if an artist's name is spelled wrong once, it will likely not be included in the search results for that artist's work. Even though both digital and Web-based CMSs are more user-friendly than ever, able to catch and correct discrepancies, it is essential that all CMS users share uniform terminology and methods. In more involved circumstances, the development of a custom handbook or guidelines may be recommended for users sharing one system.

What is "Art" for Cataloguing Purposes?

Once collectors have established a collection management system, an issue that commonly arises is what, exactly, to include in it. What qualifies as an artwork that is worthy of cataloguing? Collectors who own great works of art may also happen to own more amateur works such as those by friends or relatives or lesser artists. Some artists have been known to produce Christmas cards with original prints, and a collector may be unsure whether something like this is worth including in the database.

Which items to include in a database can be particularly challenging in the case of decorative arts. Sometimes, it is indeed hard to draw the line between possessions, collectibles, and works of art. While most collectors would feel that the original Wiener Werkstätte chandelier by Kolomon Moser purchased from a Viennese dealer belongs in their database, they may be less certain about including the family silver or the beautiful glass vase from the Venini workshops of Murano, Venice, received as a wedding present. A collector attending a Museum of Modern Art, New York fundraising dinner in the 1970s received a 6 ½-inch (16.5-centimeter) white painted wood sculpture as a party favor. This trinket was actually by the sculptor Louise Nevelson (1899–1988), from an edition of 950, but was not considered part of the collection until these pieces started appearing on the market decades later.

Collection management systems can also be useful in cataloguing the contents of the home, particularly those valuable or meaningful furnishings and objects which may not be technically considered fine art but nonetheless have aesthetic, financial, and sentimental value. All too often, family items such as porcelain, silver and furnishings which have been collected and accrued through the years are passed down to the next generations without precious information about provenance and history. Of course, comprehensive records are also invaluable for insurance and estate purposes. Collectors may thus want to consider having more than one catalogue in their CMS, one for fine art, another for furnishings, and so on. The decision about what to include in the catalogue is ultimately up

to the collector, and this often depends on the time and resources one can spend on documentation.

OUTSOURCING INVENTORY MANAGEMENT

Like home maintenance and tax record-keeping, there is no denying that collection inventory management is a considerable undertaking. Recognizing this increasing need among collectors, a growing cadre of art professionals—including appraisers, art advisors, private-wealth managers, and insurers—has emerged who append a gamut of art collection management services to the core services they provide.

When sharing the details of one's collection, trust is obviously of the upmost importance. Not only are collections financial assets, but given the competitive nature of the art world where information about artworks is a prized commodity in itself, absolute discretion is paramount. The art world is more fluid than ever. Museum curators end up at Citibank, Citibank advisors become art dealers and then museum directors, and an art collection manager could one day end up on the commercial side where consignments for galleries and auction houses are the currency of the business. Dealers and auction department heads are masters at obtaining information about private collections, using wine-soaked gallery dinners and offering appealing free services such as appraisals and expert opinions to ply information (and hopefully someday consignments) from those holding the keys to a collection. For this reason, serious collectors should consider asking those entrusted with their collections to sign non-disclosure agreements.

In the fortunate situations where collectors do have help managing their collections, communication is also essential. Just as it is challenging to stay on top of one's own database, collectors often forget to impart relevant information to their professional staff. Art owners are known to move their works around, often on a whim. A collector may relocate a series of prints from a storage closet in the suburbs to an office suite in Manhattan, or may decide to take advantage of tax laws and gift certain works of art to his or her children, even though they will remain in the family home (see Chapter 9, "Estate Planning"). If these changes in location or ownership status are not conveyed to the person charged with managing the collection, complications can surface down the road. It is not unheard of to lose track of locations—or the very existence—of artworks in one's collection.

VALUATION

From a collection-management standpoint, one of the most vital and challenging aspects of maintaining a collection is assessing its value. Whether it be for insurance, taxes, estate planning, or financing and investing purposes, the question "what is it worth?" surfaces time and time again. And, depending on the circumstances, different kinds of value will be ascribed. To further complicate matters, valuation is highly subjective and the value of a work of art can change at any given time according to a number of factors, from shifting markets to fickle tastes. Furthermore, the art market itself is a composite of some 300 individual markets which represent all the given sectors,[53] and these sectors are not in sync. While assigning value to a work of art is no longer the domain of a select few, and new appraisal tools as well as clear procedures and guidelines have evolved, valuation is not—and never will be—an exact science.

Most collectors are eager to know the value of the works they own, but can be reluctant to invest the time and money needed for appraisals. Sometimes it takes an event—a loan, a tax gift, or a death—to prompt a collector to have a work appraised. For larger collections or those that have been inherited, it can also be difficult to know where to begin. This chapter will examine the different types of value and discuss how value is determined as well as how often it should be reassessed. It will advise on which kinds of experts to call on and why, highlighting potential conflicts of interest.

VALUATION V. APPRAISAL

While the terms "valuation" and "appraisal" are often used interchangeably, there are important distinctions between the two terms.

Many in the art trade assign value to works of art. First and foremost are dealers who have the difficult task of pricing works of art. Auction-house specialists, too, assign values, but usually within a range of high and low estimates which, due to a number of competing business

factors including clients' wishes, are not always strictly correlated to real underlying value. Curators, too, are often asked to gauge value, whether for museum boards who want to acquire, or for dealers who call on them to offer opinions about works they may have on consignment. Collectors themselves assess value, at least in their minds, when they purchase or sell their works.

Appraisals, on the other hand, are professional opinions of value rendered by certified individuals with specialized education and experience in exchange for payment. In the United States, a "qualified appraiser" is an independent party who is a recognized expert in a particular field and conforms to the Uniform Standards of Professional Appraisal Practice (USPAP) which are administered by the Appraisal Foundation. In the absence of regulation of valuations, USPAP was developed to offer guidelines.

For donation, gift, and estate tax purposes (see Chapter 9), the US Internal Revenue Service (IRS) requires that appraisals be conducted in a manner consistent with USPAP's substance and principles.[54] This is also the usual standard for bank loans which use art as collateral. While qualified appraisers are held to USPAP standards and can be subject to penalty by the IRS for incorrectly prepared appraisals,[55] it is important to note also that, unlike certain experts, appraisers are not authenticators; an appraisal of a work of art by a qualified appraiser is merely a statement of value based on the *information at hand*.

Choosing an Appraiser

As in other aspects of art collection management, when seeking appraisals, collectors should request recommendations from trusted sources: fellow collectors, museum curators or other reliable colleagues. The appraiser's credentials should always be evaluated. What is the appraiser's education and experience, and does this meet the exact area of expertise needed for the appraisal? Does the appraiser have at least a BA in Art History as well as training and experience in a particular market sector? A good appraiser will be specialized within a particular niche. While an appraiser with proficiency in Impressionism may also be qualified to value a Hudson River School painting, that same appraiser would most likely not be qualified to provide the value of tribal African art; the areas of specialty are just too far apart. Appraisers who make such claims should be questioned. In the US, the Appraisers Association of America (AAA) is a reliable resource for finding qualified appraisers in specialized areas and geographic regions.

When choosing an appraiser, the terms also need to be discussed. What is the nature of the appraisal needs and what is the fee structure? Will the work be done at an hourly rate or on a project basis? How much

time will be needed? In no circumstances should a fee be based on a percentage of the valuation of the objects appraised. Any appraiser who proposes such a scheme should be disqualified.

Once an appraiser is selected, it is the collector's responsibility to provide all information related to the work to be appraised and to offer a work environment that allows the appraiser to do an optimal job with minimal movement of the artwork. Lighting should be adequate, and an art handler may need to be on hand.

Alternative Sources for Valuation

Professional appraisals can be expensive. Rates are either hourly or can be priced per report, and this will vary depending on the geographic region. If an entire collection needs to be appraised, this can be costly indeed. And, while insurers may require appraisals for works over a certain monetary value, insurance companies are generally indifferent as to the appraisal source and merits; this only becomes an issue in case of disputes. Furthermore, some collectors, eager to know the present value of their collections, are not comfortable with the thought of having "outsiders" entering their homes and being privy to what they own. (Some have even been known to move or shroud artworks that are not being appraised when an appraiser or other professional makes an on-site visit.) For all of these reasons, collectors will often rely on other trusted sources to obtain valuations when a qualified appraisal is not required—but there are certain issues to be considered.

Auction houses regularly provide appraisals and, for esteemed clients, they do this free of charge. These appraisals usually consist of a simple list of the artworks together with the value assigned. (For areas in which they do not have their own in-house experts, auction houses can also be helpful in providing contact information of outside specialists.) The collector needs to keep in mind, though, that auction houses sometimes appraise several hundred objects in a matter of days. Given the many nuances that make up an individual artwork's value, these assessments may not always be sufficient. As hourly professional appraisal rates make clear, some works clearly require much more research than others.

Similarly, dealers will provide the same kind of valuation service to their important clients. Collectors often return to the dealers from whom they originally purchased artworks to ask their opinions on current value, as these are the professionals they have come to trust over the years. Because dealers and auction-house specialists have expertise about the art they sell and are themselves determining market prices, they may, in fact, be best positioned to provide valuations. After all, who knows the market better than those who are running it?

While both of these options spare the collector significant fees and undesired exposure, such valuations can raise other concerns. Clearly, auction houses render these services with the hope of being able to one day obtain property on consignment, if not the very works being appraised. In providing such complimentary services to esteemed clients, auction houses have been known to be overzealous on occasion. In one case, a major German collector called on an auction house's Client Services department to provide insurance appraisals for a group of works in his collection, a routine practice. Due to an internal communication breakdown, the auction house proceeded to create an elaborate mock-up of an upcoming auction sale catalogue—with one of the collector's appraised works lavishly showcased on the cover. The collector, who had no intention to sell the works, was shocked and offended by this presumption. It is thus important for collectors who take advantage of such services to make sure their objectives are understood.

Dealers also regularly help clients establish values for works in their collection. However, if the dealer making the appraisal had originally sold the work(s) to the collector—which is often the case—it will be in the dealer's interest to make the client feel that the work has since appreciated in value—even if it has not. Moreover, dealers are also always interested in getting works on consignment. If there is a sense a consignment might be forthcoming, a dealer might be disposed to provide an appraisal value that is actually *lower* than the current market rate in order to maximize potential profit on an agreed upon net price (See "Selling Through a Dealer, p.184).

In short, both auction houses and dealers are interested parties, and the appraised values they provide may not always be objective or accepted by tax authorities or lenders.

WHAT KIND OF VALUE?

When discussing value, it is important to recognize which kind of value at issue. There are numerous types of value, but the three that are most important to the collector are:

- Fair Market Value (FMV)
 The definition of fair market value is what a willing buyer would pay a willing seller with both parties having full knowledge of all the relevant facts, such as in an auction context. FMV is the kind of value generally used for estate and tax appraisals.

- Retail Replacement Value (RRV)
 Sometimes referred to simply as "replacement" or "retail" value, RRV

is usually higher than FMV and is used for insurance valuations as it represents the amount of money it would cost to actually replace an item in a retail setting at any given time. RRV is comparable to gallery prices.

- Marketable Cash Value (MCV)
 This is FMV minus the expenses incurred in selling the items, such as auction-house premiums or dealer commissions plus other transaction costs. MCV is typically used when assets need to be divided, as in the case of dissolution of partnerships and divorce.

VALUATION FACTORS

Like all other markets, the art market is based on supply and demand. Yet determining the value of a work of art is a complex proposition. Appraisers have many factors to weigh, some of which are very difficult to quantify. They rely on the facts, but the final valuation itself is a matter of informed judgment or opinion. And while there are certain guidelines, as outlined below, there are exceptions to every rule. When it comes to valuation, there is thus no "formula." Every work of art is unique and must be looked at for its distinctive characteristics.

The following factors come into play when determining the value of a work of art.

Authenticity

Is the work genuine?—i.e., is the work what it is purported to be, made by a particular artist at a particular time? Authenticity investigations involve art-historical research, connoisseurship, and, in some cases, scientific materials testing. Signatures and other annotations on a work provide clues. When scholars cannot agree on a work's attribution, as was the case with the small-format "Matter" paintings ascribed by some to Jackson Pollock (1912–56), technical testing may be sought. In the Matter case, materials analysis demonstrated that some of the pigments used in the paintings were not in existence until after Pollock's death.[56]

Obviously, if a work of art is a fake, it has a very different value than if it is authentic. But, as discussed in Chapter 1, authenticity is not always so easy to determine, and opinions on whether or not one particular work is authentic can change over time, particularly in the realm of Old Masters. Some contemporary works, such as those produced by Dan Flavin (1933–96) or Sol LeWitt (1928–2007), only have value when the works are accompanied by a certificate of authenticity, the

value of the art object residing less in the object than in the tangible proof of its genuineness.

Quality

Quality is also a factor in determining value. But what constitutes "quality"? Formal traits such as composition, palette, and technical execution are surely part of a work's quality. But quality can also reside in a work's less definable traits, in a *je ne sais quoi* that speaks to the connoisseur or the viewer. Judgments of quality are subjective and may also change over time.

For many artists, certain working periods—those that tend to be emblematic of the apex of their work or a conceptual or intellectual breakthrough—are more highly valued than others. Works created during Picasso's Blue, Rose, or Cubist periods, for example, would generally have a higher value than his late works. The fact that values for Picasso's late works, particularly those of musketeers, have sharply escalated recently,[57] however, demonstrates that tastes do change—and values change correspondingly. Again, for every generalization, there are exceptions.

Certain motifs or subjects—such as Picasso's legendary lovers Dora Maar, Françoise Gilot, or Marie-Thérèse Walter—are considered more desirable and would also contribute to an assessment of the work's quality. *Nude, Green Leaves and Bust,* a 1932 painting featuring Marie-Thérèse Walter, fetched $106.5 million at Christie's in May 2010 despite its late date, making it the most expensive work of art ever sold at auction at the time. (The work also had a strong provenance, having been in the collection of the Los Angeles collectors Sidney and Frances Brody for nearly six decades.) In the case of photographs, vintage prints—that is, works printed by the artist him- or herself or within 20 years of the original image—are generally more valuable than later prints. For those, it is important to establish whether they have been authorized.

Rarity

Closely connected to quality in terms of value is rarity. How many such works are in existence? And, secondly, how many of those might become available on the market? The Metropolitan Museum of Art is said to have paid $45 million—its most expensive purchase ever—for a small panel painting by the Italian Renaissance master Duccio di Buoninsegna, the last Duccio known to be owned by a private collector (see color plate section). Only about a dozen works by the Sienese painter are known to survive, and the Met's *Madonna and Child* (*c*.1300)—also known as the Stoclet or Stroganoff Madonna—is one of just a few that is a complete work unto itself (rather than an altarpiece fragment). Its original 14th-century

frame, with candle-flame burns attesting to its early devotional purpose, makes it all the more rare—a painting worth an unprecedented price.[58]

Even though there are four different versions of Edvard Munch's *The Scream*, given the highly iconic stature of the image and the fact that three of these works were already owned by museums and hence not likely to become available, the fourth version, a pastel executed in 1895, was also considered "rare" when it came to market at Sotheby's in 2012, driving the price to $120 million (and besting the record for the Picasso, above).

Prints and Multiples

In the case of multiples, the general rule is that the larger the edition, the less valuable each individual work. All other things being equal, a single print from an edition of 300 would be worth less than one from an edition of 30.

In one novel case which underscores value with respect to editions, a collector sued an artist for reopening a closed edition and creating more art, arguing that the value of his extant collection of that artist's work was thus diminished. Jonathan Sobel's group of 190 limited-edition William Eggleston photographs from the 1970s and 1980s were valued at $3–5 million when the artist decided to produce a new series of 36 larger digital prints from the old negatives. With prices for the new prints breaking records at a dedicated Christie's sale, the collector argued that had he known the artist was going to make subsequent works, he would not have purchased the ones he had. In other words, the market value lies in the scarcity; if more works of the same picture are produced, his individual artworks become less valuable. The artist countered that as copyright owner of the work, it was his right to produce additional prints using digital technology, and that these photographs are in any case something entirely different.[59]

Confusion seems to exist as to whether a print's number in the edition affects value, e.g., 1/30 v. 25/30. Prints and multiples are not necessarily signed in the order that they were produced, so the print numbered "1" may not in all cases be the first print. The quality of the print will be the deciding factor of value. In the case of Old Master and modern print techniques where plates, stones, and woodblocks were used, the clarity and crispness of the impression would drive quality. When it comes to more advanced technologies such as digital prints where every example in a limited edition is virtually identical, prices usually go up as the edition sells out, rendering the remaining works under the control of a unique seller, such as the artist's primary-market dealer, more "rare."

There is a question as to whether artist's proofs—known as "AP" editions (or EP, *épreuve d'artiste*)—have less or greater value than the numbered prints. Traditionally, an artist's proof was a test proof made by the artist in the

course of the printing process, but it has also come to denote a body of prints, sometimes a surprisingly high number, of which the artist retains ownership outside the edition itself. Thus in some cases an artist's proof may be of lesser quality, as it may not be a fully developed composition. Or, it may have special cachet if it was retained by the artist or gifted to a close friend. Therefore, with respect to value, the answer again varies according to the circumstances, and highlights the need to seek opinions from specialists.

When it comes to a suite of prints, there will be a premium added to the value if the entire group is owned. Take, for example, Andy Warhol's *Marilyn Monroe* suite, a set of 10 silk-screen prints first produced in 1967, each in a different palette. The original edition was comprised of 250 suites with an additional 26 APs. At a time when an individual print from this series could be had for around $15,000, the entire suite was on the market for $250,000, demonstrating a significant markup for the ensemble.

Finally, a print created as an artistic endeavor in its own right might have more relative intrinsic value than a print produced for reproduction purposes. The German Symbolist artist Max Klinger (1857–1920) was the foremost modern champion of printmaking. Like the compatriot Expressionists who followed him, Klinger asserted that the very physicality of the printmaking process rendered it the most immediate and authentic means of artistic expression. His 1881 celebrated etching cycle *Ein Handschuh* ("A Glove")—which starts with a beautiful young woman losing her glove at an ice-skating rink—is prized by art historians and collectors for its quintessential intriguing dream-like narrative expressed in the artist's preferred artistic medium.

Condition

The condition of a work of art is one of its most critical value drivers. Is the paint chipped? Are there any tears or fading? In the case of older paintings, has it been relined or in-painted? When a work suffers damage, and when that damaged work is repaired, there will almost always be a loss in value of the work. (If the artwork is insured, this loss will be covered.) Assessing loss-in-value can be elusive, however, and not all appraisers are equipped to make this kind of judgment.

One gallery offered a classic Gerhard Richter (1932–) oil portrait included in the artist's catalogue raisonné to a number of clients and presented it at major art fairs during the peak market years before the 2008 crash, but it never sold—despite the heated market and the increasing demand for Richters. Upon close examination, one could note a bull's-eye pattern in the paint surface where the canvas had once been poked which apparently could not be fully restored. How valuable is a fabulous yet flawed painting that no one will buy?

And yet, when it comes to value, not all damage is equal. Blemishes and repairs are to be expected when it comes to works of a certain medium or period such as Old Master paintings. But minor injury to another type of work can have major consequences. Damage to a pristine Minimalist work, for example, will most likely drive the value down considerably. One appraiser reported that a slight blemish in a Blinky Palermo *Stoffbild*—the title used for a series of monochromatic stitched cloth pictures from the 1960s—resulted in enormous loss in value. Similarly, when Lucio Fontana's graphite-on-aluminum work *Concetto Spaziale* (1965)—valued at $2.8 million in 2008—suffered a change of color and sheen in its lower left side due to improper installation, its value plunged by $2 million.[60]

Making the condition issue even more challenging is the fact that, in certain rare cases, the infliction of damage appears to actually *add* an increment of value to the affected piece. The rather serious injury incurred when the casino magnate and collector Steve Wynn accidently put his elbow through his 1932 Picasso painting *Le Rêve* in 2006 did not seem to impact the value of the work in the end. At the time of the accident, Wynn had just agreed to sell the painting to mega-collector Steven A. Cohen for $139 million.[61] But after rescinding the sale and having the painting restored, Wynn sold the painting to Cohen for $155 million in 2013—reportedly the highest price paid for an artwork by a US collector. Can this $16-million gain in value be attributed solely to a soaring art market (a market that incidentally crashed during this seven-year time span) and the fact that an expertly repaired 6-inch (15-centimeter) tear is "negligible" when it comes to a Picasso masterpiece? Or did the very notoriety of this widely covered mishap actually enhance its value?

In another case, a 1972 Warhol print of Mao Zedong was shot with two bullets by its owner, the actor Dennis Hopper (see color plate section). After Hopper passed away in 2010, the maimed artwork achieved more than 10 times its high estimate when offered for sale at auction. This leap in value can be ascribed to Warhol's own personal annotations around the bullet holes, but perhaps also to the fact that the rather uncommon damage happened to resonate the particular mystique of this celebrity. Hopper, who had gained fame in the 1969 counterculture film *Easy Rider*, was known for his hard living. (A friend described the shooting incident as follows: "One night in the shadows, Dennis, out of the corner of his eyes, saw the Mao and he was so spooked by it that he got up and shot at it, twice, putting two bullet holes in it.")[62]

Provenance

As discussed in Chapter 1, the provenance of a work of art is the history of physical possession of the piece from the date the artist created

the work to the present day. In terms of value—and as attested by the frothy sales results fetched by items formerly belonging to celebrity tastemakers Jacqueline Kennedy Onassis, Elizabeth Taylor and Yves Saint Laurent—there is almost always a premium for an esteemed provenance. (Accordingly, questionable provenance will lower the value of the work.)

Did the work come directly from the artist's studio? Was it sold through a notable historical dealer such as Daniel-Henry Kahnweiler, Paul Cassirer, Ambroise Vollard, Paul Durand-Ruel, or Leo Castelli? Was the artwork previously owned by a renowned collector or connoisseur? Aside from rarity, the Munch *Scream* pastel mentioned above had a compelling provenance: not only did the work once pass through the hands of the venerable Amsterdam dealer Jacques Goudstikker, but the seller's father, from whom he inherited the work, was a friend and patron of Munch himself.

An artwork originating from an esteemed connoisseur or legendary dealer or collector would arguably have a more enduring provenance than a work owned by a celebrity, unless that celebrity was a respected collector or aficionado in his or her own right. That is, a painting purchased directly from Leo Castelli in the 1960s will probably always claim an enhanced provenance (and hence value), but a painting once owned by the actor Hugh Grant—who sold his Andy Warhol *Liz* painting for a record sum in 2007 (and admitted being drunk when he made the purchase[63])—may not. Only time will tell.

Publications and Exhibition History

As with provenance, other aspects of a work of art's "life" contribute to its value, namely the work's inclusion in exhibitions and recognized literature, especially catalogues raisonnés. Both attest to the artwork's importance and acceptance in the scholarly community. For example, the exhibtion history of the Munch, spanning from 1923, surely enhanced the work's value:

> Exhibited
> Berlin, Akademie der Künste, *Frühjahrsausstellung*, 1923
> Mannheim, Kunsthalle Mannheim, *Edvard Munch: Gemälde und Graphik*, 1926–27, no. 80a
> Berlin, Nationalgalerie, *Edvard Munch*, 1927, no. 54
> Chemnitz, Kunsthütte zu Chemnitz, *Ausstellung Edvard Munch*, 1929, no. 10
> Leipzig, Leipziger Kunstverein, *Edvard Munch, 1929–30*, no. 7
> Hamburg, Hamburger Kunstverein, 1930
> Berlin, Nationalgalerie, Galerie Lebenden, on loan with the permanent collection until June 12, 1933

Amsterdam, Kunsthandel J. Goudstikker N.V., *Tentoonstelling van Moderne Kunst*, 1933, no. 42, illustrated in the catalog

Oslo, Kunstnerforbundet, *Munch-bilder i privat eie*, 1958, no. 48 (dated *circa* 1893)

Kiel, Kunsthalle zu Kiel, Edvard Munch, *Gemälde und Zeichnungen aus einer norwegischen Privatsammlung*, 1979, no. 6, illustrated in color on the cover of the catalog

Washington, D.C., The National Gallery of Art, on temporary loan 1990–91

Literature

Reinhold Heller, *Munch, The Scream*, London, 1973, illustrated p. 118

Ragna Stang, *Edvard Munch, The Man and the Artist*, London, 1979, mentioned p. 90, footnote 107

Jan Kneher, *Edvard Munch in seinen Ausstellungen zwischen 1892 und 1912*, Worms, 1994, no. 106, listed p. 358

Edvard Munch in Chemnitz (exhibition catalog), Chemnitz, Kunstsammlungen, 1999–2000, illustrated p. 230

Gerd Woll, *Edvard Munch, Complete Paintings, Catalogue Raisonné, 1880–1897*, vol.I, Munich, 2008, no. 372, illustrated p. 359

Geographical Context

In the case of more regional work, such as art of the American Southwest whose primary collector base is rooted in the area of Santa Fe, New Mexico, the value of a work of art may be greater in a corresponding geographical context than it would be in another region. Conversely, enhanced values may exist in foreign markets due to limited supply and the "exotic" quotient. Mid-20th-century Scandinavian design, to take an example, is often less expensive in Stockholm than it is in New York where prime pieces are less ubiquitous and demand is great among collectors. It remains to be seen how globalization and continued development of online sales will affect such geographical distinctions.

Size

The size of a work can also affect its value. Other factors being equal, a larger work by an artist will usually have higher value than a smaller work. This is most evidently seen at solo shows of primary-market work. One contemporary gallery offered a 12-by-17-inch (30.5-by-43-centimeter) pigment print edition for $3,300. The identical image in the 45-by-56-inch (114-by-142-centimeter) size print had a price tag of $12,000, the edition numbers of each format being the same.

But here again, there are exceptions. While the last couple decades, marked by changing technologies and methods as well as shifting tastes and collector types, have seen a "bigger is better" trend, there seems to be a point of diminishing returns with respect to size. Practically speaking, how many art buyers have the space to hang a 6-by-6-foot (1.8-by-1.8-meter) picture, much less get it through a door or up a stairwell? The transportation and handling of such large-scale works present additional costs, logistical conundrums, and risk, the sum of which can give buyers pause. It was murmured that Gerhard Richter's imposing oil painting *Domplatz, Mailand* (1968), which sold for over $37 million at Sotheby's in 2013—a record price for a living artist—did not actually succeed in attracting the number of bidders the auction house had anticipated given the hot art market and the undisputed quality of the work. Experts attributed this to the issues posed by the painting's 9-by-9-foot (2.7-by-2.7-meter) dimensions.

Sometimes the size of a work is central to its meaning. The large-scale C-prints pioneered by the Düsseldorf School of photographers in the late 1980s pushed the boundaries of photographic technology with their huge print format which also served to elevate mundane, commercial, and intimate subjects to monumental stature. For those works, scale is meaningful, arguably more so when its purpose is more frivolous, e.g. when large-scale versions of works are produced expressly to satisfy art buyers' desire for works with "wall power."

Other Factors

Another important piece to the valuation puzzle is the impact of prevailing taste at any given moment or period. As seen in the contemporary market, the desire for certain "hot" young artists can drive values up at dizzying rates. The work of Jacob Kassay is an example. One of his silver canvases fetched $86,500 at a Phillips day sale in November 2010, 10 times the low estimate. The artist was 27 years old at the time. The following spring, another silver painting with a freshly market-adjusted estimate of $60,000–$80,000 jumped to $290,500 in just 20 seconds of bidding.[64] Whether such hyped artists will make it into the canon and whether their works retain their value over time is yet to be determined. Indeed, many artists that had robust markets at one time such as William-Adolphe Bouguereau (1825–1905), Theo van Doesburg (1883–1931), Donald Sultan (1951–), and Anselm Reyle (1970–)—to name but a few—have seen their work fall out of favor and values plummet.[65]

Sometimes more irrational reasons add a premium to value. Rivalrous competition at auction, while "unjustified" in terms of standard determinants of value, can also momentarily affect the

value of similar works on the market. And all of these factors can, of course, be affected by economic conditions. Values nosedived for many artworks after the financial markets crashed in 2008, and auction profit totals slumped en suite. But even under such dire economic conditions, prices for top works still flourished, underscoring the splintered nature of the art market as a whole. While the art market generally relates to the larger economy, the masterpiece realm does not seem to be connected. In fact, coveted works that appear on the market during a recession often fetch higher prices than they might during peak times because the supply of such top-notch pieces is minimal as collectors are reluctant to put their best artworks on the market.

APPROACHES TO VALUATION

When are appraisals needed and what can collectors expect? Aside from satisfying general curiosity about the worth of one's collection, there are a number of situations where a collector needs to know the value of an artwork or requires an appraisal. At times, an entire collection will need to be appraised.

When Are Appraisals Needed?

Appraisals, whether informal or qualified, should be sought in the following circumstances:

- Acquisition
 In cases where a work of art is valuable or represents a significant investment for the collector, it is recommended to have the work appraised by an independent party or to consult a trusted advisor with respect to value.

- Sale
 Likewise, when selling a significant work of art, it is also helpful to have expert valuations in order to determine whether the price and terms offered by the selling agent are fair.

- Conservation
 If a work of art is damaged, appraisals will be necessary to estimate the loss in value for tax and insurance purposes and to determine whether a piece is worth restoring. If the damaged piece is in fact restored, a second appraisal will then be required to determine the actual loss in value (based on the insured value) and the amount of compensation.

- Charitable Contributions and Gifts

 If works of art are donated to a charitable donee during the collector's lifetime, appraisals will be needed for income-tax purposes. Collectors in the US are entitled to a FMV tax deduction when donating works of art to a museum or other 501(c)(3) organization (that is, a non-profit organization). Appraisals may also be needed when artwork is transferred during the collector's life to non-charitable donees (such as their children). (See Chapter 9, "Estate Planning.")

- Estate Planning

 Art is a significant asset and the first step to estate planning is valuation. Qualified appraisals are needed at the time of death in order to determine the estate tax due. The appraisal amount also constitutes the tax basis for determining capital gains tax if the works were to be subsequently sold by heirs. (See Chapter 9, "Estate Planning.")

- Divorce

 Appraisals are also needed to divide property in cases of divorce. If current appraisals do not already exist, the parties should agree on which appraiser(s) will value the collection; separate valuations will only impede the process and can prove costly. When dividing property, the appraised values should be considered together with the projected costs of future maintenance and capital gains taxes due if works are sold. (See Chapter 9, "Selling Art.")

- Art Financing

 In order to extend a loan using art as collateral, lenders require a qualified appraisal, usually for the work's fair market value. These appraisals are reviewed on a yearly basis (at the borrower's expense), and sometimes more often if a market is volatile. (See Chapter 8, "Art Financing").

- Insurance

 Insurance appraisals are part of risk management and are needed to determine premiums. For this purpose, a qualified appraisal is not usually necessary unless the works exceed a certain amount in value. Valuations will suffice as long as they can be considered "informed input from the research of well-qualified experts in the sector."[66]

 Up-to-date valuations are needed to provide protection in case of loss or damage, but keeping values current can be a challenge. In one incident, a £6-million Impressionist painting was destroyed by an electrical fire which spread from a closet in a neighbor's

apartment. The collector had not gotten around to updating the valuations of her collection, and the work was only insured for $250,000. Not only did her painting perish, but she lost several million dollars because even as the work appreciated in value over a 20-year period, she had been paying insurance premiums on only a fraction of the work's value at the date of its loss.

How Often Should Value Be Assessed?

This raises the question of how often a collector should have his or her artworks appraised for insurance and other purposes. With values changing so rapidly, updates generally need to occur more frequently than was formerly the case. Not long ago, most collections were reassessed every five years. Now, the recommended time frame is one to two years. For more high-end collections, particularly those with a concentration of contemporary art, art professionals now recommend that values be reassessed every six months.[67] This is due to the volatility of the market and the fact that higher-valued works tend to fluctuate more than lower-valued works. The "overnight success" of Richard Prince's *Nurse* series is instructive. His *Man-Crazy Nurse #2* (2002) was purchased in 2003 for $100,000. Just three years later in 2006 it was valued at $250,000. And in May 2008, at the top of the market, the same painting sold for $7,433,000 at Christie's.[68] Such examples abound.

Appraising an Entire Collection

Having an entire collection appraised—and keeping those appraisals current—is a daunting prospect. Collectors need to be strategic about which items need to be appraised, as well as when and how. As the art market is comprised of many smaller-sector markets, all of which have variations, recognizing which items in a collection have markets in flux is key. For sizable collections, particularly those comprising artworks from different sectors, valuation is best done in stages with a number of different appraisers involved. To illustrate, a collector may ask a trusted dealer to provide valuations of a group of 19th-century paintings that fall within the dealer's area of specialization. The same collector may also arrange for further complementary appraisals of his or her contemporary works by auction-house specialists. But for other works where such helpful contacts may not be available, the collector may need to hire a professional appraiser and pay the associated fees, keeping in mind that subsequent appraisals of the same works should not be so costly since the basic research would already have been done.

Valuation Methodology and Reports

Appraisers have a responsibility to look at an object carefully and to analyze all the relevant sales data. As a general rule, the more valuable the property, the more detailed the appraisal should be. Where available, an appraiser will first look for published market comparables such as established auction prices found in databases like artnet and Artprice. If the work does not have an auction market, or if the purpose of the evaluation is to determine retail replacement value for insurance purposes, the appraiser will consider gallery sales. Valuation therefore depends on the object. The next step is to consider each of the valuation factors outlined above and adjust the comparable figure accordingly.

Appraisal reports come in many forms. While dealers and auction houses routinely provide a list of the artworks and their appraised values, the AAA requires more detail in any given appraisal, including: thorough descriptions; rationale and support for valuation conclusions; a statement of purpose of the appraisal (e.g., insurance, donation, etc.); an explanation of the valuation approaches and methods used; and a discussion of the scope of work involved.[69] For donations, estate, or gift tax purposes, the IRS also requires a photograph for any work valued at over $20,000.

Self-Assessing Value

The market value of an artwork is never guaranteed. Although it may seem like a cliché, the principal value of art for most collectors is the enjoyment of the work or the "psychic return"—a kind of value that is hard to quantify.[70] Nonetheless, if a collector himself does not have a good sense of the market value of his works, how can he rely on the recommendations of a dealer or other expert? It is thus important for collectors to engage in the market, to follow auction results and retail prices at galleries for works comparable to their own. Experienced, engaged collectors have a strong sense of the true market value of their works, enabling them to know when to seek second opinions if appraisals or any assessments of value of their works seem "off." Being knowledgeable about the real value of the art one owns is the best means to protect and make the most of a collection.

Duccio di Buoninsegna, *Madonna and Child, c.* 1300, tempura and gold on wood. Also known as the Stoclet or Stroganoff Madonna, *Madonna and Child* is prized, among other qualities, for its rarity. It is one of only a dozen works by the Italian Renaissance master and was the last Duccio owned by a private collector when the Metropolitan Museum of Art, New York acquired it in 2004.

The Metropolitan Museum of Art, Purchase, Rogers Fund, Walter and Leonore Annenberg and The Annenberg Foundation Gift, Lila Acheson Wallace Gift, Annette de la Renta Gift, Harris Brisbane Dick, Fletcher, Louis V. Bell, and Dodge Funds, Joseph Pulitzer Bequest, several members of The Cha (2004.442)

Andy Warhol in collaboration with Dennis Hopper, *Mao*, 1972, screen print. In a case of damage enhancing value, this work achieved more than ten times its high estimate when offered for sale at auction after its owner had shot the work with two bullets which were later annotated by the artist.

Gustav Klimt, *Portrait of Adele Bloch-Bauer I*, 1907, oil, silver, and gold on canvas. When Gustav Klimt's restituted portrait of the Viennese society figure Adele Bloch-Bauer was sold to Ronald Lauder for a record price of $135 million about 60 people were involved in the complex transport of the work from Los Angeles to its new home at the Neue Galerie in New York City.

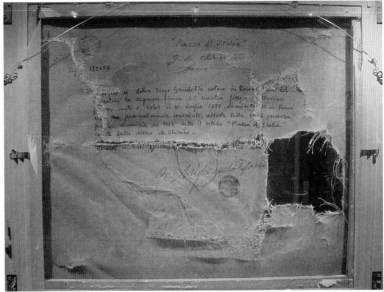

Giorgio de Chirico, *Piazza d'Italia*, 1913, oil on canvas, front and back views. A wrecking ball from construction on a neighboring London townhouse went through a collector's dining room wall, blowing a hole though the De Chirico painting that was hanging on it.

Egon Schiele, *Portrait of Wally*, 1912, oil on wood. The U.S. Customs Office famously seized this painting from the Museum of Modern Art in 1998 while it was on loan there from the Leopold Collection of Vienna when heirs to the Jewish art dealer Lea Bondi claimed rightful ownership.

Frida Kahlo, *A Few Small Nips*, 1935, oil on metal. Some artists see the frame as a physical extension of their work. In this painting, the "blood" from the murdered woman depicted by Frida Kahlo splatters onto the frame, continuing the picture onto the frame itself.

Fundacion Dolores Olmedo, México City

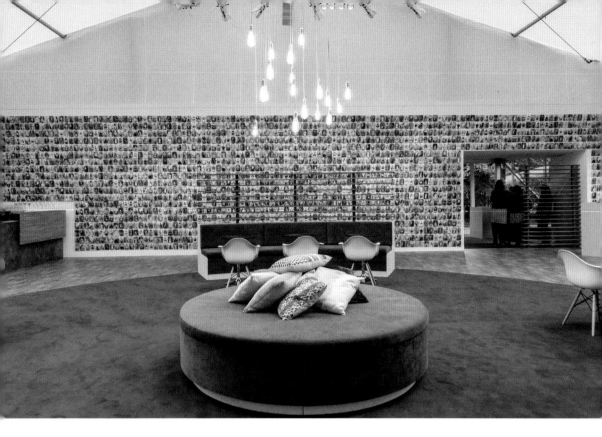

Mathilde ter Heijne, *Woman to Go* in the Deutsche Bank Lounge, Frieze Art Fair, London, 2013. Exclusive VIP lounges at the major art fairs are often sponsored by banks, such as this one sponsored by Deutsche Bank at Frieze, making evident the intersection of banking and art in private wealth management strategies.

Félix González-Torres *"Untitled" (Public Opinion),* 1991, black rod licorice candy individually wrapped in cellophane, endless supply. A manifestation of this work was denied entry into the UK when the artificial colors in the ton of candies that made up the work were found to have exceeded EU limits.

Installation view 2011/12, Sammulung Hoffman, Berlin, Katharina Grosse, *Sie trocknen ihre Knie mit einem Kissen*, 2012, spray painting; o.T., 2011, acrylic on canvas. In 1997, Erika and Rolf Hoffmann converted a former sewing-machine factory in the heart of Berlin, sharing their collection of contemporary art with the public and creating an ongoing dialogue.

Ernesto Neto, *É ô Bicho!*, 2001, polyamide fabric, turmeric, clove and pepper. This aromatic work consisting of stalactite-like nylon sacks filled with spices suspended from the ceiling was installed by the artist in the collector Martin Margulies's Miami warehouse exhibition space after it had been disassembled and packed into several individual boxes for shipment from the Venice Biennale.

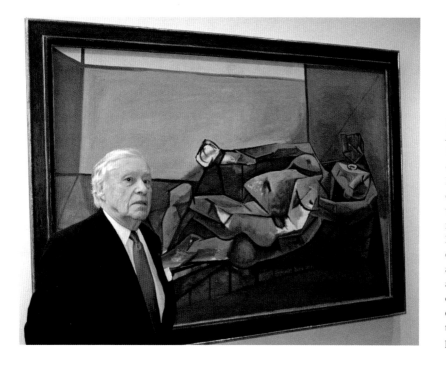

Pablo Picasso, *Reclining Nude (Grand nu couché)*, 1942, oil on canvas. The dealer-collector Heinz Berggruen gave his collection of modern art to a specially-created namesake museum in Berlin for about one-tenth of its market value, an arrangement that benefited all by preserving the legacy of the collector in his native city and greatly enhancing the state collections for a price within its reach.

COLLECTION MAINTENANCE AND HOLDING COSTS

INSURANCE

Losses sustained by galleries in Chelsea, New York, as a result of 2012's Hurricane Sandy were estimated at $500 million, making it the largest art insurance loss in history. This figure surpassed the unfathomable damage of Hurricane Katrina.[71] A year before Katrina, in May 2004, works by leading British contemporary artists such as Damien Hirst, Tracey Emin, and the Chapman brothers—many of which were owned by the high-profile collector Charles Saatchi—were destroyed in the Momart warehouse blaze in London, obliterating over £50-million worth of art from private collections and making international headlines. Four months later, the tragic fire at the exquisite Duchess Anna Amalia Library in Weimar, Germany, saw 50,000 rare books perish, with damage to 65,000 more.

During that same general period, one New York collecting couple filed three major art insurance claims. First, pipes burst in their venerable 5th Avenue apartment on two separate occasions, resulting in flooding and mold in rooms containing an Aubusson tapestry and a still-life painting by Cézanne. Coincidentally, within days, lightning struck their Barbados vacation home causing the roof to collapse, resulting in serious damage to antiquities and the ruin of several works on paper.

All of the aforementioned destruction, public and personal, fell on the heels of the 9/11 terrorist attack on New York's World Trade Center in 2001, during which $100-million worth of art in corporate collections, including monumental works by Auguste Rodin, Joan Miró, Alexander Calder, and Hiroshi Sugimoto perished on site.[72]

While the incidents described above are catastrophic illustrations, the majority of the losses a collector faces are actually the result of mundane occurrences. Most damage to artwork—some 65 percent—occurs during transit.[73] Any time a work of art is moved, it is put at risk. Breakage occurs, glassine adheres to surfaces, chips and scrapes materialize. Poor packing is often the culprit, as was the situation when a Cindy Sherman (1954–) photograph valued in excess of $60,000 was packed in little more than a cardboard box (by a reputable gallery, no

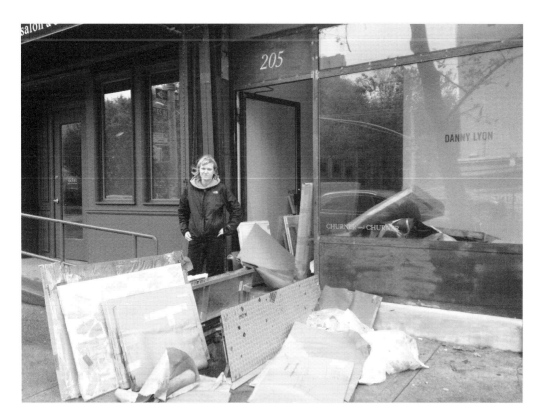

Losses sustained by New York Chelsea galleries as a result of 2012's Hurricane Sandy were estimated at $500 million, making it the largest art insurance loss in history.

less). Not surprisingly, the glazing shattered during shipping, irreparably damaging the work.

Accidents in the home are also fairly routine: a Käthe Kollwitz (1867–1945) lithograph suffers a small tear; a child takes a crayon to a Cy Twombly (1928–2011) canvas; a housekeeper knocks over a 600-year-old Chinese plate; or a party guest trips and her champagne sprays a Mark Rothko (1903–70) oil painting.[74] Other mishaps are less pedestrian. In one instance, a wrecking ball from construction on a neighboring London townhouse went through a collector's dining-room wall, blowing a hole though the Giorgio de Chirico (1888–1978) painting that was hanging on it.[75] In another, a bat flew into a painting causing scuffs, a hole and a split frame.[76] Damage can also be caused by improper cleaning and restoration, vandalism, or inappropriate lighting, installation, or storage. A painting put away in a large flat-screen TV box in the basement became the target for young children at batting practice.[77]

Artworks are thus vulnerable to a number of forces, including theft. Art crime (including looting) is estimated to be a $6-billion-per-year industry, with the brazen 1990 burglary of Rembrandt's *The Storm on the Sea of Galilee* (1633) and Vermeer's *The Concert* (1658–60) from Boston's Isabella Stewart Gardner Museum still etched in the public memory.

Increasing values make the stakes ever greater all around. In addition to security measures and preventative care, collectors can mitigate risk of loss through insurance. This chapter will outline the different kinds of insurance, explain the key terms and concepts, and discuss issues for collectors to consider as they select and negotiate coverage to protect their works of art.

FUNDAMENTALS

The Policy

An insurance policy is a contract and insurance coverage is governed by the wording of the individual policy. The policy explains what types of loss (aka "perils") are covered. Types of loss that are not covered are listed as exclusions. These policies can be exasperatingly complex, and the terms should be reviewed carefully, possibly with a lawyer, so that the insured fully understand the policy.

Any changes to the policy—such as name of the insured, additional insured, loss payee, change of location addresses, etc.—are endorsed to the policy. If the language of the policy itself is changed, this is also an endorsement, sometimes distinguished as a manuscript endorsement. On occasion, an endorsement to a policy will void an exclusion to extend coverage after the underwriter has assessed the risk. Additional charges or return premiums may apply to changes made.

Collectors should keep in mind that an insurance policy is a negotiable instrument and that annual policy renewals will offer another opportunity to make changes. This is important since the collection or circumstances may change during the course of a policy. As will be discussed, within weeks of 9/11, most insurers changed the scope of their policies to exclude terrorism, a detail that may have been overlooked in the fine print by collectors at renewal time. Post-Sandy policies are bound to change as well, potentially eliminating coverage for all works located in the worst flood zones regardless of whether or not there has been any previous history of flooding.

The Broker

Most collectors do not deal with the carrier directly, but rather with a broker. An insurance broker acts as an intermediary, helping the insured to navigate the waters described above by breaking down the terminology and assisting the collector in evaluating which is the best policy for his or her needs. A broker can also assist collectors in aggregating different

types of insurance (cars, homes, yachts, etc.) for optimal rates. Ultimately, brokers are responsible for managing and expediting claims, serving as advocates for the collector and delivering the claim check.

Brokers themselves are not financially liable for losses, but are paid a brokerage commission fee that comes out of the premiums a collector pays the insurer. When establishing a relationship with a broker, this fee should be discussed and there should be full transparency. Huntington T. Block, DeWitt Stern, Nasco Karaoglan, and R. K. Harrison are the best-known broker firms in the art insurance realm at the time of writing, but collectors should also ask for references from individuals they trust.

The Carrier

The insurance industry is a competitive one, and collectors should obtain quotes from three or more insurers when looking for a policy. Price alone should not be the determining factor. The following are questions a collector should consider:

- What is the carrier's financial solvency? As a first step, the ratings agency A. M. Best Company should be consulted. The rating is a strong indication of how well the carrier is positioned to pay out a claim.[78]
- What kind of reinsurance does the carrier have? Reinsurance is the means by which an insurance company protects itself in the case of loss. Where there is massive loss, such as a Hurricane Sandy or 9/11, a collector will want to know that the insurer has enough coverage to indemnify all of its affected policyholders.
- How does the company handle claim payments? What is the procedure and what is the turnaround time?
- What additional services, if any, does the carrier provide?

ART INSURANCE

General property insurance such as homeowner's insurance can cover loss or destruction of works of art, and for some collectors that coverage is enough. Unlike most household goods, though, works of art are unique, and often difficult or impossible to replace. Specialist fine art insurance was thus developed in the 1960s by insurance executives at AXA ART (who, incidentally, were also collectors) once they determined that ordinary replacement-value insurance was not sufficient for art or other valuable collectibles.[79] Art insurance has since grown into a global industry with major carriers such as AXA ART Insurance Corporation, Chubb, AIG Private Client Group, and Hiscox

as well as specialized art policies being offered by general insurance companies, large and small.[80]

What distinguishes art insurance from general insurance? To start, a standard homeowner's insurance policy won't cover losses more than $200,000 and the insured will usually have to pay a deductible. Secondly—and key for active collectors—homeowner's insurance only covers works that are located in the home. Thus, art held in storage, on loan to a museum, or in a conservation studio will typically not be covered under a homeowner's policy, nor will any works of art in transit—where most damage and loss occurs.

By contrast, and with some exceptions, art insurance attaches to the work of art itself, and often automatically covers new acquisitions before they make it to the home. Under such specialized policies, works will be covered at the time of title transfer, providing a window, usually 45 to 90 days, for the collector to officially add them to the policy. However, such "Newly Acquired Property" clauses will generally cover no more than 25 percent of the amount of insurance for scheduled property *of that type*—meaning that an insurer won't automatically cover jewelry or wine if the existing policy only covers art. The caveat here is that collectors or their administrators must remember to actually add the work to the policy as of the date of purchase. In cases of partial ownership—such as when a work of art is shipped to the buyer and paid for in installments over time—best practice suggests that the buyer should complete the entire purchase (and hence acquire clear title) before assuming insurance responsibility for the work under his or her policy. While dealers will sometimes offer to arrange for shipping and cover the insurance, a number of collectors prefer to take on that responsibility using their own trusted relationships. Either way, it is important always to clarify whose insurance is covering the work—and for what time period.

Another difference between specialized art insurance and general insurance is that while the latter will pay for restoration of damaged works, it will not cover loss in value—that is, the difference in a work's market value before the damage occurred and after it has been fully restored. When Steve Wynn accidently put his elbow through his 1932 Picasso painting *Le Rêve*, as discussed in the previous chapter, the insurance carrier, Lloyd's of London, paid the $90,000 restoration cost *plus* $35 million for the loss in value of the work. Since the majority of art insurance claims involve loss-of-value determinations and are quite complicated, having professionals with art-world knowledge negotiating a claim can be a great advantage and diminish the potential for conflict.

This knowledge is particularly important when it comes to tricky areas like conceptual art where there are no standards with respect to how to treat non-traditional materials, or in situations where living artists

may or may not agree to allow re-fabrication of a piece in the case of loss. (See Chapter 4, "Claims.") An art insurer has in-house art experts who know how to navigate the complexities of the art world and who have a nuanced understanding of the unusual nature of the underlying asset. For significant collections, this difference is critical.

Additionally, because carriers have a real and focused stake in making sure their clients' works are protected, they may offer a number of helpful collection-management services, many complimentary, including inventory assistance, guidance on installation, emergency evacuation plans, and advice on how to protect artworks from sunlight, moisture, dust, and vibrations from neighboring buildings (wrecking balls included).

While not all collectors need art insurance, one rule of thumb is that it is a good idea to consider specialized insurance once the total collection value reaches $50,000–$100,000.

What is "Art" for Purposes of Art Insurance?

Fine-art insurance is not exclusively limited to fine art, but covers most collectibles that can be sold on the secondary market or at auction including jewelry, furs, wine, silver, rare coins, antiques, and a wide assortment of interesting ephemera ranging from duck decoys, toy soldiers, sailboats, vintage cars, mineral collections, china, or even a collection of bear traps. In one situation, when a collector purchased a quarter-million-dollar tree for his property, the carrier even agreed to provide coverage for the tree.[81]

Costs

Carriers assert that art insurance is one of the cheapest kinds of insurance. Each company, however, has a different rating structure and different variables. Annual premiums at AXA ART, for example, might be $0.08 per $100 of art value. To illustrate, a $50-million private collection of non-fragile works in a doorman building might have an annual premium rate of $40,000. As with other types of insurance, the more insurance you buy, the lower the rate will be. So the premium for a $100-million collection with the same conditions described above might then be $70,000—but again, many variables factor into such rates, so figures can be misleading. The exact rate will depend on conditions such as size, medium, security systems, location of the collection, warehouse use, loan practices, and catastrophe hazards.

Strategies do exist for keeping costs down and such options can be explored with a broker. For example, jewelry and silver are generally expensive to insure under a homeowner's policy due to their portability

and susceptibility to theft, but it may be possible to add these items to an art insurance policy at a lower rate. Fine jewelry kept in a vault is less expensive to insure than jewelry kept in a box on a dresser.

Itemized v. Blanket Coverage

As discussed at length in Chapter 3, with respect to insurance, the importance of keeping up with the changing values of artworks in a collection cannot be overstated, especially in sectors of the art market where prices have been soaring, putting collectors at risk of becoming instantly underinsured. At the same time, a collector also wants to take care not to be over-insured and paying undue premiums.

Art insurance is intended to indemnify the owner for financial loss of unique objects, and the policy's valuation clause delineates how much the collector will receive in the case of a claim and how this sum will be dispersed. Collectors can choose different kinds of coverage which determines the amount they will receive in the event of loss.

Itemized

An insured may elect to have an agreed value for each item; these values are listed on a schedule. In the event of loss, the collector receives the agreed amount. Some carriers also offer an inflation cushion sometimes referred to as "mark to market." Chubb, for example, offers a 10 percent inflation guard, and AXA has a current market value (CMV) option under which the insured receives the current market value of the work but no less than the scheduled value. AXA also has a CMV 150 percent policy which will cover up to 150 percent of the agreed value in the event of loss if, at the time of loss, the policyholder can demonstrate the work had appreciated that much since the policy was written.

Scheduled coverage, a risk-management technique, is based on client preference, and is generally recommended for works with a value of $10,000 or more. While more expensive, this kind of coverage offers greater protection for works of higher value whose markets are often volatile. (Such an insurance schedule with appraised values, incidentally, can also be an enormous help with estate planning. In fact, sometimes insurance schedules provide the only record of estate contents and values. See Chapter 9, "Identification of Estate Contents.")

Blanket

For very large collections that span genres, changing collections, or those of lesser value, blanket coverage is often preferred. Under this kind of policy, the insured provides the average total market value of the collection and may recover for total losses up to that amount. The amount

recoverable for an individual piece is usually capped at the amount given for the most valuable work. The responsibility of proof of value at the time of the loss is on the insured party.

For collections that are not deemed to be at risk—those that are fairly stationary, housed in secure facilities and safe geographic areas—an insured may take out a "loss limit" policy with a value below the average value of the whole collection (known as "TVAR"—total values at risk). Also referred to as partial insurance, this approach can provide adequate protection and saves on premium costs.

Some collectors combine both approaches, choosing the more economical blanket coverage for works of lesser value and itemized coverage on a schedule for more valuable artworks.

In any case, collectors should make sure that descriptions of any artworks listed in the policy are detailed and clear, and include inventory numbers where possible. Schedules for very large collections can become unwieldy and difficult to decipher; one person's identifier may be unclear to the next. In one case where several hundred artworks were listed, a number of individual items appeared multiple times under slightly different descriptions, with the collector paying excess premiums for years until the redundancy was discovered by a diligent collection manager.

"All Risk"

Most reputable carriers provide what is known as "all risk" policies—that is, a policy that covers all accidental physical loss or damage unless specifically excluded in the policy. This list generally includes damage and loss due to fire and smoke damage, breakage, accidental damage, transit, water, temperature, disappearance (such as jewelry that cannot be found), vandalism/malicious mischief, natural hazards and catastrophes, and theft. With the spate of recent natural disasters and astronomical prices at the top end of the market, however, the definition of "all risk" is changing, and collectors have to pay special attention to exclusions written into their policies.

Exclusions

An insurance policy will spell out what is not covered by the policy. The exclusions under most art insurance policies are as follows.

Territorial Exclusions
Catastrophic or Coastal
From the insurer's perspective, catastrophic events such as 9/11 and Hurricane Sandy are the greatest concern. Before 9/11, most insurers

covered terrorism. This reversed quickly in the wake of the disaster, with the US government subsequently stepping in to mandate coverage under the Terrorism Risk Insurance Act of 2002. In a "post-Sandy" world[82] in which natural disasters are occurring more frequently, insurers are again being forced to rethink their approach. As New York collectors have been known to bring works of art to their second homes in the Hamptons, at least one carrier now has "wind and water damage" exclusion for works located on Eastern Long Island.

Domestic or Worldwide

As mentioned, works insured under art insurance policies will usually be covered regardless of their location, and collectors should confirm that their policies indicate "worldwide" coverage. Nonetheless, coverage may be excluded in new market areas such as China and Mexico where professional industry standards with respect to shipping and conservation are not yet deemed acceptable. Collectors should check their policies with respect to international shipping and temporary locations.

Earthquakes

With a projected disastrous earthquake in the Los Angeles area on the horizon, many carriers have decided to restrict earthquake coverage in California as well. Some carriers exclude coverage for earthquakes (or "earth movement") in certain geographic areas. Earthquake coverage will be available only after underwriting has assessed the risk, and premium rates would reflect this coverage.

War

Typically, exclusions will include government confiscation, war zones (on land as declared by the UN, but not necessarily in transit—e.g. flying over a war zone), and nuclear loss.

Wear and Tear/Inherent Vice

Degradation of a work of art from normal wear and tear and exposure, such as fading or discoloration due to sunlight or temperature, is not covered by insurance. Inherent vice—damage to works of art that by the nature of their composition are subject to deterioration or degradation over time, such as a shark that decomposes in formaldehyde—will also not be covered.[83] Any pre-existing condition, such as a crack in old wood or a fault line in marble or stone slabs, will be considered inherent vice, and exacerbations of such conditions during transit or movement will usually not be covered.

If the insured party is personally responsible for the bad packing that causes damage to an artwork in transit, this damage, too, may not be covered. If it is the shipper's packing that is deemed inadequate for the

nature of the work, the carrier will usually honor any claims for damage; but there have been cases where such coverage has been refused when a collector had not been forthcoming about the nature of the artworks (usually with the aim of receiving a lower shipping rate). However, if unstable elements are discussed and the shipper has the opportunity to inspect the work and devise an appropriate shipping solution, the collector will most likely recover if something should go awry.[84]

Bad Business Transactions

Conversion

Art insurance will also not cover a bad business transaction. Although now somewhat of a grey area with respect to the law,[85] if a collector consigns a work to a gallery and then learns that the gallery has sold the work to someone else without paying the consignor as per the agreement, the work will not be covered under the policy as the insurance industry does not consider it to be stolen.

Given the example of the Salander-O'Reilly Galleries, the ramifications of this exclusion should give collectors pause. In July 2007, the long-established Upper East Side dealer Lawrence Salander was forced to close his gallery, ultimately pleading guilty to 29 felony counts of grand larceny and charged with defrauding collectors and artists whose artworks had been consigned to his gallery. (Salander misappropriated more than $100 million from investors and clients, selling art consigned to him without paying consignors as well as selling shares in works he did not own.[86]) Likewise, the Berry-Hill gallery, another long-standing prestigious business, was accused of not paying consignors millions of dollars due.[87] In both cases, clients who had consigned works that were subsequently sold to others had no recourse unless they had filed a UCC-1 form (see discussion on UCC-1 forms in Chapter 9, "Selling Art").

Conservation

Art insurance will also not cover bad conservation work. If a collector entrusts his art to a conservator who does not adhere to accepted standards, carriers will deny coverage for loss in value that results from poor work; this, too, would be deemed to be a bad business decision on the part of the collector. However, if a work of art is damaged *inadvertently* while in a conservator's studio, the damage may be covered—if the collector had the foresight to negotiate such coverage into the policy.

Authenticity and Title

Insurance also does not cover issues of authenticity. If a collector buys a work by Rubens that turns out to be from a lesser hand, there will be no basis for an insurance claim to cover the loss in purported value. Art

insurance also does not cover issues of title. That means that if a collector learns that he does not in fact have a clear ownership interest in a work of art that he has purchased and must forfeit the work to the rightful owner, insurance will not cover the loss.

TITLE INSURANCE

With the market gap created by the lack of insurance coverage for title, specialized art title insurance was introduced in 2006. Distinct and supplemental to art insurance and modeled on real estate, title insurance for art was developed by the ARIS Title Insurance Corporation to protect buyers from issues of defective title. Although still relatively expensive for the individual collector, this form of insurance is becoming more and more accepted in the art world, and may be worth considering for certain works of art. Some transactions, such as auction consignments of Second World War era material or collateralization of art for bank loans, now require title insurance. Title insurance does not, however, cover antiquities and cultural artifacts, areas of the art market whose title issues are just too risky.

Despite the attention Nazi-era restitution cases such as that of Egon Schiele's *Portrait of Wally* mentioned in Chapter 1 have received, the vast majority of title-related claims are due to more mundane liens and encumbrances such as family or estate disputes, creditor's claims, unauthorized sales, and import/export violations.[88] In the case of the Mark Tansey painting consigned to the Gagosian Gallery which had already been partially gifted to the Metropolitan Museum of Art (see also Chapter 1, "Title"), there was no malice or intent to deceive the new buyer; it was a more ordinary failing which resulted in defective title and the legal headaches that go with it.

The advantage of having title insurance is that it will cover the cost of a full legal defense as well as the value of the forfeited artwork if such a dispute should arise, regardless of whether the insured should or could have known that there was a possible title issue. While they may offer some coverage or limited endorsements, art insurance and general insurance do not cover loss due to title defects or full litigations costs.

Title protection does not come cheap, however. In contrast to specialized art insurance where annual premiums are paid, title insurance is a one-off expense due when the policy is issued, usually at the time of acquisition. It covers the duration of the ownership of the work and remains with the artwork when it is transferred to the heirs-at-law. Rates are usually around 2 to 3 percent of the market value of the artwork, but may be less or more depending on the risk and amount of research

necessary. Title insurance for works bought on the primary market may cost as little as 1 percent of the purchase price, whereas Second World War era art without clear provenance may cost as much as 6 percent.

While title insurance offers the assurance of covering any financial loss, nothing of course can replace an actual artwork relinquished in a title dispute, and collectors must do their own cost–benefit analysis.

OTHER CONSIDERATIONS

Is the Collection Insurable?

Even if a collector decides he would like to purchase art insurance, there is the question of whether or not the collection is insurable in the first place. Not all insurers will underwrite every collection.

Insuring the Collection—or the Owner?

In the past, when it came to deciding whether or not to offer coverage, insurers used to mostly focus on the collection itself. For example, Old Masters were more desirable for insurers because, unlike with contemporary works, the owners are used to having "issues" with their works; age-related matters such as paint loss, relining, chips, etc. are more an accepted norm and not necessarily cause for alarm. Now, as insurers seek to avoid conflicts and costly litigation, they will consider the individual seeking coverage as much as the underlying collection before agreeing to accept a new client: Is the collector litigious? What are his or her professional and personal associations?

Geography

There is also a question of geography. Insurers will typically stay away from countries where they cannot rely on fair courts or above-board dealings. Some insurers, for example, will not insure collections located in Russia if they may not be guaranteed a fair trial in the event of dispute. Moreover, collectors in emerging-market countries such as Mexico and Brazil will often be denied insurance, as proper art-market infrastructures such as secure storage facilities and conservation professionals are not yet in place.

Aggregated Risk/Acute Accumulation

There is also the separate issue of aggregation or concentrated risk. With greater accumulations of artworks in an ever-expanding market, insurers are loath to take on new clients with works located in areas in which they already have as much risk as they can handle. In Manhattan,

for example, an insurer may already have such an "acute accumulation" of art in galleries in Chelsea or private residences on the Upper East Side. Certain storage facilities or freeports are also points of acute accumulation where insurance companies may be unwilling to assume more risk.

Facilities

Lastly, there is the question of facilities. For significant collections, a carrier will want to make sure that adequate security and climate-control systems are in place. They will often require an inspection, making sure systems are up to par and that the works of art themselves are not installed in vulnerable positions such as heavily trafficked hallways, under air ducts, or over fireplaces. If the collector cannot or will not take the recommended measures to correct these deficiencies, coverage will be denied.

Claims

In the case of loss or damage, how should the collector proceed and what can be expected? If present when an artwork is lost or damaged, the owner should take a picture of the work and refrain from touching or moving it. If the work is still in its crate, it should not be removed. The next step is to contact the insurer or the broker "as soon as practicable." If a collector receives a damage report from a shipper or a museum, this should be relayed to the insurer promptly. It is up to the insured to ascertain that all information and documentation related to the artwork and the loss event, including appraisals and police reports, is provided to the insurer. Some policies also require an insured to file "proof of loss" as defined by the policy within 90 days of discovery.

In most cases, the insurer will then send an adjuster to inspect the artwork. During the claims adjustment process, the adjuster will try to determine the cause of loss and gather all information related to the claim—where, when and how did the loss occur and under whose control did this happen? The adjuster investigates the claim, determines what coverage is due under the terms of the policy, and authorizes payment. Every claim depends on the circumstances and is handled differently.

The Adjustment Process
Total Loss
Where the cost of conservation is greater than the value of the artwork, the work will be considered a total loss. (Typically, where there is over 50 percent loss in value, the insurer will total the loss.) In situations where

there is a total loss, title to the artwork will usually be transferred to the insurer with the insurer paying the agreed replacement value of the artwork to the collector. That value will depend on the stated terms of the policy.

Partial or Full Loss of Value

Where there is a partial loss, such as Picasso's elbowed *Le Rêve*, the insured will be able to recover the costs of conservation (including any transport costs involved) plus loss of value. In such cases, both a qualified conservator and appraiser will be needed.

The parties will have to agree on a conservator to carry out the work. While insurers will typically be very involved in this process, examining treatment proposals and overseeing the treatment itself, they usually will not attempt to impose a conservator on a collector as they will not want the insured to later claim that the restoration was subpar or worse. What if there is a dispute after the work is restored? Some policies have a partial-loss clause for such differences, whereby the parties agree to sell the work at auction, although this is not usually a desired outcome for anyone.

The next step is for each party to select an appraiser to determine loss in value and try to concur on the loss amount. As mentioned above, if the loss is agreed to be more than 50 percent of the value after restoration, the insurance company will usually consider it to be a total loss. As no two appraisers are likely to agree on the loss-of-value amounts, the insurer and the collector will sometimes pre-agree to the adjustment procedure when it comes to artworks of high value, including which experts may be called in to assess loss. (In no case should the appraiser be the same as the conservator, as this is an inherent conflict.) Most fine art policies will also include an Arbitration Clause which provides that the parties can select a third appraiser to act as arbiter and settle the dispute. In the case of the elbowed *Le Rêve*, the parties agreed on a primary conservator but there was also an additional conservator who rendered a second opinion for a fee of $20,000.

Work by Living Artists

With regards to contemporary art by living artists, loss claims may not be so simple. *Droit moral* laws—the right of the artist or the artist's heirs to renounce a work that has been altered—may be applicable. If so, the artist must be consulted about whether he or she is willing and able to repair the work. Some artists will want to immediately disown a work that has even minimal damage. Other artists will think nothing of producing a replacement work such as a photograph or print (for a fee paid by the insurer) where possible, and backdating it.

It is often hard to predict an artist's position on conservation, but if an artist chooses to disown the damaged work, a reputable carrier will usually respect that position and pay the collector full replacement value. In cases of total loss, insurers usually do not destroy the work, but use or donate it for educational or conservation purposes. In the case of living artists who object to having their damaged works sold (see discussion of Moral Rights, Chapter 1, "Due Diligence"), the insurer may agree not to reintroduce the work to the commercial world.[89] (As a side note, some collectors actually focus on acquiring damaged artworks, and solicit insurance companies to this end.)

Collectors have also been known to refuse the work, arguing that it is "just not the same" and insisting that the insurer pay full replacement value. In one instance, an editioned light sculpture by Tim Noble and Sue Webster was destroyed, and the artists agreed to fabricate a replacement at the behest of the insurer. In the end, the collector, however, rejected the replacement because he was unhappy that the actual execution was in a different year. The insurer took ownership of the artwork and paid the full claim amount to the collector.

Most insurers are interested in settling claims, and face-to-face negotiations are strongly recommended over calls and email exchanges. Litigation is of course a last resort. Generally speaking, if the carrier is a reputable one and the client a good one who pays premiums on time and fulfils all obligations to the insurer, the process, while perhaps painful, should go smoothly.

"Buy Back" Agreements

What happens if a work is recovered after it was once deemed lost or stolen? Where an insurance claim was already paid, the insurer is the technical owner of any recovered work. This can be problematic for the collector, especially if the work has appreciated substantially in value over the time period of the loss, which can span many years. Some policies will allow for a collector to purchase the work back from the insurer for the received claim amount plus interest. Although these cases are rare, this can be an important consideration when selecting and negotiating policies.

Tax Implications

Collectors should also keep in mind that there may be tax implications to their insurance claims. In the US, if the amount recovered is greater than the original cost of the artwork, there will be a taxable gain unless a similar work is purchased within two years.[90]

The Collector's Obligation Vis-à-Vis the Insurer

Most collectors tend not to be very involved with their insurance, having agents handle renewals after they read the first paragraph and decide they can't be bothered. Many do not actually learn the details of their coverage until disaster strikes. Insurers, on the other hand, typically like to have a good overview of their exposure and want to be in communication. The more valuable the artwork, the more information and involvement the insurer will require. Insurers will want to know everything about a work of art valued at above $10 million, and they may want to be present if it is being moved.

In order to be "successfully insured," collectors are advised to keep the insurer informed on several fronts. The insured is required to provide notice of changes of location of the artworks and to fully identify any and all storage facilities where works covered by the policy are kept. Collectors also need to advise their carriers of any fractional ownership in a work of art, either because they have gifted part of the work to a museum or other party, or because they purchased the work jointly with another party. If each fractional owner insures only his fractional ownership of a divided work, problems are bound to ensue in the event of a claim. In such cases, it is actually better to take out a separate policy for the individual piece so that any potential claims are coordinated.

Loans

When loaning a work to a museum or gallery for exhibitions, it is good practice to report such loans. (See Chapter 7, "Museum and Gallery Loans," for a full discussion.) The loan agreement usually offers "nail-to-nail" (or "wall-to-wall") coverage, meaning that the work of art is insured by the borrower from the moment it comes off the nail or starts the movement process. However, the collector must determine whether this coverage is adequate and whether their own insurance should be in effect as well, particularly if their coverage is superior. In such cases, the museum might pay a portion of the collector's premium and will request a waiver of subrogation (to prevent the insurer from seeking indemnity from the museum in case of loss). If, under the loan contract, the collector agrees to take on the insurance risk for terrorism and/or earthquakes, the carrier should be notified as they may have an aggregation issue without adequate reinsurance.

Is It Worth It?

Most serious collectors consider fine art insurance to be an essential part of their collection and wealth-management strategies. Other collectors

choose to only partially insure their collections. With the concept of total-loss disasters becoming more of a reality in light of 9/11, Hurricanes Katrina and Sandy, and the scattershot effects of global warming, however, more collectors are beginning to consider full coverage for their collections.

Nonetheless, not all collectors choose to insure their collections. Annual insurance premiums add up over time, and some individuals would rather take their chances, especially if their collections are static, their facilities are top notch, and the collection is housed in what is considered to be a geographically safe area. Since there is usually an allowable tax deduction for a loss from fire, theft, or other casualty (limited to the lower of cost or fair market value, the "casualty loss deduction" and only to the amount in excess of the collector's adjusted gross income), the collector may thus opt to "self-insure," foregoing insurance if the tax savings are greater than the cost of paying for insurance.[91]

Still other collectors choose not to insure their collections for privacy reasons. While not often discussed, many collectors fear that providing an inventory of their artworks to a third party will render their estates more accountable to tax authorities. In some parts of Europe (like France, for example), the government actually *requires* insurers to disclose the collection information of its clients. Even if potential tax liability is not their concern, some collectors don't want outsiders to be privy to information about their collections, period. Finally, still others take the position that insurance is only money; nothing can replace an original work of art once it is gone.

SHIPPING, STORAGE, FRAMING, AND INSTALLATION

Art collecting also involves the logistical aspects of owning a collection. Such considerations are often not at the forefront of a new collector's mind at the time of acquisition, and even seasoned collectors are known to dismiss these more mundane practicalities when they are in pursuit of an artwork they desire. Once a work of art has been acquired, however, the logistics – and their related expenses and possible risks – can no longer be ignored.

How are works of art moved, stored, put in place, and presented? How can a collector find the right service provider and how should these services be vetted? Getting an artwork to its destination may be easy as picking it up and carrying it, or may demand extensive planning, creative thinking, and scores of personnel. Some artworks come with the perfect frame; others require research or even debate to settle on the appropriate style and materials. It is questions like these that every collector must consider. This chapter will look at the fundamentals of art shipping, storage, framing, and installation, providing an overview of these subjects as well as general guidance.

SHIPPING

When purchasing, loaning, or moving an artwork to another location for any reason, one of the first issues to consider is shipping. How will the worked by shipped: by land, by air, by sea—or by some combination thereof? What is involved and how much time will it take? And, most importantly, how can an artwork get from Point A to Point B in the same condition? Art is not usually created with portability in mind, and there is a serious question about whether rare and valuable works of art should travel at all. As discussed in the previous chapter, most art insurance claims are due to damage incurred in transit.

The specialized art-shipping industry evolved in the 1980s with the emergence of corporate collecting, and has steadily grown in tandem

with the global expansion of the art industry.[92] As the commercial gallery business rapidly shifts from the relative stability of brick-and-mortar spaces to the transience of art fairs taking place worldwide each year, art is being shipped around the world like never before. In the New York metro area alone, there are now over 70 companies dedicated to art shipping and handling, some with specialized units just for art fairs.[93] And, with the very definition of art evolving to include complex installations and unorthodox materials such as plants, chocolate, and drinking straws, the art-shipping industry is faced with ever new and perplexing challenges.

Choosing a Shipping Company

The best shipping companies—also known as "logistics companies" or "carriers"—in the business see themselves as stewards of cultural artifacts.[94] Nonetheless, there are no prescribed standards for best practice in this industry.[95] This is complicated by the fact that it is challenging to impose standards in an international market where differing customs and conditions can exist during the course of one single transaction. Even within more circumscribed territory, stories abound of incompetent packers, unattended trucks, and even artworks being handed over for shipment to individuals with criminal records. Those in the industry are amazed at how cavalier collectors can be when handing over valuable artworks to a carrier or warehouse, failing to take the time to understand the actual practices and procedures of those to whom they are entrusting their art.

In choosing a company to transport one's art, it is important to ask the right questions, and collectors should be vigilant about learning what the conditions will be and getting this information in writing. There are certain basics that should be considered when choosing a carrier:

- Does the carrier belong to ICEFAT, the International Convention of Exhibition and Fine Art Transporters, or a similar trade group? ICEFAT and ARTIM are the main groups worldwide, and are to the art-shipping industry what USPAP is to the appraisal industry and APAA is to the art-advisory business: professional organizations dedicated to establishing standards and best practice in an industry where regulation does not exist. When a collector does not have a trusted reference for a reputable carrier, these organizations are the best place to start. With international networks, these groups provide some reassurance that certain standards will be upheld, no matter how far a work travels.[96]
- Is there a subcontracting clause in the agreement? Even when entrusting artwork into the hands of a reputable shipping company, a collector cannot always assume that it will stay there, as that company may hand off the work to someone else who is less reputable. (See "Process, " below.)
- Is the company asset-based? That is, does it own the trucks and equipment that it uses? Are the crates made in-house? Or is each part of the shipment brokered out? An asset-based company is desirable because it has more oversight and control over the works of art consigned to its care, and it will have more flexibility with timelines and budgets.
- Does the shipping company have an enclosed loading dock? An indoor loading dock enables trucks to enter the building and have the entrance closed behind them, allowing artworks to be unloaded directly into the building with utmost security and confidentiality.
- Does the shipping company share a dock with other companies? This is important since most theft or cases of "missing" objects transpire on loading docks.[97]
- What are the security procedures within the facility?
- Is the facility itself located in a flood zone?
- Where crates are made in-house, are there air-filtration systems to keep the rooms where art is being handled as clean as possible?
- Does the company have a Certified Cargo Screening Facility (CCSF)? Like the insurance industry, the shipping industry changed in the aftermath of 9/11. The 9/11 Commission Act of 2007, implemented by the Transportation Security Administration (TSA) effective

August 2010, mandated the screening of all cargo—including artworks—transported on passenger planes. With those airport personnel opening crates to inspect contents having no art-handling experience whatsoever, damage is commonplace—so much so that most insurers will no longer cover such inspection damage. Airport inspection is thus something that all collectors should strive to avoid. To this end, more and more logistics companies are offering on-site government-approved screening facilities, allowing for artworks to be safely monitored by competent art professionals so that they remain undisturbed at the airport.

Process: Estimates, Subcontracting, and BOLs

In selecting a carrier, it is worthwhile to obtain estimates from different companies. Once a shipping company has been selected, a cost estimate should be requested. An estimate, however, is just that: it is non-binding, and the details on which a quote is premised—locations, dates, sizes, etc.—can (and frequently do) change. In reality, quotes are generally obtained informally over the phone, and sometimes an estimate form will be issued.

Basic shipping estimates can also be obtained on some websites. The London-based moving and shipping company Cadogan Tate, for example, has developed PicturePack.net, a free online quotation service which provides an instant price estimate for packing, handling, transport, insurance (if needed), and customs formalities.[98] This kind of service can be helpful in estimating total costs when considering new acquisitions or obtaining ballpark figures, but such quotes likely reflect shipping via indirect routes with outsourced segments so may not be an accurate indication of actual cost for the service desired. They are also subject to change due to fluctuations in fuel costs, occupancy, and other factors.

All relevant information about an artwork, including dimensions and specifics about materials, should be provided to the shipping company in advance of the shipment. It is not uncommon for individuals to withhold certain information from carriers in the belief they will get a better estimate by making the job appear simpler. This is a misguided approach, one that inevitably leads to delays, budget overruns, and ultimately can put artworks at risk unnecessarily. Where works of art are fragile or may be physically vulnerable in ways that are not readily apparent to the carrier, it is especially important to be clear about providing details as any damage incurred during transport may not be covered by insurance due to inherent-vice exclusions.

As mentioned, subcontracting is common in the shipping industry especially in cases where a carrier does not do particular routes, and

shipping contracts will state that the carrier has the right to subcontract which means it can pass off the work to a cheaper transporter. Most collectors understand this—until there is a problem. Collectors should, however, not accept such conditions without discussion. In some cases, it may be appropriate for collectors to delete such clauses from their shipping contract before signing. Collectors pay a premium to use specialized art shippers in lieu of commercial couriers—one estimate is 60 percent more[99]—and they should endeavor to ensure that the service they are getting matches their expectations.

In the logistics world, the Bill of Lading (BOL) is the controlling document, the actual shipping contract. The BOL describes the goods consigned to the shipping company for transport and specifies how the transport will be undertaken. It is the BOL that is produced when a carrier arrives to collect an artwork, and this document should always be included in the collection management system, both as a hard copy in the paper file and as a scanned copy in any digital system. Companies usually list their official terms and conditions of their services—the fine print—on the BOL, usually on the back, and they are also included on websites. In truth, most people don't read the fine print. This is a mistake.

Some carriers won't allow deletions to their standard Bill of Lading contract, but they may allow clients to make certain stipulations in their estimates—e.g., the need to be notified in advance of any subcontracting that might be necessary for the project and the need for prior approval in writing. If, for example, a truck broke down on a cross-country route and the best alternative would be to rush the shipment by the nearest available cargo plane, the carrier would first have to obtain permission. While this sounds logical, re-routing shipment off-plan without any notification is more the norm in the shipping industry. Collectors who have a good relationship with their carrier, who have an active account and pay their bills, will obviously have more negotiating power in maintaining control over their works of art once they have left their hands.

Most Direct Route Possible

If the TSA requires screening for passenger cargo, why not ship works of art on designated freight (cargo) planes or by sea, both of which are not subject to the same screenings? While freight planes and shipping by sea are the only means to ship very large works such as a monumental Richard Serra sculpture—the usual size limit for cargo on passenger planes is 63 inches (160 centimeters)—passenger planes are generally preferred for shipping art because routes to destinations are more direct, reducing the number of legs on any given trip. As each transfer puts an artwork at risk, with all other factors considered, the most direct route possible should

always be sought. Also, cargo plane schedules can be erratic. A flight that might have been regularly scheduled for five days a week can suddenly become a one-day-a-week flight, thus possibly affecting deadlines for exhibition loans, art fairs, and other time-sensitive transactions—not to mention the risk of having freight stranded in unsupervised locations.

Third-Party Shipments

Sometimes a gallery (or auction house) will organize shipment of works to or from the collector in the context of purchase, consignment or loan. In such cases, the collector should confirm that those handling the art are qualified to do so, particularly with less-established galleries which are often cash-strapped. Galleries have been known to take shortcuts here—as evidenced by the smashed Cindy Sherman mentioned in Chapter 4—and some collectors prefer to use their own art handlers to do the job.

It is also important to clarify who is responsible for insurance coverage at all times. Different galleries and vendors apply different standards as to when their insurance ends and the collector's coverage begins. Does the gallery's coverage end before the shipment or when title is transferred? Or not until the purchaser takes possession? Collectors need to make inquiries about the specifics before engaging in any transactions.

Packing and Crating

Appropriate and adequate packing of any work of art is essential—and can be very expensive, especially when a crate is required. The range of packing and crating needed varies with each piece, and collectors should ask their carriers for the details about how a work will be packed. It is all too common that works of art are not packed properly or handled with care; in times of economic downturn when corners are cut, proper art handling and packing are often the first to be compromised.

Some general packing principles include:

- Conservation-grade soft packing materials such as acid-free tissue, foam, and cardboard should always be used.
- Although the use of bubble wrap is common (as can be observed at any art fair) and often indispensible, it should be used with other interfacing materials such as pH-neutral glassine and never be placed directly on the surface of a work. The bubble wrap can soften and melt, fusing to a surface or imprinting the bubble design.
- Simple and secure padding may suffice for some art transport such as local moving across town.

- For shorter journeys, travel frames (or shadow boxes) should be used on unframed works or pieces with no backing.
- For longer distances and any air shipment, a custom crate or travel case will often need to be constructed. Wood used for international shipping must be chemically or heat treated to comply with international pest-free restrictions, and must be stamped. In some cases, double crating may be required.

On the receiving end, the delivery and unpacking of an artwork should be supervised by either the collector himself or a qualified representative in a properly lit space prepared for the delivery. Art should be examined in detail upon arrival so that minor changes will not be overlooked. As the signature constitutes the owner's approval of arrival condition, this task should not be left to household staff or whoever happens to be on hand. In the case of valuable or vulnerable pieces, a conservator should be present.

Repurposing and Reusing Crates

Crates are expensive to construct and by no means environmentally friendly. By 2013 rates, the cost of a standard crate for a painting measuring approximately 29 by 36 inches (74 by 91 centimeters) would be close to $800.[100] Many collectors thus endeavor to recycle or repurpose crates. The fact is, however, that it is very rare that a crate used to ship one piece can be adequately retrofitted to ship another. Moreover, ill-fitting crates can easily damage a piece. Custom crates are worth saving for later shipment of the same piece, though this raises the question of where such crates can be stored in the interim. Many shippers and storage facilities will hold crates for their clients for a fee, and some collectors even build their own facilities exclusively dedicated to crate storage. In any case, when a crate is stored for reuse, it should always be carefully inspected before later use to see if any of its components—screws, glue, joints, and seams—have become degraded in the meantime.

Conditions of Transport

After a shipper has been selected—or as part of the selection process itself—the collector should be proactive in making queries about the conditions of transport, namely:

- Climate Control
 For road freight, will there be adequate climate control—i.e., will the vehicle be maintained at the proper temperature?

- Security
 Will there be adequate security? Will there be oversight of the
 artwork at all times and can the vehicle be tracked? Is the truck
 alarmed? Is there an enclosed loading dock?

- Safety
 For ground shipping, is there air-ride (or "air-drive") suspension as
 well as multiple drivers?

- Consolidation
 Costs can be reduced if a work is shipped in a consolidated shipment.
 In such cases, in order to reduce handling, the collector may want
 the artwork to be the last on the truck and the first off—known as
 "LOFO"—which may incur an added fee.

- Air Shipments
 If works are shipped by air and accompanied by a professionally
 trained air courier (usually a museum curator or conservator), will
 the work ever have to be left unattended? Sometimes, more than
 one courier may be involved for this reason.

 Also, will the courier have security clearance at an airport,
 allowing the courier to supervise loading and unloading? Specialized
 supervision companies such as the Global Elite Group can be hired

Crate Construction
Workshop, Atelier 4 Fine
Art Logistics, Long Island
City, New York

at most airports. Their agents have security clearance, allowing them to personally monitor the freight being handled from inside the cargo areas and loaded onto the plane, thus ensuring optimal conduct from the airport workers.

- Shipping by Sea
 In the case of very large works such as sculpture, it makes most sense to ship a work of art by sea. The risks here are firstly that there is no guarantee that the work will be placed in a lower berth which is most stable on the water, and secondly that the delivery schedule can be unpredictable. If one item on a manifest raises questions, an entire shipment can be held up, with storage expenses being borne by the collector. When shipping by ocean, temperature-controlled reefer containers are often needed.

FedEx Custom Critical Services

FedEx also provides Art and Museum transportation services.[101] Depending on the medium and how a work is packed, FedEx can be a reasonable shipping method for US-based domestic road service under 1,000 miles (1,609 kilometers). International shipments, however, are riskier as the routes are likely to be very circuitous with many stops. One New York dealer regularly ships his clients' works on paper to Berlin by FedEx for conservation as the fees of his trusted paper conservator there are significantly less expensive than comparable work in New York. In this case, the dealer (sometimes together with the collectors he works with) takes on the risk of overseas shipment to save money on desired conservation, but the art may also have spent time in Memphis and Paris. Obviously, it is important that such works are well packed for the journey. The US-based company Masterpak is a supplier of archival materials for the packing and shipping of fine art.

Insurance

As discussed in the previous chapter, many collectors do not have art insurance and those who have general or homeowner's insurance will not be protected when their works are in transit. Some carriers, however, offer all-risk art insurance when uninsured works are transported under their auspices, although this kind of short-term insurance comes at a premium. (The logistics company Atelier 4 provides a fine art risk policy through Lloyd's of London, for example.) Carriers who do offer insurance can nonetheless refuse to insure works that are unstable or those that are destined for high-risk countries where professional art handlers and

infrastructures are not yet established. Again, the collector will want to know whether the insurance is "all risk" or another type of limited-risk policy such as a "theft-only" option which come at reduced rates (about half of what the all-risk costs).

In the US, a collector who does not purchase insurance à la carte is essentially uncovered as the carrier's standard insurance will only be applied at a typical rate of around $0.60/lb. Art carriers in Europe, however, do provide a certain level of insurance coverage as part of transport, so it's important to clarify.

Taxes and Customs

When shipping internationally for commercial transactions, import and customs fees may apply, with the amount due and methods of tax collection varying from jurisdiction to jurisdiction. In the United States, import duty on art is governed by federal Customs and Border Protection (CBP), and must be paid at customs. Undervaluation of artworks is a crime.

For works leaving the US for entry into Europe, Value Added Tax (VAT), a form of consumption tax, will be due at the port of entry and varies with each country, the minimum being 15 percent. In several European countries, art is taxed at a significantly lower rate (5 percent in the UK) than ordinary goods. In China, VAT of 17 percent is imposed on top of import duty of 6 percent for original works of art as levied per the HS ("Harmonized System") code of the item.[102] Such fees are, however, continually being reassessed and are subject to change.

And yet, the definition of art continues to confound customs officials. In the US, fine art is duty-free, but the definition of "fine art" is not exactly clear. Antiques over 100 years old and works "executed entirely by hand" are considered fine art for customs purposes, but there are questions surrounding photographs and some installations.[103]

The question "what is art?" for customs purposes was famously proposed in a 1928 case where abstract sculptures by Constantin Brancusi were taxed at a rate of 40 percent, the standard tariff for manufactured metal, when they were imported into the US.[104] More recently, in a 2010 decision that has been described as "astonishing," the European Commission ruled that light installations by Dan Flavin and disassembled video works by Bill Viola could not be classified as art but rather "wall lighting fittings" and "DVD players and projectors," meaning that the importing gallery, Haunch of Venison, would have to pay full VAT and customs on the stated value on the works imported rather than the usual 5 percent for art.[105] The implications of this ruling are still unclear.

Imported works of art may also be denied entry if they are in violation of local regulations, such as violations of the US Endangered

Species Act. Candies that were meant to be used in a manifestation of Félix González-Torres's *Untitled (Public Opinion)* (1991) were denied entry into the UK when the artificial colors in the candies were found to have exceeded EU limits (see color plate section).[106]

While a shipping company may technically be listed as the importer of record, carriers in the US are not responsible for collecting any taxes or customs that may be due. Active collectors thus usually rely on customs brokers to manage such complexities along with all the required paperwork (e.g., CF 7501-Entry Summary, Invoice, Bill of Lading, Packing List, etc.), but many shipping companies also have an in-house team which can simplify matters. In other countries, however, carriers do remit taxes on behalf of the client and may be penalized if found to be complicit in tax fraud.[107]

Freeports

Artworks shipped on approval or en route to their end location may be deposited in freeports, or bonded warehouses, where no import taxes or duties will be levied. Freeports are thus a kind of suspension zone which postpone VAT and customs for unlimited periods of time until a work of art reaches its final destination. Works sold within a freeport are also exempt from transaction taxes, and dealers are thus looking to establish commercial space within the physical premises of the freeports. The sleek Singapore Freeport located at the Changi Airport, for example, operates a round-the-clock free-trade zone which, in addition to the tax advantages, provides integrated professional services and simplified customs procedures. Its website boasts "the world's safest storage and trading platform," which offers "a new era in wealth protection and creation."[108]

Europe has 40 such zones with the highest concentration in Switzerland. The fine art shipping firm Natural Le Coultre operates warehouses at the Geneva Free Port, a 435,000-square-foot (40,000-square-meter) freeport with an additional 130,000 square feet (12,000 square meters) being built to specialize in art. The same company, which also operates the Singapore Freeport, has plans to open a 215,000-square-foot (20,000-square-meter) entity in Luxembourg as well as a gargantuan space in Beijing. It is speculated that this surge in freeport construction and expansion is driven by demand from a new breed of collectors, those who are looking to invest in art as an alternative asset and who have purchased art with no intention of ever displaying it; they require secure space to store their art and a means to avoid taxes.[109]

Modeling itself on Singapore, the Beijing Freeport of Culture, established by the state-owned Gehua Cultural Development Group, hopes

The sleek Singapore Freeport—now known as Le Freeport, Singapore—located at the Changi Airport operates a round-the-clock free-trade zone which, in addition to the tax advantages, provides integrated professional services and simplified customs procedures. *Above*: the corridor and display room. *Below*: the impressive lobby.

to establish China as a major art center in which dealers and collectors may hold their art freely.[110] Sotheby's auction house has developed a partnership with the Gehua group and is slated to begin holding auctions in the freeport in 2014 (and had planned to team up with TEFAF to hold its first Asian edition of its fair in the freeport that same year). With the aforementioned tax burden eliminated, China aims to encourage collectors to keep their art within Beijing. Collectors should keep in mind, however, that when the time comes to remove an artwork from a freeport, the import tax and customs due will be based on the work's value at the time of importation—which may be significantly higher than when the art was initially parked in the freeport.

These developments are, incidentally, of particular interest to art insurers who typically offer "worldwide" coverage, insuring artworks regardless of their location. With warehouses, bonded or not, being tight-lipped about their contents, insurers have concerns about being able to determine the extent of their aggregate risk in any given freeport. The sudden proliferation of freeports, coupled with natural and other catastrophes seemingly on the rise, may mean that the time may come when insurers might find that this unknown risk is just too great and thus refuse to insure any unidentified works in a freeport.

Self-Transport and Handling of Artworks

Owning art usually involves handling your own artworks in some capacity. If, like the collectors Herb and Dorothy Vogel who only bought works small enough to take home in a taxi cab (as mentioned in Chapter 1), collectors are transporting their artworks in a similar fashion, the work should be held securely on one's lap. If a framed work cannot be safely held in this manner, it should be laid down flat, face-up, and braced on the sides in the back of a vehicle such that it cannot move.

One cardinal rule to remember when handling artworks is never to touch the surface of a painting, photograph, or work on paper with bare hands. As will be discussed in greater detail in the following chapter, collectors should always wear white conservation gloves when handling art so that the natural skin oils do not permanently mark the surface (an adulteration which manifests at a later date). Two hands should always be used when carrying a framed artwork, and an unframed painting should be picked up by the stretcher, avoiding contact with the surface. All artworks should be carried as low to the ground as safely possible. Finally, pictures should never be leaned against corners of furnishings of doorways because of the risk of pressure dents.[111]

Art-Shipping Case Study: Gustav Klimt's *Portrait of Adele Bloch-Bauer I* (1907)

What is the best way to transport a $135-million painting across the United States? When Gustav Klimt's 1907 portrait of the Viennese society figure Adele Bloch-Bauer was restituted and subsequently sold to Ronald Lauder in 2006 for a record price (see color plate section), the work had to be transported from Los Angeles to its new home at the Neue Galerie on East 86th Street in New York City. The only airplane with the capacity to transport the sizable crated painting would not take on the insurance risk, so a truck was specially outfitted with air-suspension such that a full cup of water would not lose a drop on a test drive through Los Angeles. Once this seemingly impossible standard was achieved, guaranteeing that no bumps on the roadway would cause vibration to the painting, four tractor trailers—three of them decoys—made the 3,000-mile (4,800-kilometer) journey cross country, accompanied by armed security escorts. For the first time ever, the whole of 5th Avenue was closed to traffic once the fleet arrived in New York, allowing for the safe delivery of this magnificent work of art. All in all, about 60 people were involved in the transport of this one single painting.[112] Shipping this "Mona Lisa" of the Neue Galerie[113] was truly an exceptional feat, serving to underscore the thought, creativity, and expense that transporting a highly valued work of art can entail.

STORAGE

The art-storage business is closely related to the art-shipping business, and certain logistics companies—such as Atelier 4 in New York, Miami and Los Angeles and Momart in London—offer storage services in addition to their primary transport services. Other businesses such as Cirkers in New York and Museo Vault in Miami are primarily art-storage facilities, but also offer local transport, art handling, and installation which collectors rely on when moving artworks between storage and the home. The logistics company André Chenue SA in Paris, once the royal packer for Marie Antoinette, is said to have the largest dedicated art-storage facility with over 560,000 square feet (52,000 square meters).[114] And it was in the storied Day & Meyer Warehouse in New York that the art dealers Joseph Duveen and Georges Wildenstein deposited the paintings that would be sold to J. P. Morgan, Henry Clay Frick, Andrew Mellon, and John D. Rockefeller, among others, that would become the foundations for America's most important collections.

Warehouses typically offer a choice of temperature-controlled storage or, for a greater fee, fully climate-controlled space with proper

relative humidity levels which may be essential for delicate furniture or certain paintings and materials. Specialized storage companies may also offer exclusive storage rooms which provide the collector with greater security. Most storage and some shipping facilities also have viewing rooms which can be rented by the hour or the day, usually with a two-hour minimum. Such spaces offer comfort and privacy with the benefit of having art handlers on the premises. Collectors use them to inspect their works or to invite other professionals (appraisers, conservators, photographers, dealers, etc.) or potential purchasers to view art where discretion and convenience are needed.

Typically, a collector will provide an inventory list to the warehouse. Storage fees are usually charged on a month-to-month basis and are based on volume and conditions. Monthly invoices will include additional work orders such as packing and transportation of works to and from the residence or viewing room. Most collection management systems can produce labels that include thumbnail images for easy identification. Some warehouses have systems that enable collectors to see their inventory online and request services as needed.

Choosing a Storage Facility

Collectors should choose their storage facility with care, walking through any potential warehouse space and investigating the following issues:

- What kind of security does the warehouse have? Is it properly alarmed and monitored 24/7? Must all visitors sign in and show identification? Who has access to what areas?
- Who works at the facility and what are the hiring practices? Are there background checks?
- How are the works handled?
- Are there adequate smoke- and fire-protection systems in place? In addition to sprinkler systems triggered by smoke alarms, heat alarms are necessary, as sprinkler systems are only activated after smoke damage has occurred and can easily damage artworks.
- How are temperature and humidity controlled?
- Where is the shipping or storage facility located? Is it in a flood zone?
- What else is stored in the building and what are the neighboring buildings used for?

 This is a central question which is rarely asked. In the case of the Momart warehouse fire in London mentioned at the beginning of Chapter 4, highly flammable plastic electronics were also stored in the same building, which proved disastrous. The warehouse was also located next to a gas station.[115]

- What kind of inventory system is in place? Can the works be readily identified and located? Works of art have been known to go missing in storage when systems have not been adequate. Clear identification reduces the movement and potential damage to a work when a particular item needs to be accessed or relocated.
- How is billing managed?
- Is there an indoor loading dock? (See "Shipping," above.)
- Has the facility been constructed expressly as a storage warehouse, or is it a building that has been adapted from another use (which is not always optimal)?
- Do the staff ensure adequate privacy and confidentiality? The art business (as well as the art theft business) thrives on information— who owns what?—and this information must not be divulged to third parties.
- Is there a backup power generator?
- Where, exactly, will the works be kept within the facility? In the case of the Momart fire, unbeknownst to the owners, works were actually not stored at the main facility, but transferred to an auxiliary storage whose conditions, as noted above, were much more precarious.
- Does the storage company have a written storage contract?

"GRASP"

In an effort to implement recognized standards in art storage, the specialized art insurer AXA Fine Arts has created a Global Risk Assessment Platform (GRASP), a system for assessing warehouse and museum facilities whereby storage facilities are evaluated and best-practice recommendations are made. The initial assessment results were alarming, with only two out of 50 facilities passing the test. Sixty-five percent of storage facilities did not conduct background checks and most had no key control, meaning there was no way to determine which employees had accessed which rooms.[116] (One well-respected facility grumbled that they failed because they were under construction at the time of inspection but could not have the visit postponed.) Warehouses approved by AXA under this system are listed by state on the company's website, and this may be a helpful resource for collectors.

Warehouse Insurance

While shippers and storage facilities usually have plenty of insurance, none of this insurance actually covers the artworks. Rather, it protects the owners and operators in case of liability. As discussed in the previous chapter, art insurance covers works kept in storage, but the insurer needs to be informed of the storage location. A tension exists between art-insurance companies which have an interest in the concentration of value

in any one storage location and the warehouses themselves which have an obligation to their clients to remain discreet.[117]

Self Storage

It is not surprising that many collectors store works of art in their homes: in closets, in extra rooms, or even under beds. Some collectors have storage systems built into their homes, whether those are racks installed in climate-controlled spaces or simple archival flat boxes. Any home-storage space should be located away from water pipes or heating, lighting, and electrical systems. Temperature and humidity fluctuations should be minimal, and works should be stored away from exterior walls and windows or any exposure to direct sunlight. Art should never be stored in hot attics or damp cellars where it is not only exposed to unfavorable climate conditions, but also to all sorts of vermin.

For security reasons, collectors should avoid storing all their works of art in one place, whether it is a single residence or a single storage facility. One New York collector splits her stored artworks in the city between two facilities, one on the Upper East Side and one on the Upper West Side of town. Other collectors have multiple storage facilities in different cities or different countries.

Accidents Happen

Every art shipper and installer, including the most reputable, has horror stories of accidents where artworks have been damaged or destroyed in the process of movement or installation. Accidents do happen. If an accident occurs, the following procedures should be followed:

- Don't panic.
- If a large work should begin to fall, it is usually better to let it go as the act of trying to save it usually does greater damage.
- Collect any loose fragments into Baggies or something similar.
- Take comprehensive photos immediately.
- Place the damaged artwork in a safe spot out of the way until it can be assessed by a conservator or insurance adjuster.
- Contact the appropriate professionals without delay.

FRAMING

As art historian Fred Leeman, former chief curator of the Van Gogh Museum in Amsterdam, observes:

> Framing a picture is an act of appropriation. Framing an acquisition offers the opportunity to the private owner to embrace his conquest, to domesticate it, to adapt it to his own ambience, and finally to subject it to his own taste.[118]

Framing is an aesthetic choice, one that asserts ownership and personal style. For some art such as works on paper, framing is first and foremost for protection, the glazing (or protective glass) offering a shield from environmental forces. Art is also framed to enhance the work's value. Recognizing the impact of framing, auction houses and dealers often go to great lengths and considerable expense to dress up works with new custom frames in order to boost market appeal, in due course offering to sell the frames to the purchaser along with the picture.[119] In any case, framing (or reframing) a work of art is not a process to be taken lightly. There are visual and conservation aspects to consider—both of which, if ill-considered, can compromise the integrity of an artwork.

A frame often tells us less about the picture than about the person who chose it, whether that be the artist, a curator, a dealer, or a collector. Artists are often very deliberate about choosing or producing frames for their works. Francis Bacon (1909–92) insisted on gold frames with glazing. Edgar Degas (1834–1917) had a predilection for green frames, and included frame profiles in his diaries and notebooks. In his mind, the frame was "the reward for the artist."[120] Picasso enhanced his modern works in early Italian and Spanish frames. Henri Matisse (1869–1954), too, used 17th-century Italian frames, but whether it was because he deemed them to be the perfect complement for his paintings or whether they were simply fortuitous flea-market finds is not exactly known.[121] Vincent van Gogh (1853–90) was particular about his frames and preferred simple frames, painted in black, white or colors which complemented the dominant colors in his pictures. Dealers such as Durand-Ruel—famed for his association with the Impressionists—however, favored the "civilizing influence" of ornate carved and gilded frames in the Louis XIV style as they were more closely aligned with the conventions of the Paris Salon (the official and highly influential annual art exhibition of the Académie des Beaux-Arts in the 18th and 19th centuries) and thus reassuring for buyers of more radical works.[122]

An original frame, especially one chosen or designed by the artist, is often considered integral to the artwork itself. Some artists, such as photographers Hiroshi Sugimoto or Christopher Williams, see the frame as a physical extension of their work. Early Italians like Lippo Memmi, Dutch and Flemish masters, and the American realist John Sloan (1871–1951)

signed their frames, in some cases in lieu of signing the canvas itself. Other artists use the frame as an extension of the canvas. The carved wood frame of Frida Kahlo's *Still Life* (1942), a painting that abounds with sexual and procreative references, is in the shape of a womb. In *A Few Small Nips* (1935), "blood" from the murdered woman depicted by Kahlo splatters onto the frame, extending the picture into the frame itself (see color plate section).

How to Approach Framing

Choosing a frame for a new work of art can be overwhelming, the choices seemingly endless: blond woods, metal, gilded, plain, ornate, minimal, heavy, antique, floating frames, box frames, glazed, or unglazed. A collector should aim to select a frame that fits the artwork—as opposed to a frame that fits the decor of the room. Experienced art framers are usually extremely helpful in narrowing down the hundreds of choices, and a dialogue with a good framer can be instructional and rewarding.

Collectors should seek recommendations to find a suitable art framer. While certain framers have excellent reputations and tend to be favorites in the art world, collectors should also consider turnaround time. The top art framers in major cities are in demand by museums and galleries and often under pressure to do large jobs for exhibitions and art fairs on a very tight schedule. It may be thus sometimes preferable to explore alternative operations which can focus more on individual collectors' immediate needs. Some framers will pick up artworks from the home for an added fee, which may be a safer alternative than a collector transporting the work him- or herself. For important works, professional art shippers are recommended.

A framer can also help with selecting a mat, the material that separates the art from the frame and from the glass. Such spacers can be invisible or they can make a dramatic statement. Matting, too, comes in different widths, colors, textures, and depths, and can be layered, all of which can significantly change the presentation of an artwork.

Most importantly, the frame and the mat and any other fillers should meet archival standards to preserve the integrity of the work. Acid-free materials should always be used, and UV-protective glass should be chosen for glazing. There are different levels of archival framing, including "conservation grade" and "museum grade," the latter being the most expensive. Anti-reflective glass is also available for an additional charge. While most serious collectors choose museum glass, collectors should weigh the relative expense against the value and vulnerability of the piece.

A good framer should make a notation about the glazing materials on the back of a picture frame, for example on an adhesive label with

a checked box. If not, a collector should do so and be sure that this information is included in the collection management system. Knowing what kind of protective glazing has been used (or not), for example, may determine where a particular work can be installed. Also, Plexiglas scratches easily and needs to be handled differently from glass. Over the years, it is easy to forget what specific materials were used for each framed piece in a collection and to which degree each individual work might be vulnerable to light exposure or handling. Notations help tremendously when it is time to move or store work.

Collectors seeking to have their works framed should be forewarned, however. Even if the right questions are asked, a number of framers will rattle off assurances that proper materials will be used—when that is not the case. If in doubt, a collector should ask to see samples of the materials to be used. Proper archival framing is expensive, and the price will reflect this as well. In the long run it will be better to spend $500 on an archival frame than to spend $200 on a job which will require the frame to be replaced and which could damage the artwork. One Madison Avenue framer assured his client that he provided "museum-quality" framing, but used commercial Scotch tape to adhere a commissioned portrait drawing to the back of the frame. The tape degraded the paper, and the paper had to be restored professionally and the work reframed properly. The collector, anxious to have her art framed to gift to her family and not wanting to wait in line at known art framers, had ignored the signs at hand.

When buying works on the primary market, the framing conundrum is often moot or at least simplified as the art is often sold pre-framed, the framing done at the direction, or in consultation with, the artist and usually according to archival standards (at least when work is purchased from reputable galleries). Framing may be built into the price in such cases or invoiced as an additional charge. Where the works are purchased unframed, the gallery or artist may be able to recommend a specific framer or frame type. The German husband-and-wife duo Bernd and Hilla Becher worked with the company Halbe to develop frames suitable for their iconic photograph typologies, and these frames have been further recommended by the New York gallery that represents them. Collectors should not be shy about asking for framing details and recommendations when purchasing an unframed work.

A Question of Style

Aesthetic approaches to framing often reflect the zeitgeist—and shift over time. Frame styles are steeped in cultural traditions and personal tastes, and trends in framing can be more capricious than those in collecting. The issue of how a work is to be framed can even evoke emotional reactions, outcry, and even subsequent "corrections."

Private collectors or custodians will sometimes rush to reframe a piece to fit their own style without a proper appreciation for the history and significance of the frame itself. In hindsight, such updating can be called into question or even deemed to be a mistake (not unlike certain conservation techniques, such as lining paintings—see the following chapter). Before replacing a frame, a collector should thus take steps to learn something about it, as sometimes the frame can be more valuable than the picture itself, both historically and in terms of actual market value. (Antique frames can cost tens of thousands of dollars.) The original 14th-century frame of the Metropolitan Museum of Art's Duccio panel painting (discussed in Chapter 3, "Valuation Factors") certainly adds to the work's value and extraordinary aura.

Framing for the Times

Historically, up until the Abstract Expressionists in the 1940s who did away with frames altogether, frame styles would often be changed to fit the times. As tastes changed, for example, the Spanish royal collection would be reframed every 30 years; having old frames was a signal that you could not afford to update. Much of the fabulous collection of modernist paintings in the Netherlands' Kröller-Müller Museum, which boasts 270 works by Van Gogh, are ensconced in light-wood frames with overlapping corners expressly commissioned from the noted architect H. P. Berlage (1856–1934), considered to be the father of modern architecture in the Netherlands.[123] During the 1980s, MoMA paintings and sculpture curator William Rubin infamously removed all the frames (including those of John Sloan) and replaced them with austere strip moulding in an attempt to emphasize the picture as object. In each of these cases, frames were selected to mirror the tastes or progressive aesthetic of the period.

"Historical" Framing

With respect to older works, it is only recently that connoisseurs have begun to abandon contemporary or decorative frames and consider period frames which take the artist's original preferences into account. In 2007, Yale University Art Gallery's curators made a decision to reframe Van Gogh's *The Night Café* (1888), abandoning a Louis XIV gilded frame for a new, restrained custom frame more in sync with the artist's own well-documented framing experiments, a frame that "achieves a certain harmony with the picture," and "presents it in its best light so that the work will clearly be seen and so that the frame does not call attention to itself."[124] Although many cheered this change as producing a more "authentic" result, the decision to modify the frame of this masterpiece by substituting a newer one provoked heated

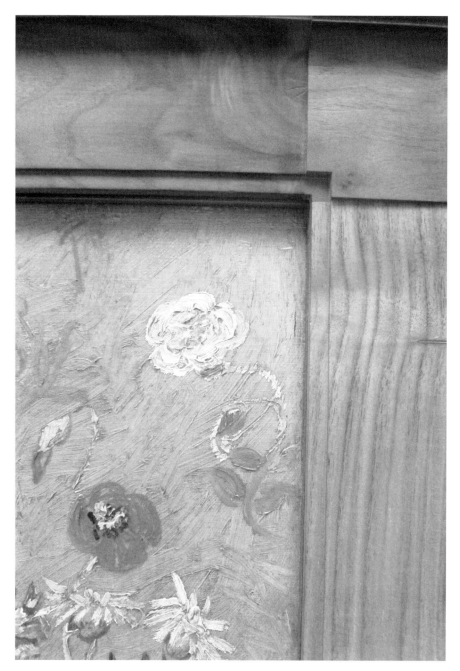

Detail, Vincent Van Gogh, *Portrait of the Postman Joseph Roulin*, 1988, oil on canvas. Much of the fabulous collection of modernist paintings in the Kröller-Müller Museum, which boasts 270 works by Van Gogh, are presented in wood frames expressly commissioned from the noted architect H.P. Berlage (1856–1934) who was considered to be the father of modern architecture in the Netherlands.

controversy among scholars.[125] The Louis XIV frame, while contrary to the artist's own preferred aesthetic, had historical value in its own right as an early frame of this iconic picture. The debate, in any case, serves to underscore the impact of framing.

Frame Collecting

The frame was once celebrated as much for its own beauty as for the work of art it surrounded.[126] Frame collecting and connoisseurship can be a passion in its own right. Eli Wilner, the noted American frame dealer, restorer, and collector, is an expert in "frame forensics" and has bought and sold more than 10,000 antique frames throughout his career. Some of his clients are collectors of frames, not art. For these collectors, the frames themselves are the art, fit to be hung on the walls with nothing inside them. They may buy paintings because they fall in love with the *frame*, putting the picture itself up for auction. Antique frames have been valued at as much as half a million dollars, and are worth learning about whether one collects them or not.

INSTALLATION

Installation and display of artworks is an art in itself, and there are both technical and aesthetic dimensions to consider. Artworks, whether newly acquired or being shipped from the warehouse or another location, should be installed upon delivery or as soon as possible thereafter. Most shipping and storage companies with local transport provide this service. Art handlers should be on hand for installation with the appropriate tools and equipment, and optimal conditions, especially lighting, should be provided.

Although it may seem evident, the first practical issue to consider when it comes to installation is whether a work of art will actually fit into a space. Can the work fit in an elevator or through a doorway? Many collectors spend a good deal of money on shipping and handling, only to be foiled once the artwork arrives. Often it is a matter of a mere centimeter that prevents a work from going up a stairwell or around a corner. It is surprisingly easy to put such technicalities out of mind when one is captivated by a "must-have" work of art.

One determined collector had his framed large-scale Mimimalist work on paper transported to his penthouse *on top* of the building's elevator cage when the artwork would not fit into the elevator itself. He was not the first collector to attempt such a dangerous feat. Large artworks are also sometimes hoisted through windows or balconies

from the outside, and this takes preparation and planning. In certain localities (New York City, for example), a licensed rigger might be required, and it usually makes sense for art handlers to carry out a site visit before the installation.

As considered more in depth in the following chapter, installation of works of art should be done in a way that protects the artworks. The best way to learn about installation is to observe how works are presented in homes, galleries, and museum exhibits. Deciding upon a layout or design of a collection can take considerable time and thought; the actual installation is relatively quick.

Guidelines

When installing a work of art, the following guidelines may be helpful:

- Art should never be placed in a position where it will be vulnerable. This includes exposure to sunlight, heating systems, humidity fluctuations, sprinkler systems, or high-traffic areas.
- Sculptures and objects should be stabilized and secured by using display cases, bases and mounts, or plinths.
- Where works might be susceptible to light, solar shades and UV filters should be employed, and delicate works should be rotated from time to time or covered when owners are away.
- When installing an entire room (or rooms) of art, the layout should be determined first. When hanging a group of works salon-style, pictures are best arranged on the floor until the desired constellation is achieved.
- Hanging paintings at various heights, e.g., lining up matting versus frames, can break the viewer's thought pattern and serve to direct attention towards the work.
- When hanging pictures, observe what is going on within the image itself. What is the direction of lines or which way do figures face?
- A measuring tape and a level should always be on hand before hanging a picture.
- The recommended height for hanging pictures is between 58 and 60 inches (147.3 to 152.4 centimeters) from the floor to the center of the work, with the center of the picture hanging at the viewer's eye level. While most installers depend on measuring, the importance of the eye should not be discounted; adjusting a work up or down by an inch or even a centimeter can have a great impact.
- It follows that centering a work on a wall with a measuring tape is not always the best approach. Furnishings and lighting within a space will also affect the overall display, so works should be placed to visually balance the whole setting. Also, before any drilling or

hammering starts, pictures should be held in place for preliminarily viewing to try out various possibilities.

Some contemporary installations can only be accomplished by the artist or studio assistant, or may come with installation instructions provided by the artist. Work known as installation art, loosely defined as "work intended to surround or immerse viewers," presents conservation and display challenges of its own (and can thus affect the desirability of these works for some, especially in a difficult market).[127]

The Miami collector Martin Margulies fell for the Brazilian artist Ernesto Neto's expansive installation *É ô Bicho!* (2001) when it debuted at the 2001 Venice Biennale as one of the most striking presentations in the Arsenale, the former shipyards and armories where a core portion of the show is held (see color plate section). The aromatic work, consisting of stalactite-like nylon sacks filled with spices such as black pepper, turmeric, and clove which are suspended from the ceiling, was disassembled and packed into several individual boxes for shipment to Miami. Thereafter, the artist was flown in to install the work in Mr. Margulies's warehouse exhibition space, assisted by a team led by the collection's longtime curator. The day-long installation, which included a scissor lift and was complicated by the fact that Mr. Margulies's space features a second-floor viewing gallery which offered a different perspective on the work, continued until 10 p.m. that night and finished the following morning.[128]

It is also worth noting that when it comes to large-scale artworks which have become popular with collectors over the last couple decades, such as an outsize photograph by Andreas Gursky, installation will require a different approach and greater precision. For example, such oversized pictures cannot be hung with a wire as they will be impossible to keep level, and a hanging cleat, designed to disperse the weight of very heavy works, may also be required.[129]

Lighting

Lighting is a vital aspect of installation and display. While lighting can make dramatic differences in showcasing works of art, it can also cause great harm. Fluorescent bulbs produce damaging ultraviolet radiation and incandescent light can cause irreversible fading. Collectors should thus take precautions when illuminating their works of art:

- Lamps should be placed at least 10 feet (3 meters) away from the art object; the lower the wattage the better (no more than 60 watts).
- Spotlighting artworks can be especially harmful, and spots should be positioned such that the light does not fall directly on the artwork, but instead reflects off an intermediate surface.

- Individual picture lighting suspended over the top of a picture should be used sparingly, with no more than 25 watts.

There are many specialist lighting companies that offer solutions for collectors. True expertise is necessary, so it is important to consult a lighting specialist.

Security

As mentioned in Chapter 1, art theft is purported to be the third largest part of international criminal activity (after drugs and arms trading), with an estimated $6 billion of art stolen annually on a global scale.[130] While there is much press about museum heists and looting, private collectors must also pay attention to the security of their artworks, particularly if they are of recognizable value and the collector is publicly known to be such. One must also keep in mind that private theft in the home is probably less often committed by burglars than by "insiders"— those who have had legitimate access to the home or facilities, such as contractors and staff. In one example, a house painter on Long Island employed by one of America's greatest collecting families systematically removed works by Picasso, Jean Dubuffet (1901–85), and Frank Stella (1936–) from the house over time in garbage bags.[131] In another instance, in Detroit, millions of dollars' worth of art was stolen from a private collector's storage facility in 2012.[132]

While insurance can make a collector whole in the case of theft, it cannot return the artwork. All collectors should thus consider a security system within their homes. In the case of works of great value, the individual works should be alarmed. A limited number of individuals should have access to the alarm system, and alarm codes should be changed as soon as any such party (collection manager, curator, staff) is no longer in the service of the collection. A home safe should be considered for jewels and smaller items.

An important issue to consider is that some artworks are becoming so valuable that private collectors must ponder whether they are actually worth keeping. In other words, is the pleasure derived from owning such works really worth the anxiety and sense of vulnerability one shoulders as the caretaker of works of extraordinary value? (Not to mention the cost of insurance and proper security.) To take an example, how could Petter Olsen, the Norwegian real-estate developer whose father was a neighbor of Edvard Munch in the village of Hvitsten, possibly afford to hang on to the version of *The Scream* which he inherited? With works by Munch already having a history of headlining thefts in that county,[133] and with a value confirmed by the $120 million fetched at auction, it seems Mr. Olsen

could hardly afford to keep this pastel—short of living in a fortress. It is one thing to acquire a work of astronomical value with an awareness of the potential risks and responsibilities; it is quite another to inherit or buy a valuable work that shoots through the roof in value over the decades. Many such collectors and owners are simply not equipped or positioned financially to take on such risk.

CONSERVATION AND COLLECTION CARE

It is estimated that only 5 percent of the world's artworks will survive the next 100 years.[134] Some will meet violent ends, as did the De Chirico smashed by a wrecking ball or the Cindy Sherman whose surface was mauled by shards of glass, but most will degrade over time as a combined result of the inherent nature of their materials and environmental stress. Many works will suffer damage and be painstakingly restored, possibly several times. The field of conservation encompasses both restoring works that have suffered harm and the preventative care of collections. As conservation measures cost money, take time, and are generally not as thrilling as acquiring art, it is another aspect of collecting on which most collectors would prefer not to dwell.

And yet, from both a scientific and historical perspective, conservation can be a fascinating subject. Collectors can learn a great deal about their works of art from conservators, including matters that affect value and authenticity. A conservator can reveal that a paintbrush bristle embedded in the impasto of a Franz Kline (1910–62) painting confirms the date of the work since the artist was known to use a particular kind of paintbrush during that one year. Or that an ostensibly pristine Ming-dynasty vase actually had a past; one collection manager discovered through a conservator that someone in the household had evidently broken the vase and had it quietly restored a few years earlier. Conservators have a wealth of specialized knowledge, and spending time with them can be one of the great pleasures of owning art.

INTRODUCTION

Terminology: Restoration v. Conservation

Before exploring this area of art collection management, it is helpful to clarify some basic terms. Restoration refers to an attempt to restore or bring back an artwork to something like its original state. Restoration

Conservation materials and tools, including paints, swabs and Eschenbach magnifiers, photographed in the studio of Modern Art Conservation, New York.

is to be distinguished from preservation, which refers to preventative work and is more often applied in the world of architecture or the built environment. Glenn Wharton, former Time-Based Media Conservator at the Museum of Modern Art and Clinical Associate Professor at New York University, suggests that conservation is a more global term which refers to an "overall, proactive approach." Wharton further notes that these connotations can shift with the culture. For example, in the UK, the term "preservation" has a slightly negative implication, conjuring freezing something in its present state or attempting not to recognize change.[135] For the purpose of this discussion, the blanket term of "conservation" will usually be most appropriate.

Different approaches to conservation which stem from opposing philosophies can also lead to bitter debate, as illustrated most recently by the divisive restoration of Leonardo da Vinci's *The Virgin and Child with Saint Anne* (*c*.1508) at the Louvre. Museum experts were pitted against outside professionals who charged that the cleaning of the 500-year-old canvas had been too aggressive, damaging the artist's extraordinarily delicate *sfumato* in order to produce a brighter, "crowd-pleasing" picture.[136] Most art lovers are familiar with a similarly heated controversy surrounding the restoration of Michelangelo's Sistine Chapel ceiling frescoes (1508–12) in the 1990s: in attempting to bring the work back

to its original state by removing the accumulations of candle smoke and grime, did the restorers ruin it by going too far? Mistakes in approaches can be serious, irreversible, and can significantly change the value of a work of art; the stakes in conservation can thus be very high.

Context: Some Conservation History

Professional conservation started primarily as a science. In the 19th century, chemists dressed in white smocks were invited to sites, most commonly to laboratories set up within museums themselves. Since then, conservation has evolved into a collaborative exercise which considers not only science but also aesthetics—and with many parties (and stakeholders) involved. Today, an important conservation decision typically involves not only conservators, but also curators, art historians, art dealers, registrars, and, in the case of contemporary works, artists themselves—in short, anyone with knowledge of the artist's process and intentions.[137] This may include the collector.

Conservation is a field that continues to evolve as new techniques and materials are developed, but also as knowledge and opinions change over time. Certain past practices of even the best-intentioned and most highly trained conservators ultimately resulted in damage to some works of art—damage which then had to be reversed, where possible, by subsequent generations of conservators. For example, during the 1950s and 1960s, it was common for conservators to coat modernist paintings with varnish to protect the paint layer. As time went on, however, those varnishes began to yellow, often dulling the vibrant palette of the original work, whether it was a Wassily Kandinsky (1866–1944) or a Georges Braque (1882–1963). Not only did the discoloration of the varnish change the paintings' appearance, but—according to today's thinking—it was not consistent with the artist's aesthetic choice *not* to varnish the work. Much of the restoration of modernist works today involves removing old varnish.

Another once-common conservation practice that has been questioned is in-painting, a term of which all collectors of paintings should be aware. In-painting describes the technique of filling in areas of paint where there has been loss, usually where paint has cracked or flaked off over time. The degree to which a conservator tries to match the original (and thereby disguise the restoration) and the use of irreversible materials have been the subject of debate. As restored paintings age, the in-painted areas can become more discernible due to the differing chemical compositions of the original paint and the new material. Not only can the in-painted areas end up looking terrible, but they fundamentally change a work of art from that created by the artist's own hand.

Likewise, the practice of lining paintings is also frowned upon today. Generally speaking, lining is the process of attaching a new layer of strengthening support under brittle, fragile or torn canvases. Believed to have been started in the 18th century and with different techniques developing over the years, lining became quite commonplace—until problems began to surface. Adhesives such as glue and wax would seep into the canvas as they were applied or compromise the painting over time. Thus a canvas that has been lined may have condition question marks, and collectors should carefully investigate this issue when purchasing older paintings.

Due to these potentially harmful practices, the conservation principle of reversibility evolved: whatever is done to an object should be able to be reversed. In other words, an object's integrity and the care of the original material are what matter most. Now, if in-painting were to be deemed necessary, the process would likely be one that is reversible. A paint medium whose composition is, under close inspection, distinguishable as well as soluble would be used. If the original painting is oil, for instance, the in-paint might be acrylic.

In the case of paint loss on a canvas by a living artist, collectors are sometimes inclined to contact the artist directly and ask if he or she could touch up the original work. Although contacting the source might seem like the obvious approach, this can sometimes prove to be a mistake. The artist is mostly likely not thinking about how the chemical compositions of his current materials may differ from that which he originally used—and the possible permanent consequences of using inconsistent matter. In other words, sometimes the conservation damage done to an artwork is caused by the artist him- or herself. Bringing a conservator into the restoration conversation at the outset is thus a good idea even if the collector has a direct and close relationship with the artist.

Around the 1960s, as conservation codes of ethics and standards of practice were developed, this principle of reversibility became more common. The standard today has moved from reversibility to what Glenn Wharton calls retreatability—that is, using minimum intervention to restore a work of art and focusing on "sustainability" or collection care to prevent future damage. Most conservators will repair a tear in a canvas because it is so far from that which the artist intended, but other decisions on how far to go are not so straightforward. Like plastic surgeons, conservators sometimes find themselves in the difficult position of having to deny a collector's demand for more extensive interventions, reluctant to do invasive work on ethical grounds. For today's reputable conservators, the integrity of the work of art—not the wishes of the collector or curator—comes first.

WHEN IS A CONSERVATOR NEEDED?

Before Acquisition

Collectors should make a point to learn about the technical history of an object before acquiring it, keeping in mind that the long-term condition of an artwork is rarely paramount in the seller's mind. As the condition and the condition history of a work directly affect value, it pays to do one's homework before the work is purchased. For major works, a conservator should be consulted. Sometimes, an hourly fee will be charged for examining a work at a dealer's or auction house, and other times the conservator may offer an opinion gratis for clients.

Before buying a work of art, unless it is coming directly from an artist's studio or the primary market, it is essential to ask for a condition report. This is especially important when one considers that dealers and auction houses often spend a considerable amount of time and money to get a work "ready" for sale. Any conservation work should be documented in the report which collectors can obtain from dealers or auction-house sale specialists. Today, auction houses even offer basic condition reports in their online catalogues.

Nonetheless, a collector may need to dig deeper than the standard condition report. While dealers and auction-house specialists often have a lot of knowledge about a work's condition and the best of them will share all that they know, they are still interested parties with one driving objective: to sell the work. The issue of why the work was restored in the first place may be worth investigating. Was it just cleaned due to age? Or are there other endemic issues in the work that are likely to recur again? What do the cracks or partial discoloration in the surface mean? Will it even be possible to maintain a quarter-million-dollar work of art made up of donuts?[138]

A collector should never assume anything about a work's condition. An eager collector may believe that a work can always be restored, especially if there is a body of similar work by the artist in a "normal" state, but that may not be the case. There can be aberrations in the work of even established artists with well-known techniques. Artists often experiment and sometimes they (or their studio assistants) make mistakes which can render one work in a series or from a particular period unlike all the rest. For example, a painting by a hot contemporary artist with an incredibly strong market had a couple long cracks in the surface which seemed odd for a painting created only a decade earlier. When a conservator was called in to address this, he discovered that there had actually been a number of earlier cracks in the painting which had been in-painted by another conservator. The repeated restoration in this relatively young work's history suggested that the artist had perhaps mixed varnish into

the paint—and, more importantly for the collector, that the issue might be a chronic one.

One thing a collector should never do—tempting as it may be—is ask the conservator's opinion on whether or not to actually *buy* the work. Collectors sometimes need to remind themselves that a conservator can only comment on the condition of a work and should not be asked to advise on the purchase.

When a Work is Damaged

The obvious time to contact a conservator is when a work is damaged. In case of damage, the first thing a collector should do is document it—i.e., take a photograph immediately. (See Chapter 5, "Accidents Happen.") Unless saving the artwork depends on it (as in the case of disasters—see below), work should not be moved. Once a work of art is compromised, it is vulnerable to even further damage if handled.

The next step is to contact the conservator. The conservator will be the best person to dictate if and how the artwork should be transported to the studio for restoration. Where applicable, the insurer should also be contacted. The corollary is that a conservator should also be on hand *before* an artwork is damaged. That is, whenever an important work is being loaned for an exhibition or transferred to another residence, the collector should have a conservator present to supervise the packing and crating of the work.

The Artist's Say

In the case of work by a living artist, a collector might have to consider whether or not an artist wishes for the damaged work to be restored. As mentioned in Chapter 1, in Europe and in states like California and New York, artists retain *droit moral*, or moral rights—that is, a legal right in the integrity of their artwork, which includes the right to disavow a work of art that has been altered in some way.[139]

This means that even if the collector has the work completely restored, it may have little legitimate value if the artist does not approve. In one case, a floor sculpture by a renowned artist was consigned for $1 million to a gallery by a prominent collector. When the crate was opened at the gallery, the dealer was shocked to see that the sculpture, made of lead, was squished. When the artist's studio was contacted about how best to restore the piece, the irate artist renounced the work. Fortunately, the collector had art insurance which covered the damage, although the $1-million consignment value was the subject of some debate and it is not clear how much the collector was ultimately able to recover.

It should be noted that usually if an artist disavows a work, he or she will insist that it be destroyed. Sometimes, however, an unsavory party will try to sell a restored work that had been disowned by an artist to an unwitting party. This is yet another reason why due diligence on the part of the collector is so important.

Cleaning/Age Deterioration

One of the most common conservation techniques is cleaning. Over time, certain works of art begin to appear dull, if not dirty. A mid-19th-century Barbizon School landscape loses its luster. A painting by Piet Mondrian has yellowed. A Gerhard Richter picture has layers of dust. As dealers and auction houses know, a good cleaning can make a world of difference with respect to how an artwork appears and, accordingly, the perception of its value. Sometimes a cleaning entails removing old varnish and sometimes it means removing dirt from the surface with special swabs and solutions such as acetone, mineral spirits, or aqueous solutions. It is possible, however, for cleaning solvents to cause damage, removing the top surface of paint. Over-cleaning a painting can thus be worse than a tear. While the latter can be repaired, a lost top surface—like that on Michelangelo's Sistine Chapel ceiling or the Da Vinci painting mentioned above—is gone forever.

Specialists therefore often seek alternative means to address this concern which can require a good deal of investigation and experimentation. Conservators at Modern Art Conservation in New York describe themselves as "detectives," relying on unconventional cleaning methods and even partnering with unusual collaborators, including the United States' National Aeronautics and Space Administration (NASA), to find restoration solutions.[140] While studying atomic oxygen damage to spacecraft, NASA discovered that layers of soot or other organic material could be removed from a surface without causing damage to paint pigments (since atomic oxygen will not react with oxides), inadvertently devising a sophisticated approach to cleaning paintings. Although not your everyday cleaning method, this conservation approach has been used to successfully and safely remove everything from serious soot on an Old Master painting to lipstick on a Warhol.[141]

Conservation is perhaps most common when a work of art simply starts to come apart or break down due to age. Paint will chip, glue and canvas will deteriorate, and installation parts will simply wear out or stop functioning.

With respect to works on paper, one telltale sign of age is foxing— spots of discoloration on the paper or mat. These brownish marks can be fairly easily removed by a paper conservator. Foxing should also be an

alert for the collector to check the mat ("mount" in British English), the paper-based border material framing the work within the frame, which is often the culprit. Before acid-free (pH-balanced) materials were invented, mats of wood-based papers were used. These would decay over time, "infecting" the work on paper. Old matting should thus be replaced with acid-free materials.

Another issue to be considered is whether replacement materials are even available. French Art Deco masters like Jacques-Émile Ruhlmann (1879–1933) and Jean Dunand (1877–1942) made furniture of exotic woods such as ebony and burl; these were often embellished with ivory and shagreen, the greenish-beige shark or stingray skin—all once-abundant materials that were sourced from now-endangered species. Similarly difficult to replace are the fragile bird feathers found on some Native American Kachina dolls. Some originate from species that are extinct, and the Migratory Bird Treaty Act of 1918 and US Endangered Species Act of 1973 banned possession or sales of such materials. So when a child decided to remove a Hopi Kachina from its mount while the adults were occupied elsewhere, the feathers that were destroyed during play could not be replaced. While conservators are resourceful in finding substitutes, this work of art will never be quite the same.

General Collection Maintenance

With today's conservation emphasis on sustainability, focus has shifted to the prophylactic care of a collection. Specifically, are the light, temperature, and relative humidity levels appropriate and stable? Hands-on collection care demands yet another way of looking at and thinking about art, and can actually deepen the connection a collector feels with the artworks over time.

In the case of large and particularly valuable collections, it is generally advisable to have a conservator come in to carry out a conservation survey of the works in the collection, making recommendations about which works might need intervention or would benefit from cleaning. Any collection of significant size should also have a conservation plan: instructions about the general care of the collection, timetables for specialized maintenance, and instructions for proper care and display, especially for fragile or sensitive works. Conservation surveys (usually in the form of a written report), conservation plans, and maintenance work will usually be based on an hourly fee. Rates for private conservators vary, but many charge around $150 per hour.

A comprehensive conservation plan might recommend that objects such as sculpture, antiquities, pottery, baskets, installations, and textiles receive an annual cleaning from respective experts, all

of whom have arsenals of specialized tools such as mini-vacuums and particular solvents that they may bring on site. It may also advise on how to protect sensitive works of art such as photography and works on paper; how best to secure fragile works to pedestals or display shelves (museum wax is often recommended); and when and how to wind rare clocks. For large collections, daily walk-throughs by someone with a trained eye and knowledge of the collection to check condition are recommended.

A conservator may also alert collectors to new developments such as anoxic or oxygen-free storage,[142] make installation recommendations (e.g., avoid hanging directly above fireplaces or in the path of heat and ventilation systems), and give directions on pest management (silverfish consume paper and moth larvae eat through textiles). Any time the physical conditions of the collection change, the conservator should be informed.

COLLECTION CARE CHALLENGES

Light and Heat

While conservators can be incredibly inventive and resourceful, no one knows how to reverse the damage when a drawing or a photograph fades. Prolonged exposure to ultraviolet light can easily cause permanent damage to works of fine and decorative art—yet it is surprising how many art owners choose to install items from their collection near windows. One collector hung a small black-and-white Man Ray (1890–1976) photograph in her bedroom, conscientiously positioning it so that it would never be exposed to the direct sunlight from her large windows which she enjoyed keeping open. Nonetheless, after 10 years, she one day noticed that parts of the photograph had turned color, taking on a distorted reddish hue most likely caused from indirect exposure. The photograph was moved to a dark corner of the room to decelerate the deterioration, but it would never be the same. Light sources also generate heat, and heat accelerates the deterioration of materials such as paper which is made up of cellulose fibers. Heat exposure can cause gradual deterioration which may only be noticed once it is too late.

One British collector of architectural drawings became so obsessed with preserving his works that he eventually closed off all the windows in his home, to the bewilderment of visitors. But less extreme measures can be taken. UV filters can be installed in windows and as sleeves over fluorescent lighting,[143] and framed works can be glazed with UV-filtering acrylic. Blinds should be drawn when rooms are not in use, and works

should be covered with cloth when the home will not be inhabited for a long period. Rotation schedules, allowing certain delicate works to "rest" in storage, may also be advised.

Temperature and Relative Humidity

As any insurance underwriter will attest, water is another major culprit when it comes to harming artworks. While burst pipes and flooding are always an obvious danger, but humidity in the air, although less perceptible, can also threaten a collection. When relative humidity (RH)—the ratio of moisture to temperature—is high, organic materials absorb moisture and physically expand. As fluctuations in RH and temperature due to climate or air conditioning can seriously stress an art object through its expansion and contraction, collectors should seek to establish stable environmental conditions for their collections.

Fine furniture can be especially vulnerable to poor temperature and humidity conditions, resulting in cracking woods and peeling veneers. Generally speaking, temperatures should be maintained at 68 to 72 degrees Fahrenheit (20 to 21 degrees Celsius) and relative humidity at 45 to 50 percent. Hygrothermographs and data loggers measure temperature and relative humidity for individual rooms and are usually installed as unobtrusively as possible where delicate or high-value artworks are placed. Regular readings monitor fluctuations. Since there is often a clear correlation between abnormal fluctuations and damage—peeling shagreen is a good example—once this correlation manifests, the cost and trouble of employing these systems seem less burdensome.

Some collectors go to great lengths and great expense to create HVAC (heating, ventilation, and air conditioning) and lighting systems in order to provide an optimal setting for their precious artworks, and a conservator can be helpful in making recommendations for such systems. In older residences, ideal conditions are often not so easy to achieve and maintain. The most important thing for collectors to keep in mind is to modulate changes and to avoid extremes such as turning air conditioners on and off.

The question arises, though, as to how far a collector should go in maintaining an ideal environment. Some collectors will seek museum conditions for their home, preserving year-round optimal conditions for their artworks even when their residences may be unoccupied for several months a year. But others are more focused on the costs of such maintenance, both in terms of expenses and the price to the environment. With their environmental footprints in mind, many collectors are now adjusting their HVAC standards in order to strike a balance between preserving their art and conserving energy.

People

Collectors should be aware that human contact is one of the greatest threats to their artwork. Not only is there physical risk when handling artworks, but chemical harm can be wrought through the natural acids and perspiration of one's own hands. Often the stains created by such oils are not visible immediately, but cause yellowing over time.

In the context of an auction preview or gallery opening, potential buyers can be seen picking up sculptures and running their fingers over the surface of a painting, often with an expert right at their side. Such practices, while perhaps useful for selling art, are not the model for preserving art. At home, all collectors should have several pairs of white cotton conservation gloves available to be used when handling artworks (with the exception of rare books and delicate unframed works on paper, where gloves can hinder dexterity, causing tears). These gloves, which are inexpensive and readily available, prevent the transfer of dirt and harmful oils to artworks, not to mention fingerprints on frames and glazing.

Since the kind of care needed for art collections is not always second nature, anyone handling artworks should be trained in the basic museum approach to collection care, particularly members of household staff who inadvertently inflict much damage on artworks as they go about their housework. First, the works of art should be clearly identified and discussed with staff. In the case of contemporary art, it is not unheard of for artwork to be damaged or even discarded by overzealous housekeepers who have little information about the objects they encounter, such as the cleaner who scrubbed off the patina of a private collector's £690,000 Martin Kippenberger (1953–97) work in 2011, causing irreversible damage.[144] Handling instructions, where applicable, should also be given. For example, vases or urns should never be picked up by handles, but rather at the base. Depending on the particular medium and condition of a piece, a conservator can also make recommendations on how various items should be handled.

Photography

Photography has become one of the most popular collecting niches, despite the challenging conservation issues the medium raises. Because of the chemical processes used in its production, photography is an especially vulnerable medium. Dyes fade and colors mutate, gelatin binders can swell or crack. In short, a photograph's very structure can rapidly deteriorate due to improper light, temperature, and humidity levels or even toxins in the atmosphere. It has been estimated that photographs constitute 40 percent of contemporary art-insurance claims.[145]

During the 1990s, artists from the Düsseldorf School including Andreas Gursky, Thomas Ruff, and Thomas Struth, started creating chromogenic-prints ("C-prints"), large-scale photographs characterized by their crystal clarity and sharp color. As the complex organic compounds in C-prints are especially unstable, however, these artists endeavored to confront the conservation issue in the production process itself by using face mounting with Diasec, which adheres the photograph to a sheet of Plexiglas. Whether this Diasec method of sealing a photograph will actually prolong the life of these works is yet to be fully determined; 20 years in, there is some evidence to suggest that it may not.[146]

Regardless, these Diasec face-mounted prints have introduced another conservation conundrum: preserving the Plexiglas itself. Acrylic is easily scratched and, when adhered to the photograph, cannot be replaced once damaged. Such scratches are readily visible on certain works in private collections and on the market. Collectors should therefore take extra precautions with these photographs, not displaying them where they are vulnerable to traffic and using extra caution and careful packing when moving.

With the validation of the photography market over the last 30 years and an Andreas Gursky photograph surpassing the $4-million mark in 2011,[147] interest in preservation has never been greater. To this end, the Centre de Recherche sur la Conservation des Collections (CRCC) in Paris, in collaboration with AXA ART Insurance, has been working on the development of an accessible dosimeter, a device used to measure the impact of light over time. This new-generation dosimeter will be able to alert collectors when a work has been overexposed and should be removed.[148]

Contemporary Art

Much has been written about the tangle of conservation challenges presented by contemporary art.[149] What happens when a $12-million shark in formaldehyde starts to decay? Damien Hirst's *The Physical Impossibility of Death in the Mind of Someone Living* (1991), an emblem of the Young British Artists era, is an illustrious example of the challenges that the conservation of contemporary art can raise. The original work featured a tiger shark caught by a fisherman in Australia in a formaldehyde solution to prevent it from decaying. This so-called "wet preparation," however, did not prevent the shark from gradually decaying. The artist eventually replaced it in 2006 with a second shark which had to be shipped from the Queensland coast in a 20-foot (6-meter) freezer, a journey that took roughly two months.[150]

Moreover, how do you preserve or restore a work of art made of elephant dung, hard candy, or VCRs? Some works, after all—such as

Félix González-Torres's candy spills, endlessly replaceable mounds of cellophane-wrapped sweets—or Janine Antoni's *Lick and Lather* (1993), chocolate and soap busts which the artist "re-sculpts" by eating or bathing herself—are *meant* to be ephemeral; that is the very point.

The pioneering Fluxus artist Nam June Paik's (1932–2006) works are commonly cited as a classic contemporary conservation dilemma since the television sets he used to create his early works are no longer manufactured and becoming more difficult to find. What are the options when one of the now-irreplaceable TV sets breaks down for good? Does replacing it with a newer model completely change the artwork? What would the artist have wanted? When it comes to time-based media, one artist may only care about how a work is presented (e.g., how projected and where). For others, the equipment itself is an essential element of the artwork and is considered an irreplaceable component of the piece.

The Artist's Intent

With respect to such difficult conservation questions, the intent of the artist is of primary importance. When a Terence Koh (1977–) piece in a private European collection started to exhibit mold, the collector contacted the artist who instructed that the mold must be considered part of the "life" of the artwork. The collector has respected this position and has taken no steps to remove the mold or mitigate further growth.

Conservators and museums have made a lot of progress in developing systems to better document the intent of the artist as well as protocols for maintenance or restoration of the work. Collectors, too, are sometimes being asked to participate in this documentation process as they may have specific knowledge about an artist's intent or process. In any case, when acquiring a work in any new medium, whether it be video or an ephemeral object like a shark in formaldehyde, the collector should ask the dealer or auction house for detailed documentation on how the work is to be installed and maintained. This includes how parts are to be replaced, where applicable. To obtain a replacement fluorescent bulb for a Dan Flavin light installation (auction records for which have topped $1.5 million),[151] the collector must present the original certificate of authenticity to the estate.

Interestingly, in the case of emerging art, dealers and artists have often not considered the issue of long-term maintenance—and this can sometimes be an opportunity for the collector to build replacement terms into a purchase agreement. When asked what would happen if one of the miniature LED bulbs in Julian Opie's 2009 *Walk*, a computer–animated edition, were to burn out, one dealer did not have a quick answer, but eventually offered a one-year replacement guarantee. But what happens to the work after a year, or further into the future if for some reason the

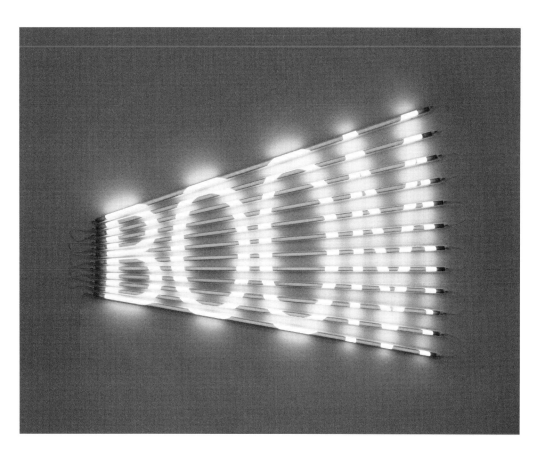

bulbs are no longer manufactured? The media artist James Clar's dealer candidly admitted that she did not know what would happen if one of the specially designed fluorescent bulbs in his work *BOOM* (2011) burned out, but helpfully offered to broker a replacement agreement between the artist and the collector.[152]

DISASTER PREVENTION AND RECOVERY

Emergency Contingency Plans

As 9/11 and Hurricane Sandy have highlighted, disaster-prevention and recovery strategies are an essential component of art collection management. All collectors should develop an emergency contingency plan to protect their works in the event of disaster.

The first step is to prioritize, to draw up a list of the most important artworks to be rescued in the event of an emergency and assign a

responsible party for each work. (AXA ART Insurance, for example, usually has 30 to 40 employees on the ground at an art fair like TEFAF, each of whom is assigned different artworks to protect should a disaster strike.)[153] This list should also contain emergency phone numbers which include the insurance company (with policy numbers), conservators, transport and storage contacts, and any other individuals who may be needed to provide emergency repair work or other services.

The plan should spell out the steps to be taken in case of different types of emergencies. These steps will vary according to the specific threat. In the wake of 9/11, many New York collectors considered how to prepare for another terrorist attack on New York. Clearly, this kind of preparation would require different procedures than a pending hurricane would, and there would most likely be no warning. Depending on the situation, steps might include removing artworks from the walls and moving them to protected locations within the home or to another facility, keeping in mind that power may be lost and transportation routes may be inaccessible.

Alternatives for relocating collections to safer locations at a moment's notice should be explored. Collectors located in hurricane regions often move their collections to another venue for the season. For a prepaid deposit, some storage facilities such as Museo Vault in Miami offer the option of having pre-packing materials, crates, and manpower reserved and on call. An alternative is to prepare the residence for a hurricane with proper protective shutters, storm closets, and a backup generator for the HVAC system. Specialized insurance carriers may work with collectors to create specific emergency plans, advising on everything from the size of storm closets to recommending emergency evacuation centers.

A digital copy of this plan should be included in the collection management system, and printed copies should be kept in a fireproof storage box on-site (along with a hard copy of the collection catalogue) as well as another location off-site.

Post-Disaster Recovery

If works of art are damaged in the event of disaster, immediate steps should be taken towards recovery:

- All artworks, including decorative arts, should be checked for damage.
- Damage should be photographed immediately.
- Wet or damp materials such as mats, porous frames, and backing should be removed where possible.
- Whether damaged or not, all art should be moved to a dry, well-

ventilated space. Mold develops quickly in damp environments and should be addressed first thing.
- Professionals (conservators, insurers) should be contacted.
- "Destroyed" artwork should not be thrown out without consulting a conservator.

Excellent resources for emergency care are available from a number of sources. In the wake of Hurricane Sandy, the website of New York's Museum of Modern Art provided emergency guidelines for "art disasters," while the American Institute for Conservation of Historic and Artistic Works (AIC) provided a 24-hour hotline to answer questions about salvaging works, offering advice such as freezing works on paper to prevent mold until restoration is possible.[154] While abundantly helpful, such assistance presumes that Internet and phone services will be available in the aftermath of emergencies, and this is often not the case. It thus behooves collectors to look into these resources before disaster strikes, and to keep hard copies of such materials together with, or incorporated into, their emergency contingency plans.

THE CONSERVATION PROCESS

Finding a Conservator

There are many types of conservators: paper conservators, object conservators, painting conservators, and textile conservators, to name just a few. In seeking a conservator, the collector should first consider the kind of specialist that is needed. Aside from references from a dealer or expert on the artist's work or other trusted professional, the best place to start in the US is to consult the AIC's website, which lists members of the professional organization in just about every niche. The Institute of Conservation (ICON) is the UK equivalent.

Larger conservation studios like Amann + Estabrook Conservation Associates in New York will often have several different specialists under one roof. Some collectors feel most comfortable having all their artworks in need of conservation located in one place, and it obviously helps with logistics, too. An advantage to working with larger studios is the professional conditions they are positioned to offer: proper and adequate climate control, inventory systems, racks for storage and security. The disadvantage, if it's an issue, may be cost.

For less important works, the collector may want to consider alternatives. Larger studios may be able to recommend junior conservators who might be better suited for a particular job. Museum conservators, such as those at the

Metropolitan Museum of Art in New York, often take on outside projects (or work directly for larger conservation studios). In one instance, the young object conservator in charge of restoring bees' nests at New York's American Museum of Natural History was recommended to restore cinder holes which burned through a box-mounted canvas damaged in an apartment fire.

Another factor to consider is movement—where is the conservator located and how will the work of art get there safely? While minor conservation work may occasionally be performed on-site, as discussed earlier in Chapter 4, moving a work of art is never something to be taken lightly and should be avoided whenever possible. If the work is valuable, reliable art handlers should be entrusted with getting the piece to the conservator. If the work is damaged, the conservator may need to be involved in the packing. In every case, the collector should take pictures of the work before it leaves the premises. In the unfortunate event that the work is further damaged while in transit or at the conservator's studio, it is crucial to have a visual record of the state of the work before it left the collector's possession.

Conservation takes time. Collectors should keep in mind that most conservation work takes months, if not years to complete, and they should plan ahead for the absence of their art. Once the work is in the studio, a location note should be made in the collection management system. It is also a good idea to check in with the conservator for an account of the work's progress from time to time.

Costs

Conservation is also costly. Collectors often have to decide whether the expense of conservation or restoration is actually worth it, whether enhanced value or enjoyment of the piece justifies the endeavor.

In one case, a California woman found a mid-size (20-by-40-inch (51-by-102-centimeter)) post-Impressionist oil painting in her deceased grandfather's attic. It was an appealing picture with a strong palette and composition and, having belonged to her grandfather, possessed some sentimental value. But the condition of the painting was deplorable. Having gathered dust and weathered extreme temperature changes for decades, not only was there a veneer of dirt and visible paint loss, but the wood stretcher was disintegrating, the original nails had rusted, and there were a number of tiny holes, probably from attic vermin, in the canvas itself.

The estimate for the restoration (conservation, plus materials, plus state sales tax), not including the frame, was $8,500. Research revealed, however, that similar paintings by the artist were on the market for approximately $70,000 at the time. The painting, as found, was probably not worth much, but the owner regarded the conservation as an

investment which also enabled her to enjoy the painting and preserve the family legacy.

Sometimes, a museum will offer to clean or restore a loaned work from a private collection to prepare it for an exhibition. This can be a boon for a collector reluctant to part with the funds for restoring the work, and can be a good bargaining chip for a museum trying to securing an otherwise difficult loan. Given the state of museum finances today, however, the collector may be asked to cover the conservation costs. Once collectors make the sometimes difficult decision to loan an important work of art, they are usually motivated to put their work's best face forward for the public and are sometimes more comfortable using their own trusted conservators. A museum (or any other borrower) should never go forward with any conservation treatments without the owner's consent in writing.

The Treatment Proposal

Treatment usually begins with a conversation between the collector and the conservator about the condition of the work and the collector's objectives.

Within a few weeks (but sometimes after a few months), the collector can expect to receive a detailed treatment proposal from the conservator. A treatment proposal will identify the work with the essential label copy (artist, title, medium, date, dimensions, and inscriptions), and offer a condition report, a detailed analysis of the current condition of the artwork. The conservator's condition report should include issues of stability (structural soundness of the work), environmental effects (e.g., mold, insects), damage (from light, decay, or inherent vice), and technical analysis and history (whether the work has been restored in the past and how that restoration has held up). It will also usually include "before" pictures. This kind of condition report will go well beyond that typically provided by an auction house or dealer.

Much of the language in this document may be unfamiliar. Terms such as "mitered," "mortise," and "tenon" along with materials like "Beva," "ethylene-vinyl acetate emulsion," and "Brij 700 surfactant" are the kind employed liberally throughout such documents. Collectors should not panic or be unnerved by this foreign vocabulary, but aim to glean the general treatment idea from the content, ideally in further discussion with the conservator.

The conservation proposal will also outline the suggested treatment, indicating whether cleaning, structural work, or filling in areas of loss are recommended. These proposals are often more generic, using language such as "will be repaired with appropriate adhesive." If more controversial

treatments such as in-painting or lining are proposed, collectors need to question whether this approach is necessary or desired, and whether the actions would be reversible.

The proposal should also include a cost estimate. If it does not, the collector should be sure to ask for one, to avoid shock later on. Moreover, the collector should ask to be notified if it looks like the conservation work will exceed the estimate by a significant amount.

Once the work is finished, the collector will receive a treatment report. This will tend to mirror the language of the proposal, using the past tense and filling in the specifics. In all cases, a professional conservator will document their work photographically and provide "before and after" images to the owner of the work. Sometimes a treatment report will include a maintenance strategy or recommendations for storage, exhibition, or travel.

Proposals and reports have traditionally been provided on paper, usually by mail. While a collector should always have a hard copy of such reports, digital copies for the CMS should be requested as well.

Liability

A proposal will usually require the collector's signature to indicate that he or she has agreed to the terms, although an email affirmation can be sufficient to constitute a legally binding agreement. Proposals usually contain a clause limiting the liability of the conservator, and some require the consignor to confirm that he or she has art insurance. Collectors thus have to ask their insurers to provide a waiver of subrogation.[155] That being said, collectors should avoid signing off on proposal agreements that relieve conservators of all negligence and due care, although in reality collectors very often cede to this language when seeking the services of in-demand professionals.

Unfortunately, in the case of bad restoration work the collector will be left with little recourse unless willful negligence can be demonstrated—often a time-consuming and costly process. In such cases, the art will usually be taken to another conservator to have the work reversed, if possible. As discussed in Chapter 4, insurance policies typically exclude damage due to poor restoration, but may cover art that is inadvertently damaged while in the conservation studio. Larger studios usually have their own insurance to cover damage incurred by flood and fire or mishaps, and collectors should inquire at the outset whether any consigned works will be covered under such a policy. In any case, a collector should always notify his or her art insurer when a work is placed with a conservator.

CONSERVATION AND COLLECTION CARE: A COLLECTOR'S OBLIGATION?

Many collectors' primary focus is to take pleasure in their works of art during their own lifetimes. It is thus not uncommon to see rare furniture installed in tropical vacation homes, delicate prints hanging in sun-filled atriums, or oil paintings mounted over active fireplaces. While some collectors may be ignorant or indifferent to the potential harm they could inflict on the artworks by this kind of exposure, most are really just more interested in the daily experience of living with their artworks than with their deterioration. Others feel that the costs of preventative measures and even the environmental impact of maintaining optimal climate-control systems are simply not worth keeping the art that they own in pristine condition. With respect to very important artworks that may be considered significant to cultural patrimony, there may be an actual obligation to protect art. In civil-law countries such as France, owners of artworks significant to cultural heritage may have an implied legal duty to maintain the integrity of the work, whereas in common-law countries like the US and UK, personal property rights trump any obligation to protect an artwork (moral rights aside). In theory, a US owner of a rare Picasso could set it on fire, if desired.

Most serious collectors of significant works of art are interested in preserving the value of the collections and maintaining them to that end. They consider themselves to be custodians of the art in their hands, taking care of these treasures for future generations. Investment value aside, the obligation to care for important works of art is really an ethical one. With more awareness and resources becoming easily available, collectors are beginning to see conservation and collection care as an inextricable aspect of owning art, and this is a most fortunate development.

PART FOUR

THE PUBLIC AND PRIVATE
WORTH OF COLLECTIONS

SHARING COLLECTIONS: DISPLAY, LOANS, AND PUBLISHING

Most collectors take great pleasure in the artworks they own. It is not uncommon to hear collectors speak of the joy experienced when looking at their art, about how their art moves and inspires them or makes their lives richer. The collector and winery owner Donald L. Bryant, Jr., who has both sold and purchased art for record prices, becomes emotional when speaking of his collection. Bryant dedicates time to reflecting on his art, describing his abstract paintings which include works by Jasper Johns, Jackson Pollock, and Willem de Kooning as a "playground for the mind."[156]

It is not surprising, then, that collectors like Bryant derive further pleasure from being able to share their art with the public, whether by inviting others into the domestic space or creating a dedicated public home for their collections; loaning their artworks to public or private institutions for exhibition; or making their art available for scholarly use and publication. Private corporate collections are also motivated to share the art they own. Deutsche Bank, which owns one of the most significant and active collections in the world, regularly loans works to museums, making their art accessible to the public.

Sharing collections is also about relationship building—with institutions, curators, other collectors, and the public. It is about expanding one's experience with the art one owns and possibly accruing future benefit. This chapter will speak to the collector's interest in sharing works of art with others and present issues to consider that may be raised by such gestures.

DISPLAY

Private Display

One of the true pleasures of owning art is deciding how it will be displayed. Sometimes, a work of art is acquired with a specific site in mind; other times, the decision about where an artwork will be placed is finalized after the fact. Many collections are fixed; their owners remain satisfied

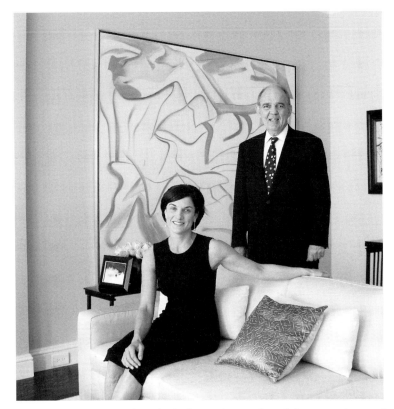

In the background, Willem de Kooning, *Untitled XXII*, 1983, oil on canvas. The collector Donald L. Bryant, Jr., and his wife Bettina in their New York home which has been likened to a personal museum. The Bryants, who consult with curators and scholars when installing their artworks, consider such exchanges to be vital to their lives as collectors.

with a permanent display which they enjoy unaltered for years. Some of these private collections can even resemble museums, the living spaces dedicated primarily to the display of fine art. Other collections are more elastic; the works on view are changed on a regular basis in order to add new acquisitions, refresh the presentation, or rotate works from storage.

At times, a more random approach to installation is favored; collectors put new works on view as they are acquired wherever there may be space, allowing any sort of connection or dialogue to manifest organically over time. Other collectors will strive to display their art in a curatorial fashion, using historical, intellectual, or compositional connections among the works to foster a dialogue within the collection. The great patron and collector Dominique de Menil was devoted to the contemplative presentation of works of art and was considered herself to be a skilled curator, with the art historian Rosamond Bernier remarking that de Menil "had a magical ability to intuitively understand what would happen when a particular work was placed in a particular position or given a particular neighbor; her unexpected juxtapositions made you stop and look again."[157]

In some cases, museum curators or the artists themselves may be called in to help a collector determine the most meaningful installation of certain works. Donald Bryant, Jr. changes the installations in his Manhattan

duplex periodically, whether to accommodate new acquisitions, or simply out of the desire to rediscover works that have not been on display for a while. With each new installation of his collection, Bryant calls on curators from the Museum of Modern Art or the Metropolitan Museum of Art or respected independent scholars for counsel. These exchanges are a vital aspect of his life as a collector, and the presentations of the artworks in his home—which has been likened to a private museum—are central to the many lively soirées he and his wife Bettina host for fellow collectors, dealers, artists, and curators.

Collectors also build specially designed spaces for display purposes. When a European collector's home could no longer hold more art than he wanted to display, he had a designated two-storey museum-quality building constructed on his property. The state-of-the-art facility includes a system of eight sliding exhibition walls, each filled with works of art. With a touch of an iPad, walls can be put on view or recessed, enabling the collector to change the works on display in the course of minutes even from remote locations.

Public and Semi-Public Display

However many collectors prefer to enjoy their artworks in private, more and more collectors are choosing to share their collections on another level, opening their homes to the public or creating dedicated spaces to display their works to a wider audience. The foundations of many of the world's most treasured art museums—including the Frick Collection in New York, the Isabella Stewart Gardner Museum in Boston, Massachusetts, and the Kröller-Müller Museum in Otterlo, Netherlands—were built on the private collections of a single owner. Today, a proliferation of "private collector museums" has emerged, most notably in parts of the developing world where powerful collectors are employing their art to garner acceptance for global contemporary art (e.g., PinchukArtCentre, Kiev, Ukraine; Colección Jumex, Mexico City) or to educate the public on non-local movements in their respective regions (e.g., Museo Soumaya, Mexico City).

And as globalization transforms the art business, new models of "public-private collections" continue to appear. The *BMW Art Guide by Independent Collectors* lists 217 private collections of contemporary art in 156 locations around the globe which are accessible to the public[158]—a striking number which reflects the changing complexion of the art world. From the shores of New Zealand to Tel Aviv, these collectors are part of an international network bound by one desire: to share the collections they have passionately put together with others. In doing so, they offer innovative perspectives and means of interacting.

In Berlin, Erika and Rolf Hoffmann converted a former sewing-machine factory in the heart of the city's developing art locus—the Mitte district—in 1997, opening their collection of contemporary art to group tours in the space where they live and work (see color plate section). This step was an innovation at the time, in spirit with the radical changes taking place during the Reunification period.[159] This private collection has since become an anchor in one of the world's most vibrant art scenes.

Ten years after the Hoffmanns opened their doors, the advertising executive Christian Boros began sharing his collection of contemporary art with the public in a nearby converted Second World War bunker, offering public tours of his collection in a mammoth structure which had formerly housed one of Berlin's most legendary techno nightclubs as the post-Wall gallery landscape was just emerging. A number of Berlin collectors have followed suit in making their collections available to the public, if not on such an idiosyncratic level.

In Miami, Don and Mera Rubell, the energetic collecting couple whose acquisitions help drive the young contemporary market, established a foundation to exhibit their collection to the public within a former Drug Enforcement Agency confiscated-goods facility. Aside from presenting exhibitions to the community, the Rubells' Contemporary Arts Foundation sponsors an internship program, an ongoing lecture series, and a museum loan program, as well as housing a public-research library. The Rubells are credited with pioneering what is known as the "Miami model," whereby local private collectors create new, independent institutions which are open to the public.[160]

Just a few blocks away, the collector Martin Z. Margulies likewise presents his collection of photography, sculpture, installations, and video art to the public in a 45,000-square-foot (4,200-square-meter) retrofitted warehouse which has set hours for the public each week and offers educational programming for the community. Visitors to the non-profit Margulies Collection at the Warehouse pay an admission fee which is donated to a local shelter for homeless women and children. The Warehouse is operated and funded by the Martin Z. Margulies Foundation, and welcomes students and visitors from around the world.

Rosa and Carlos de la Cruz had opened their private home in nearby Key Biscayne to the public for 15 years before launching their three-story exhibition and education space in the Design District in 2009. The de la Cruz Collection Contemporary Art Space is equally active, sponsoring lectures, educational workshops and a residency program. All of these neighboring collections also curate annual thematic exhibitions to coincide with Art Basel Miami Beach, and these shows have become de rigueur for fair visitors. Together, these private collections have transformed not only the neighborhood but the art community of Miami, and have upped the

ante for local museums and other institutions to expand their platforms. The impact of these private collectors, both in the region and in the art market as a whole, cannot be underestimated.

Whether in Miami, Berlin, or Basel, it is also becoming more and more common for art fairs to ask local collectors to open the doors of their private homes for fair VIPs. It is up to the individual collectors to decide if they are comfortable sharing their collections under these conditions and to what extent they would like to participate. While some elect to leave their entire art-filled homes open, offering a cocktail and a map, others will block access to more private rooms of the residence. There is no question that such privileged access enhances an art fair visitor's experience, but collectors also benefit, finding that such one-off sharing with a select public allows them to meet fellow collectors who share their specific interests or to learn about their artworks through the open interaction with guests.

For these passionate and generous individuals, sharing their collections is another level of continuing engagement with their art, an opportunity for learning and renewing the dialogue that began when they were initially attracted to the works. Rosa de la Cruz is known to spontaneously provide personal tours. Mera Rubell will instruct students how to look at an artwork, asking them what they see. Erika Hoffmann often appears from her private quarters to ask a group if they have any questions or comments on her collection. And Marty Margulies and his longtime curator, Katherine Hinds, are regularly on hand to discuss the collection's history and objectives with visitors.

Other collectors share their collections more selectively on a very private basis, accruing no measurable gain beyond goodwill and perhaps some interesting exchanges with their guests. One Dutch collector opens her family's collection to select groups, including other collectors and students, on a word-of-mouth basis. She herself conducts the tours, engaging her guests in candid and lively discussions about her collecting approach and contemporary-art developments in general.

While personal and altruistic motives are usually at the heart of sharing collections, there are other benefits to be gained as well. There is no doubt that sharing a collection with the public bestows social and cultural capital.[161] By opening collections to the public, collectors assert their individual identity through their art, raise their public profile, and create a legacy. Collectors also gain market influence through their public spaces, establishing a greater position with dealers when it comes to acquisitions and possibly even raising the value of the art itself. Prices for certain artists' works have been known to escalate after being displayed in these collectors' spaces, with "copycat" collectors buying works by the artists once they have been ratified within the walls of these respected public and semi-public venues.

There are also tax benefits to be had in sharing collections. In certain jurisdictions, if a collector can demonstrate that a collection meets the requirement for public access, it can file for tax-exempt status as long as ownership in the works is transferred to a foundation. In the case of Ronald Lauder, whose collection forms the core of New York's Neue Galerie, donating his art to a private foundation has enabled the collector to qualify for tax deductions worth tens of millions of dollars in federal income taxes over the years.[162]

Perhaps the main advantage of sharing a collection with the public to this extent, though, is the very attractive opportunity to make a contribution to society while maintaining control over one's collection.

MUSEUM AND GALLERY LOANS

To Loan or Not to Loan?

When we think of sharing art collections, we most commonly think of loaning works of art for museum or gallery exhibitions. As loans of certain artworks can be crucial to the narrative or the success of any given show, curators and dealers will thus often go to great lengths to secure a loan from a private collector, courting the collector for months with phone calls and invitations. For especially important loans, a museum director or even the artist may step up to make a personal appeal to the collector.

Some collectors will choose to get involved, perhaps sharing anecdotes or information about the loaned works which will be useful for the catalogue, or attending lenders' dinners and interfacing with others who share their interests. Those collectors who choose to loan their works to museum or gallery exhibitions receive the intangible benefit of sharing with others, but also the added financial luster their works may gain from being included in prestigious shows; the value of a work of art tends to go up with its exhibition pedigree. A history of generous engagement with a gallery or museum may also position the collector favorably when it comes to priority for new acquisitions from dealers or when making gifts to institutions. (Not all gifts and bequests are happily accepted; see Chapter 9, "Estate Planning.")

Collectors have reason to hesitate before agreeing to loan their artworks, however, and many collectors are loath to do so unless their work is absolutely crucial to a show. The primary concern is that the work of art will be damaged. As mentioned in previous chapters, movement of any sort puts art at risk. Aside from more obvious accidents, it is not uncommon for collectors to have works returned in a different state than when they left. Often the harm—such as a pinhole in a canvas, a small

chip or tear, a scraped frame, a missing historical exhibition label or slight discoloration—is not immediately apparent.

Other changes incurred during loans may be more ineffable. The wife of a famous early 20th-century German Expressionist artist used to complain that her husband's works always seemed to have lost their "aura" whenever they arrived back from exhibitions. It was as if the crowds who gathered to see the great paintings would somehow deplete their vitality. The artist's wife was adamant that the returned works needed quiet time back in the home or studio to "recover" after exhibitions.

Another factor for the collector to consider when loaning a work is the absence of the work itself. Exhibitions generally last anywhere from six to 12 weeks, but when multiple venues are involved, the art can be away for a couple years. If the work is particularly treasured or is the centerpiece of a living space, this absence can be painful. Borrowers sometimes have the authority and the means to offer the collector a substitute work of art—a work by the same artist or one of similar style and significance—for the duration of the loan. In one instance, an artist's estate offered a substitute work to a private lender, so important was the loan to the exhibition and the exhibition for the artist's legacy. In another case, in order to secure the loan of an important work of an Abstract Expressionist painting, a museum curator promised the collector a work from the museum's holdings in exchange for the loan—a promise that was vetoed by the museum's trustees after the collector agreed to loan the work on that basis. (It is always good to insist on having such conditions in writing.)

When approached about loaning an artwork, a collector should ask the following preliminary questions:

- What is the duration of the loan?
- What other works will be included and who are the other lenders?
- How many venues will there be? A collector may agree to lend a work to only one venue or to only those venues that meet his or her approval.
- What kind of security exists at each of the venues?
- Will there be adequate climate control, both during shipment and at the venue(s)?
- Will there be a published catalogue? If so, who will be the contributing writers? Will the loaned work be illustrated and, if so, how? (Color or black and white, what size plate, and where?)
- How will the work be packed and transported?
- How will the work be insured for the duration of the loan?
- Who will pay what costs?

Once a collector has agreed to a loan, certain precautions should be taken. In the case of extremely rare or valuable works, the collector may want the work to be hand-carried on an airplane by a qualified courier, usually a curator or trusted art handler.

In all cases, it is important to have the work photographed and to have its condition documented in detailed reports at every step along the way, especially when a work will be loaned to multiple venues. If damage occurs somewhere in transit, it can be otherwise impossible to determine where and how it may have transpired. (Insurers have been known to deny claims that are not promptly reported, even if the owner did not know of the damage when it happened.)[163] Ideally, all documentation should be included in the collection management system.

Documentation is especially important when a loaned artwork has been in storage for some time. In one case, a valuable painting arrived at a museum directly from a warehouse with a punctured canvas. Since the original packing crate had not been opened before the shipment, no one knew whether the damage had occurred during the loan transport—or in the warehouse years ago. While reputable art shippers routinely provide condition reports, usually for an additional fee of a few hundred dollars, it can be in the collector's best interest to have an independent curator or conservator document the condition of an artwork before and after arrival of a loan. For very important artworks, this is imperative.

The Loan Agreement

In the case of any loan, the loan agreement will be an essential document. While standard loan forms are typically used, the terms of these agreements can usually be negotiated. In addition to specifying all the details of the loan as outlined above, the agreement should stipulate that there will be no alterations to the work, including framing, cleaning, conservation, or restoration, without the written consent of the collector.

As mentioned in Chapter 4, the loan agreement usually offers "nail-to-nail" (or "wall-to-wall") insurance coverage, meaning that the artwork will be insured by the borrower from the moment it comes off of the nail or starts the movement process. While the insurance responsibility should shift to the borrowing party during the course of a loan, it is incumbent upon the collector to read the agreement carefully and ensure that the insurance coverage will be adequate. Many collectors will want their own insurance to be in effect for the duration of the loan as well, particularly if their coverage is superior. In such a case, the museum might pay a portion of the premium and request a waiver of subrogation. Sometimes museum loan agreements can even be used to expand provisions of the insurance policy.

Immunity from Seizure

Lastly, if a work is being loaned abroad, if there is even a remote possibility that an artwork may have a title issue, the collector may want to confirm that the borrowing jurisdiction has an immunity from seizure statute in place. As mentioned in Chapter 1, the US Customs Office seized Egon Schiele's *Portrait of Wally* (1912) from the Museum of Modern Art in New York in 1998 while it was on loan there from the Leopold Collection of Vienna on grounds that it was stolen property which had entered the US, demonstrating in full color how public exposure through exhibitions or publication can make an artwork vulnerable to a title claim. The effect of this well-publicized controversy was reluctance on the part of art owners to lend their works. In a number of jurisdictions worldwide, immunity-from-seizure statutes were hence developed to encourage lenders by providing protection for artworks "of cultural significance" from seizure while they are on loan to a museum in a foreign jurisdiction.[164] Thus, if the possibility of seizure is a concern, it is important to check to see if the borrowing jurisdiction has such a statute in place and, if so, to file an application for protection for the work. While borrowing institutions will usually assist with this process, sometimes the onus will be on the collector to raise the issue and have it incorporated into the loan agreement. In one case, an American collector loaned a German Expressionist work to a Munich museum for a retrospective. When the loan agreement mentioned nothing about immunity from seizure, the collector pressed the curator who then did the legwork to obtain immunity of seizure from the State of Bavaria and incorporate it into the loan.

For loans to the US, the State Department provides the following sample language for a loan contract on its website:

> (applicant/borrowing institution) agrees to seek deter-minations from the U.S. Department of State that the exhibition items are of cultural significance and that their temporary display in the United States is in the national interest, and to request that there be publication to that effect in the Federal Register prior to importation of the items.[165]

(Note: As was seen when four artworks—a Degas, a Léger, a Miró, and an Yves Klein, collectively worth over $6 million at the time—were dramatically seized by US marshals at the Gmurzynska Gallery's booth at the 2009 edition of Art Basel Miami over a financial dispute, immunity-from-seizure statutes do not apply to works consigned for sale.)[166]

UCC-1

As unlikely as it may sound, a real risk of loaning a work of art for exhibition at a commercial gallery is that the work could be sold without the lender's knowledge. (See discussions of the Salander-O'Reilly case in Chapter 4, "Bad Business Transactions.") In the US, lenders to commercial enterprises are thus urged to file a UCC-1 form, a legal document which perfects one's security interest in the work and puts the world on notice of one's ownership rights in that work. This form should be filed in the state where the loaned work is located as well as the state where the exhibitor is doing business, if they are not the same. The loan agreement should reference the UCC-1 form. Now that auction houses are engaging in selling exhibitions in addition to auction sales and thus also acting as de facto galleries, the same risk would theoretically exist for loans to auction houses.[167] (A UCC-1 should also be filed in the case of consignment for sale: see fuller discussion of UCC-1 in Chapter 9, "Consignment Agreements.")

Value During Loan Period

Finally, collectors should also pay attention to value during the course of a loan. Especially where multiple venues are involved, a work of art may be on loan for the better part of a year, during which time its value could change dramatically. In order to ensure that the work is adequately insured and protected for the length of the loan, any such changes in value should be communicated to the borrowers and/or the insurers.

PUBLISHING

Another means of sharing collections—and often a corollary to loaning—is publishing. Museum and gallery exhibitions are often accompanied by tandem publications. These catalogues usually contain an exhibition list of all the works exhibited in the show as well as images of all works, or a selection thereof. With respect to the latter, it is up to the borrower to secure all the necessary copyright permissions from the artist or artist's estate, where applicable.

Collectors can also share their works by participating in a catalogue raisonné project (as defined in Chapter 1). Typically, scholars working on such a publication will contact the individuals who, according to their research, own the works of art. While the main objective is to confirm ownership of the work as part of its provenance, a collector may also be asked to provide images of the work that meet the project's specifications. This cost is often borne by the collector, both because such projects are

not usually well endowed and because there is a tacit understanding that inclusion in the catalogue raisonné will confer value on the work of art. Collectors should try to learn as much as possible about the project before providing the requested information and materials. The project, if well run, will usually keep the collector informed of publication dates. Catalogues raisonnés generally take years to complete.

It is also becoming more common for collectors to self-publish comprehensive catalogues of their own collections, primarily to serve for their own reference and enjoyment but also as another way to document and perhaps validate their collections. One European collecting family has published several hardcover volumes on their contemporary-art collection, one for each medium: paintings, photography, decorative arts, sculpture, etc. These publications are primarily for the benefit of the family and also provide them with a means to view and enjoy their works in storage, but they are also made available to scholars who wish to study the collection.

Nelson A. Rockefeller found that his collection provided "therapeutic delight," and insisted on making his work available to others.[168] In addition to loans, museum donations, and the access provided to his collection at his Kykuit home in Westchester County, New York after his death, Rockefeller — controversially—sold reproductions of his art through the Neiman Marcus department store during the 1970s so that the work he owned could be enjoyed in the homes of others for a reasonable cost.[169]

In the digital age, there are of course other means to share a collection. For example, The Independent Collectors website, the publisher of the aforementioned *BMW Art Guide by Independent Collectors*, is an online networking platform which allows collectors of contemporary art to "upload, share, and manage" their private collections.[170] Many collectors now have their collections on their iPads or mobile devices ready to share with friends or even with a pleasant neighbor on the airplane, if the occasion arises. And of course there is nothing to stop collectors from publishing works they own on Facebook—nothing except copyright law, that is.

CAVEATS TO SHARING

Copyright Law

With so many means of publishing one's collection today, collectors must remain mindful of the fact that the copyright to an artwork does not reside in the work itself, but is a separate right which is not transferred when a work is sold unless there is a written agreement stating such. In other words, when a collector buys a work of art, he or she does not obtain the copyright in that work and therefore may not publish it—whether that be

online, in printed catalogues or greeting cards, or in film, etc.—without express permission from the copyright owner (the artist, the artist's heirs, or anyone who has acquired copyright by contract), unless the work is in the public domain.[171]

Privacy

Sharing an art collection requires balancing the desire to impart and perhaps do civic good with the need to protect the artworks and also to maintain privacy. The grease that oils the wheels of the commercial art world is information. Having a work featured in a public exhibition or included in a catalogue raisonné can be an advertisement of ownership. Auction houses and secondary-market dealers, as well as other collectors seeking specific acquisitions and curators looking for material for loans, not to mention tax authorities, are all on a quest to find out who owns what works of art. Many collectors simply do not want to be pursued by these parties who can sometimes be aggressive and relentless. Sharing collections can also make owners more vulnerable to theft.

When loaning works of art, one obvious solution is to stipulate that the lender remain anonymous, specifying terms such as as "Private Collection," or "New York Collection." Other options are to invent a name entirely for the loan purposes, or to loan under the auspices of a company set up to hold the collection.

Conflicts of Interest

As mentioned, sharing can also have a pecuniary benefit. It is generally understood that loaning a piece for exhibition to a respected museum or gallery enhances the work's pedigree and in turn boosts its value. That is why exhibition histories and labels are of significance when it comes to the work's valuation, and such considerations are a valid impetus for sharing. Collectors should use caution, however, when loaning their works to institutions with which they have other discrete financial ties. While it is certainly not uncommon for museum board members, for example, to lend works from their own personal collections to museum exhibitions (this is often one of the reasons they are asked to be on the board in the first place), ethical issues and conflicts can arise if this generosity is deemed to go overboard.

Such concerns are usually only an issue when a show is dedicated to the works of one individual collector. This was the case when the Greek collector and New Museum of Contemporary Art board member Dakis Joannou lent his collection for a show at that museum, an exhibition incidentally curated by the artist Jeff Koons, an artist whose work Joannou collects in depth.[172] Usually,

when a museum showcases work owned by living collectors, there is a firm expectation or even a clear written agreement the work will be bequeathed to that museum—or at least not subsequently sold within a certain period of time. (The New Museum, however, does not have a permanent collection.) In one situation, contemporary Chinese artworks from the Estella Collection, which was put together by investors, were exhibited at the Louisiana Museum of Modern Art in Humlebæk, Denmark—only to be auctioned in Hong Kong the following year. Irate museum officials who have an interest in retaining the public trust said they never would have organized the exhibition had they known the works would be sold.[173]

As was the case in the "Sensation: Young British Artists from the Saatchi Collection" show at New York's Brooklyn Museum in 1999—an exhibition which made a splash when it originated at London's Royal Academy two years earlier—questions can also arise when the collector-lender does not have a fiduciary duty to a particular institution, but is nonetheless an active player in the art market who also provides financial support for the exhibition featuring the work that he or she owns. The Brooklyn "Sensation" show was newsworthy not just for its controversial content—which included Chris Ofili's use of elephant dung to adorn his painting of the Virgin Mary—and for Mayor Giuliani's histrionics, but also for the presumed value enhancement such an exhibition would bring the lender, the advertising mogul and collector Charles Saatchi, who had partially funded the show.[174]

Such sensitive controversies about collector–museum ethics seemed to be much more pronounced in the United States where museums and similar institutions have long been much more reliant on private philanthropic support. Given the uproar and ethical questions raised by "Sensation," the American Association of Museums (now American Alliance of Museums) issued guidelines for borrowing art which include these "cautionary flags":

- a show devoted to one collector;
- a show in which the collector is a board member, donor, or underwriter;
- a show in which the museum gives away or pools curatorial judgment with the collector.[175]

And while the real responsibility of avoiding such conflicts lies with the museums, such issues can reflect poorly on the loaning collectors as well. Collectors with any direct financial ties to institutions should thus fully consider the scope of the loans they make to those same institutions.

Despite these potential concerns, there is much to laud when a collector shares a work of art, especially if it is something rare or

extraordinary. Works of art can be important educational tools, and exceptional artworks can provide unforgettable or even life-shaping experiences. Auction-house previews often bring in the crowds, eager to see and come into contact with certain works of art before they are "lost" again to private hands. Many magnificent, museum-worthy collections are only accessed by a privileged few for years on end, and this can have a cost to scholarship and to society at large.

ART INVESTING AND FINANCING

While the aesthetic and psychic dividends of owning art are at the heart of art collecting, the pecuniary value of a significant art collection cannot be overlooked. With art prices in certain sectors skyrocketing in the new millennium, world auction records being established at seemingly every major auction, and certain individuals clearly making a fortune selling art— all this at a time when the stock-market crash of 2008 has underscored the unreliability of traditional markets—art is suddenly, it seems, being viewed as a viable and bona fide investment vehicle in its own right.

Given the unique nature of art, it is not surprising that a tension exists between its intellectual and emotional value on the one hand, and the very concept of art as an asset on the other. Many collectors thus bristle at talk of "art investing," while some may enter the market motivated primarily by financial gain. Regardless, most who buy art would like to think their investments will at least hold their value over time.

Markets crash, banks collapse, and blue-chip companies have been known to disappear overnight, but "a good Canaletto will always be a good Canaletto."[176] It is becoming more commonly understood that art, like gold, can offer a hedge against inflation and currency fluctuations, and thus be a legitimate piece of an overall investment portfolio. While art and finance have been entwined for as long as there has been an art market, the very idea of "art as an investment" has recently seeped into the public dialogue and consciousness as never before.

From Poland to China, art funds developed specifically for investors and venture capitalists have been popping up around the globe, and a whole industry geared towards art investing has emerged. Art indices such as Mei Moses, Artprice, Art Market Research, and artnet, are modeled on stock-market performance indices and provide various market-performance analyses for the art market. New enterprises such as ArtTactic and Artvest, aimed at consumers looking to make a profit by buying into the market, create reports and offer investment advice. And, in January 2011, the first stock exchange for art, offering shares in artworks for as little €10, was created in Paris.[177] Meanwhile, *Skate's Art Investment*

Handbook, an art-world pariah rejected by art-museum bookstores when first published in 2004,[178] is now an accepted (if not universally read) publication within the art-world discourse. It is not surprising then, that panels on art investment, funds, and leveraging collections have become regular public sidebars to major art fairs from TEFAF to Miami to The Armory Show.

All of this activity had been girded by the emerging literature and related academic symposia in the field with contributions by economists, finance scholars, and art historians who have served to legitimize and endorse the concept of art as an asset in the minds of both today's art consumers and global financiers.[179] It is notable that today's art enthusiasts rely not only on the traditional art press such as *Artforum* and the *Art Newspaper* (and nowadays, various blogs) for news and reviews in the field, but also turn to *The Economist*, the *Wall Street Journal*, the *Financial Times*, and *Bloomberg* to keep informed.

So what does all this mean for the individual collector? How can art serve as an alternative investment or be leveraged as an asset to provide needed capital for seizing other investment opportunities or paying estate taxes? This chapter will look at the core activities in the realm of art investing and financing together with their caveats, while considering their relevance for the individual collector. Even if a collector has no interest in investing in art per se, or has no need or standing to leverage an art collection, given the degree to which these topics have entered our current collection age, it is useful to be informed.

INVESTING IN ART

It is undisputed that more and more collectors are entering the market with art's investment potential in mind. Some are speculators, those solely interested in turning a profit who may or may not have a sophisticated understanding of the market. Others are true, seasoned collectors and art professionals who, in addition to collecting out of passion, have the specialized experience and knowledge to seize a potentially lucrative opportunity when they recognize one. And then there are amateurs simply following the hype. Some of the greatest profits made in the history of art collecting, however, have been inadvertent, due to a combination of having the right eye, intuition, and chance.

Inadvertent Investing

Naturally, collectors who are in a position to buy the best works, whether through providence or sheer financial buying power, are very often the

ones who ultimately see the greatest returns on their art investments. Even if investment is not on their minds at the time of purchase, some collectors see unimaginable profits years down the road. One couple purchased a handful of works from Leo Castelli for a few thousand dollars when they lived in New York in the 1960s; they were simply buying work from their time by their peers for their enjoyment—and yet just one of these works, a Cy Twombly blackboard painting executed in 1967, sold at auction in 2011 in excess of $15 million. Art purchased purely for pleasure can thus become a primary asset.

There are also countless examples of wealthy individuals, able to afford blue-chip artworks with established markets from the outset, making unimaginable profits even though investing was not their main objective when they set out to acquire an artwork. To take just one example, in the span of just a few months in 2006, Hollywood mogul and über-collector David Geffen sold his Jackson Pollock classic drip painting *No.5, 1948* (1948) for $140 million—the most expensive painting ever sold at the time (besting the sum paid in October 2006 for Klimt's *Portrait of Adele Bloch-Bauer I*)—as well as two other paintings by Willem de Kooning and a seminal Jasper Johns, for a total of $421 million. While it is not known how much Mr. Geffen originally paid for any of these artworks, it is most certain that his return was breathtaking.[180]

Simply buying the best, though, may not always ensure the greatest profit margins in the long run. Being able to identify soft sectors of the market and purchasing fine examples of art in those areas may ultimately result in the best investment performance. This is where experience comes in.

Experienced Investing

Through years of collecting, looking at art, and following the market and historical or economic patterns, collectors can develop a degree of expertise which enables them to recognize investment-worthy works of art. Like secondary-market dealers (and sometimes in concert with them), collectors who know the market well and can identify emerging art with future value or undervalued secondary-market works sometimes buy art primarily for investment, with the clear intention of selling as prices appreciate, and this can be a legitimate and exciting way to realize a profit from art. One avid contemporary-art collector saw the potential in collecting Chinese contemporary art through his business dealings in that country in the early 1990s. Although this area of the market was not where his passions resided, he bought 100 works and put them directly in storage for investment, in essence creating a separate art collection solely for that purpose. It would be an understatement to say this was a canny investment.

Collective Investing (Private-Investment Initiatives)

While art funds are generally open to outside investors, private-investment initiatives are—like much of the art world itself—a purely insider affair. (That being said, some art funds are actually just friend-of-friend investment consortiums, hence room for confusion.) As long as there has been an art market, groups of dealers, collectors, and other individuals have pooled funds together to purchase art and resell at a profit. Sometimes established artists with cash to invest will also join in these deals. The co-investors may hold the work for a while before selling it to one of their clients or they may have a specific client in mind from the get-go. Profits are then split on a pro-rata basis once payments have been made.

The advantage here is that the investors tend to have special expertise in this very particular investment market and that holding costs are absorbed within the regular business. In the case of such private-investment initiatives—or Private Investment Partnerships (PIPs)[181]—tax-deferral strategies are often employed, but it is important that the proper structure is in place and all requirements are met, so tax advisors and specialist attorneys must be consulted. (See "Tax Implications: Like-Kind Exchanges," below.)

On occasion, collectors or other backers may invest in the gallery itself. The gallery uses the capital to keep the business up and running with maximum muscle, buying choice secondary-market works and producing high-quality catalogues, with the net year-end profits of the gallery business split at the agreed-upon investment rate. The dealer benefits from the investor's cash, and the investor benefits from the dealer's knowledge, contacts, and art-business skills. Some investors may be completely hands-off and only interested in the balance sheet.

Other investor-collectors may negotiate rights in the gallery's inventory as part of the investment deal, such as priority for coveted new works by particular artists represented by the gallery. Such was the case when the collector Jean-Pierre Lehmann invested $75,000 in the New York gallery The Project in 2001. The investment agreement provided that Lehmann would receive an aggregate total of $100,000 in discounts on the gallery's works, but also first choice on the works produced by the gallery's artists, including works by the of-the-moment Ethiopian-born artist Julie Mehretu. This investment was in essence the collector's way of buying access to the gallery's roster of in-demand artists.[182] (When Lehmann was, in fact, not offered first choice, he sued for breach of contract, thus publicly exposing the investment arrangement.)

Art-Investment Funds

The heated art market pre- and post the 2008 crash generated much talk and a fair amount of hyperbole about art investing and art-investment funds in particular. In 2011, Artvest calculated the global art-fund industry to be worth $1 billion.[183] In China, art funds and other art-investment vehicles such as art exchanges are believed to be fueling the art-market boon there, with banks involved in pushing the industry forward.[184] This, however, is but a tiny fraction of the comprehensive global art trade which has been estimated to be about $60 billion,[185] underscoring the fact that art funds are not for everyone—including most collectors. In fact, investing in art funds has been described as "diving into a black hole."[186]

But what exactly is an art fund? An art fund is a privately offered investment fund, usually set up on the model of private-equity funds. The idea is that a group of individuals pool a fixed amount of investment capital, typically $100,000 to $250,000, used to acquire a portfolio—in this case, made up of art—and pay expenses throughout the life of the fund. During the life of the fund, the artworks in the portfolio are often lent to museum exhibitions with the objective of enhancing the provenance and thus the value of the underlying asset while diminishing costs of storage and insurance (which is usually covered by the borrower). The art is sold after a fixed investment period—usually five to 10 years, with possible extensions of a year or two—the proceeds of which are divided among the investors. Like private-equity funds, an art fund typically has an investment manager who receives a management fee, usually in the range of 1.5 to 2 percent of the total capital and sometimes with an additional percentage of the payout at the fund's termination. And again like equity funds, art funds in the United States are usually organized as a limited partnership and are often registered offshore in places such as the British Virgin Islands to avoid capital gains taxes. The difference between an art fund and a private-equity fund is the underlying asset—and all the complications that go with it.

The investment value of art has been acknowledged for centuries, and despite all the recent attention, the art-fund concept is not a novel one. Founded in Paris in 1904, the Peau de l'Ours (skin of the bear) art club, is the first and favorite example of a successful art fund. The members acquired more than 100 works of modern art which were auctioned off 10 years later at the Hôtel Drouot, quadrupling the initial investment. The British Rail Pension Fund (BRPF) initiated in the 1970s was the first major art fund to succeed, and remains an oft-cited example in current fund discourse. Developed as a hedge against the oil crisis inflation of 1973, the BRPF turned a reported profit of 11.9 percent over the course of 25 years.[187]

Today's art-investment funds have different strategies which are usually targeted towards specific groups. Some pursue a focused regional category such as contemporary Indian art, while other funds invest in a diversified range of works which span market sectors. One fund started with the works in the private collection of its founder.[188] The Fine Art Fund (FAF), co-founded in 2001 in London by CEO Philip Hoffman and a former colleague from Christie's, is perhaps the most robust fund example, purporting to have 40 art and financial professionals on staff and representatives in London, New York, Switzerland, Athens, and Dubai.[189] Known experts in each sector suggest works for purchase, and these proposals are vetted by an advisor together with the fund's management. Its initial fund, "FAF I," was diversified in focus with purchases from five market sectors: Old Masters, Impressionists, Modern, Post-War, and Contemporary. That product closed in July 2005 with a 15 percent IRR (international rate of return—a measure of profitability of investments) on all assets held, with FAF subsequently introducing other vehicles such as the Middle Eastern Fine Art Fund and the Chinese Art Fund.[190]

With its detailed website and public face, the Fine Art Fund stands in contrast to other funds which are not advertised or little known. (The Fine Art Fund now even has a separate art-advisory business, acting in a consulting capacity to banks and private collectors.) But the goals are essentially the same: finding the value in today's art market and turning it into profit, whether the strategy is recognizing markets that have not yet matured or focusing on distressed assets and potentially undervalued works such as those that have been bought in at auction.[191]

Pros and Cons for Collectors

Pros

The obvious appeal of these funds, particularly in a bull market, is that they provide individual collectors with the ability to buy art which would otherwise be unattainable. Greater investment capital in turn can confer greater bargaining power on the acquisition front, though serious dealers generally do not favor clients purchasing primarily for speculative purposes. Moreover, some funds allow individual investors to actually take possession of the artworks and enjoy them in their own homes during the course of the investment, provided that the investor takes responsibility for all associated costs of transport, display, and care. Usually, there is a rental fee for this benefit which is applied towards the fund's operating costs. In theory, this allows investors to reap the intangible benefits of a collector for a fraction of the cost.[192] Also, as this book reiterates, maintaining an art collection can be a costly endeavor. Because the operating expenses—including the transaction and maintenance costs of the fund's collection—

are shared by all investors, the individual burden of maintaining the collection is diminished.

Cons

The most obvious disadvantage in investing in an art fund for the serious collector is that the works will eventually have to be sold. Of course the individual collector/investor can purchase a work from the fund—FAF, for example, offers its investors a right of first refusal—but that defeats the point of the investment. Generally speaking, investing in art funds is not the path for passionate collectors to acquire art for their own enjoyment. In fact, dispassion is more the rule of the art-fund game.

There are other considerable disadvantages and clear risks to investing in art funds. First and foremost is the nature of the art-fund business together with the underlying asset itself. Namely, art-investment funds are unregulated. There are no reporting requirements, and activities are not monitored by governing agencies such as the US's Securities and Exchange Commission. With the art market itself being notoriously opaque—there is no other asset class that gets transacted with so little transparency—these investments can be especially risky.

This, in part, explains why the success rate for art funds—meaning those that endure and show profitability—is said to be just one out of two. Fernwood Art Investments, launched with copious attention in 2003 and a headlining roster of art-world advisors, folded after failing to raise the suggested capital and having been plagued by conflicts of interest. Its founder Bruce Taub, a former Merrill Lynch executive, was subsequently sued by its investors and found guilty of fraud, the fund's ultimate legacy being the Harvard Business case study for how art funds go wrong.[193]

The challenges inherent in valuation present yet another pitfall. Unlike other investment vehicles, the true value of an art fund's underlying asset can be difficult, if not impossible, to ascertain. As emphasized in Chapter 3, appraisals of any given artwork are highly subjective and can vary widely. And even if several different appraisers agree on upon which a value, the art market will not necessarily deliver on this value when it comes time to sell the asset.

The fact that the art market is not a liquid market presents another risk that cannot be ignored. Unlike securities, art cannot be sold in an instant; such sales require time, knowledge, and a good deal of expert finesse. Art-fund investors thus have very little flexibility on the exit, all the more complicated by the fact that the art market is fickle, subject to incalculable cycles and tastes. While Impressionism and Modern art were the flagships of the auction business at the close of the 20th century, post-war and contemporary art now largely drive the industry. The typical five-to 10-year span of a private-equity fund may not match the performance

cycle of the artworks, especially if a crash like that of 2008 were to happen during that period.

Lastly, in contrast to traditional investments like stocks or bonds, holding art costs money. The fund—meaning the investors—will be responsible for insurance,[194] storage, transportation, and appraisal costs, as well as the fees of any experts engaged as fund advisors. In addition to the fund manager, most art funds also engage art experts—scholars, curators, art consultants—to advise on acquisition and disposition of the assets. Not only are these experts costly, but they often have conflicts of interest in that they themselves may be pursing similar works in a private or professional capacity as those desired by the fund.

Depending on the fund's terms, these expenses may have to be put in up front or they may be periodically assessed through capital calls after three or four years, which can lead to penalties if an investor happens to be short of cash and cannot meet them. Collectors should also note that, given the extraordinary costs of maintaining an art fund, the published return of the fund may not reflect the actual returns to the investors. Moreover, returns reflect returns for works *sold*—that is, works that have appreciated. They do not reflect the artworks still being held, which may not have appreciated or may even have lost in value and are typically predominant. Investors need to be mindful of such discrepancies when considering participation in an art fund.

Investing in art funds requires serious due diligence on the part of the collector. Collectors considering this type of investment should seek those funds which are fully transparent in both fee structure and approach. All fund terms are contained in the offering documents and should be scrutinized by investors before any commitment is made. The backgrounds of any experts engaged should also be investigated, probing whether they are indeed known experts who have acknowledged expertise in the particular sector.

Tax Implications: Like-Kind Exchanges

Before participating in an art fund, investors should also consider the tax implications and discuss with a qualified professional. For example, in the US, even though art funds are structured as a financial asset, the gains achieved, depending on income, are taxed at the 28-percent federal rate for collectibles, which is somewhat higher than the 15-percent rate due on other long-term investments. Section 1031 of the US tax code, however, will allow tax-deferred exchanges for disposition of artworks held exclusively in the US during the fixed life of the fund as long as certain conditions are met. That means works of art whose values have peaked or plateaued may be replaced with "like-kind" artworks without incurring capital gains tax on the sale. To qualify for such a tax deferral, the artwork

being sold must be of the same nature and character as the one being purchased, although "nature and character" are not clearly defined.[195]

In order to meet the Internal Revenue Service (IRS) requirements, the fund's exchanged artworks must be used for trade and held primarily as an investment. Since any enjoyment of the artworks could undermine their primary investment purpose, fund investors seeking this tax advantage should avoid personal possession of the artworks (one of the purported benefits of art funds): revenues from the sale of artworks under this provision must also be held in a segregated bank account for the duration of the exchange, which is not to exceed 180 days. Once a work is sold, the fund has 45 days to identify the replacement work of art.[196]

As this tax strategy was originally developed for real estate, its exact application to art remains a grey area, however. Like-kind exchanges are a tax strategy currently employed in a variety of situations with respect to their art transactions, with some collectors remaining intentionally unaware of the IRS's narrowly defined intentions. However, with volumes and visibility of the art market steadily on the rise, scrutiny and regulation are bound to increase. As such, caution is advised.

Also, a lawyer or tax advisor with expertise in Section 1031 exchanges will thus have to be engaged to structure the transaction, provide the required documentation, and navigate the technical requirements—and this will have its own costs.

The art-fund industry in its latest incarnation is still in its infancy. Continued global uncertainty and low returns on other investments have kept the door of viability open for art funds, and second- and third-generation funds such as those of the Fine Art Fund group are finding it easier to raise capital as they become more established. It bears repeating that there are still very few art funds of significance, and the long-term viability of these funds with all their risks and pitfalls, as well as any potential value for the average collector, remain to be seen.

Third-Party Auction Guarantees

For those rare collectors with extraordinarily deep pockets, acting as a third-party guarantor at auction is another way to invest in the art market, particularly since Christie's and Sotheby's largely stepped away from the practice of financing guarantees after the crash of 2008.[197] A guarantee is an agreement to pay a specified amount for a work, regardless of whether or not the work actually sells. Auction houses offer guarantees to sellers in order to entice them to consign their works for sale. The guarantee provides consignors with the security of knowing they will receive a certain acceptable amount for their artwork, and that their consigned

work will not get "burned"—that is, have the taint of publicly failing to sell, which can negatively affect value. For the collector, providing a third-party guarantee can offer the opportunity to obtain a desired artwork at a good price.

Third-party guarantors, also known as irrevocable bidders, work with auction houses, agreeing to submit a bid on a work for an undisclosed amount. If the bidding does not go beyond that price, they acquire the work. If the bidding exceeds the price, they split the profit from the sale with the consignor and the auction house. If a work sells for an amount above the guarantee, the guarantor can make significant sums of money—in some cases, millions of dollars, as was assumed to be the case when Picasso's *Nude, Green Leaves and Bust* (1932) broke the auction record at Christie's at $106.5 million, above a low estimate of $70 million, in 2010.[198] (Guarantees typically only take place where the stakes are high.) Usually, the larger the initial guarantee, the greater the proceeds to the guarantor once the minimum is met. The obvious corollary, particularly in cases where the auction estimates are too high, is that the investor can also lose money—and potentially be stuck with the "burned" artwork that was bought in at auction and will be harder to sell.

Sometimes, third-party guarantors will also be exempt from paying the buyer's premium on the work if they obtain it, a reward for taking the risk known as a "financing fee" which amounts to a discount on the purchase price—although not all auction houses are willing to give this additional advantage to the guarantor.[199]

Other times, a dealer or collector will guarantee a work not so much to make a profit but to control the value of similar works they may own. It is believed to be common practice for third-party guarantors to bid on the works they are guaranteeing to drive up the price. While the fact that someone with a financial interest in the work will be bidding is usually disclosed in the catalogue, this practice raises ethical issues and is becoming the subject of scrutiny.[200]

ART FINANCING

One of the upshots of the growing acceptance of art as an asset class is the developing practice of using fine art as collateral for loans. When liquidity dried up dramatically in the wake of the 2008 financial crisis, collectors realized that the art on their walls could be employed to access needed cash without disrupting an investment portfolio. The result is that the art-financing business has seen significant growth, with both existing and new art-financing businesses stepping in to assist collectors to collateralize their art.

Using Collections as Collateral

The practice of art financing gained traction in the boom years of the 1980s, with many lessons learned when that market collapsed in the early 1990s.[201] Today, art financing is more structured and more sophisticated, with more and more players getting into the action, from private banks to auction houses, making up what is estimated to be a $7 billion business.[202]

Art financing allows those with artworks of significant value to monetize their collections to raise needed cash. Sometimes short-term financing is sought using artworks as collateral in order to buy more art at a moment when other resources are perhaps tied up. Art loans are also structured to develop real-estate investment properties, provide business capital, and pay estate taxes without having to liquidate a collection. (As discussed in Chapter 9 ("Selling Art"), selling a collection can be a very expensive endeavor, incurring up to 30 percent transactional costs plus an additional 28 percent in federal capital gains taxes alone.) Loans also allow collectors to hang on to their artworks when the art market is down, obviating the need to sell works at the wrong time in a market cycle. One of the key benefits of such loans is that the collector can sometimes keep the artwork on his or her walls without others knowing that it has been pledged as collateral.

Loan to Value

Typically, the loan amount will be 40 to 50 percent of the appraised value of the artwork to be collateralized, with $500,000 to $1 million being the minimum value of the artwork. This ratio is known as "Loan to Value." As discussed in Chapter 3, however, appraised values are not so easy to define and can be the subject of dispute. Moreover, the loan documents do not always define the kind of value; borrowers may assume the appraised value means one kind of value (e.g., retail), but the lender may interpret "value" to mean something else (e.g. marketable cash value, which is lower).

Appraisals will be determined at the time of the loan and every year thereafter, unless the market is volatile, in which case the lender may want a six-month appraisal. In order to expedite the process, it is in the client's best interest to provide as much information and documentation as possible at the outset: bills of sale, certificates of authenticity—in short, everything in the collection management system.

Privacy

Collectors considering collateralizing their artworks should also take privacy into account. The goal of all lenders is to get a perfected security

interest that cannot be contested by others. In the US, a lender will file a UCC-1 form to create a public record of ownership (see discussion on UCC-1 forms in Chapter 7, "Museum and Gallery Loans", and Chapter 9, "Selling Art"), but this can be an issue for borrowers who do not want a public record of their financial dealings. Most lenders will also lend funds to another entity such as a limited-liability company, but the detailed collateral descriptions required (e.g., artist, medium) may in effect reveal the borrower's identity anyway.[203]

Terms

Terms of such art loans vary wildly and some can be downright treacherous. The loan terms depend on the lender type (see below) and should be scrutinized carefully to make sure there is a full understanding of all the associated fees, including those for appraisals, title insurance (which is becoming a standard mechanism to protect the lender, with the borrower bearing the cost), and prepayment or default penalties. Generally speaking, there are four types of lenders in the art-financing business. These lenders have different objectives which are reflected in the terms of the loans.

Types of Lenders

Private Banks

When we think of art financing, we tend to think of banks first and foremost. Exclusive VIP lounges at the major art fairs are often sponsored by banks such as Deutsche Bank (Frieze, Art Basel Hong Kong) and UBS (Art Basel and Art Basel Miami Beach), making evident the intersection of banking and art in private-wealth-management strategies (see color plate section). In fact, for banks such as Citibank, JPMorgan Chase, and U.S. Trust, art financing is not a core business, but rather a service provided for their high-net-worth clients. (Some banks, such as UBS, actually outsource their clients to specialized asset-based lenders such as Emigrant Bank Fine Art Finance.)[204]

Private-wealth management is a competitive business, and banks are energetic about pursuing clients, offering collection-management services, art advisory, and similar perks to art collectors in the hopes of gaining their business. As far as art-investment loans go, the terms for private bank loans are usually the most favorable, with rates between 2 and 5 percent of the interbank lending rate. Collateralized blue-chip secondary-market works, being more secure from a market perspective, will be at the lower end. The minimum loan size can be anywhere from $5 million to $10 million.

In reality, the banks are not lending solely against the work (or works) of art, but rather against the client's overall wealth portfolio. They

want to know that if the borrower were ever to default at a time when the value of the art plummets, there would be other assets to go after.[205] In the private-wealth management sector, the lending institution usually knows a client well, if not personally. Beyond credit, banks look to the character of the borrower. Is the owner of the artwork a person of integrity who will also take care of the art during the course of a loan, thus protecting its value? U.S. Trust, for example, typically structures its loans as revolving credit lines for a renewable commitment period of one to three years. It provides loans to "serious collectors," defined as those possessing a collection of at least $10 million in value or those who are building their collection or "have influence in the market."[206]

Unlike other art lenders, banks are not interested in the underlying asset—namely, the client's artworks; their primary concern is that there is cash flow to meet the payment schedule. As such, borrowers will typically have to provide a few years' worth of personal financial statements, tax returns, and asset appraisals. The credit arm of the bank will then examine the financials while the art specialist—either the bank's own art advisory (which assures privacy) or outside experts—will assess the value of the art, personally inspecting it wherever it is located. In the case of insolvency, a bank may have to sell the artwork to settle the debt, and is not required to seek the best price; but generally banks prefer not to get involved in such transactions and such defaults are rare.[207]

Depending on the relationship, the loan document itself can be anywhere from a few pages to 30–40 pages, and in some cases the funds can be provided in just a few weeks.[208] Aside from offering the most favorable rates, the greatest advantage of getting an art loan through a private bank is that most banks allow their clients to keep the work in their possession; the collector is able to hang on to his art and enjoy it fully for the entire duration of the loan. (The collector is almost always obligated, however, to seek approval from the bank before giving possession of the collateralized work to a third party, such as a museum for a loan. In such cases, a bailment agreement must be executed between the bank and the third party.) This, however, is the case only in the US, where the Uniform Commercial Code filings provide the lender with a legally recognized security interest in the work, and in part explains why New York is considered the center of the art-financing business.[209]

Specialized Niche Lenders

Specialized niche lenders—most notably Emigrant Bank Fine Art Finance, a subsidiary of Emigrant Bank—often provide the quickest art loans because these specialized loans are the stuff of their business. Whereas the larger private banks will only accept a limited pool of collateral such as paintings and sculpture, Emigrant will also lend against other collateral

in the collectibles sphere such as stringed instruments, stamps, and coins. Such specialty lenders will also make smaller loans—for example a loan in the $1-million range—and the terms of these loans are often considerably longer than those that non-specialty banks offer. While the loan terms of JPMorgan Chase or Citibank might be one to three years (which may or may not be rolled over), a bank like Emigrant might offer a 15-year term. Depending on the circumstances, rates offered by specialty lenders may be the same as or a little higher than the private banks.

Specialized niche lenders tend to get business that other banks are not willing to take on—say, in situations where a client is not committed to moving their banking relationship to the lending bank—or, in some circumstances, they may share loans with banks. As art financing is their core business, specialty lenders may be more sensitive and responsive to issues that may arise during the course of a loan, and offer a degree of flexibility that other lenders might not. And, as is the case with bank loans, the owners usually get to keep their art.

Asset-Based Lenders

If a collector does not have a relationship with one of the few banks that offer art financing, or if a collector has poor credit but a strong collection, he or she may turn to an asset-based lender to get a loan. While banks see art loans as a means to accommodate high-net-worth clients, asset-backed lenders are motivated by high returns, with their eyes directly on the pledged assets (not the credit) of the borrowers, some of whom—as was the situation in the unfortunate Annie Leibovitz case (see below)—are distressed. These specialist providers such as Art Capital Group and Art Finance Partners, both based in New York, lend directly against art at rates ranging from approximately 10 percent to an astronomical 25 percent, typically towards the higher side. The UK-based lender borro, with its full-page ads in the *Art Newspaper* and sponsorship of art-industry symposia and ArtTactic podcasts, also aggressively markets its services to collectors. Promising no credit checks and money within 24 hours, borro's lending rates are 2.5 to 5 percent a month—a percentage that works out to a staggering 30 to 60 percent annually.[210]

The downsides to asset-based loans are thus considerable. Additionally, these kinds of lenders do not allow owners to retain possession of their artworks. According to its website, Art Capital Group requires borrowers to relinquish the artworks for the loan duration, either to Art Capital Group's own storage facility or to its Madison Avenue gallery space for display.[211]

Aside from the high interest rates for such loans, there is often an upfront fee of 2 percent plus onerous penalties for not being able to meet payments. An asset-based lender can sometimes declare default within

days of a missed payment, and has the sole power to make determinations about the borrower's financial status or to decide which appraisers are to be used. Any violation of the loan agreement—such as moving property—may be deemed to be a default, and such determinations can be subjective or as arbitrary as the lender's discomfort with a change in the finances of the borrower's spouse. Borrowers must thus use extreme care in reviewing the events which constitute a default.

In the case of Annie Leibovitz, who famously leveraged the intellectual property rights in her life's work to the Art Capital Group when she was facing extreme financial difficulties, the results were disastrous. Failing to make timely payments on two separate loans totaling $15.5 million, the artist ended up paying a reported rate of 44 percent on her loan.[212] Given her high-profile persona, the workings of Art Capital Group and other asset-based lenders came under the microscope, with their activities being likened to pawn shops. This case serves as a cautionary tale for those looking to monetize their collections in this way.[213]

Auction Houses

Auction houses, too, are in the art-financing business, their practice being somewhere between those of private banks and asset-based lenders. Sotheby's Financial Services, for example, hails itself as "the world's only full-service art financing company."[214] Christie's Secured Art Lending, while operating under another business model, also arranges art financing for clients.

For auction houses, financing provides a way to boost revenues and to forge further ties with collectors, with the prospect of obtaining consignment property. The bottom line for an auction house is the potential of gaining artworks for consignments, with terms typically requiring a pledge that works be sold through the auction house for a certain period such as two years.

Clients may borrow money against the value of their collection or a part thereof, or receive a bridge advance against the future proceeds of a consigned work. This is done at favorable rates of 9 to 10 percent (though rates as low as 6 percent or below may also be extended in certain circumstances), the 40- to 50-percent Loan-to-Value advance rate being based on the low auction estimate. The terms of these loans tend to be very short, but longer-term loans may be available. If the leveraged work should fail to sell, the borrower will of course have to find the funds elsewhere, and other works in the collection sometimes serve as collateral. (The auction house is required to disclose when it has any such economic interests in a lot, usually noted in the sale catalogue.)

In all art-financing situations, collectors may not collateralize artworks that have been promised elsewhere, whether as a gift to a

museum or as collateral for another loan. While this may seem obvious, it is not unheard of for individuals with complex finances who are involved in multiple and constantly shifting transactions to lose track of some of the details. This can be especially true if they are ardent collectors who become myopic in the heated pursuit of a desired artwork.

One such collector purchased a multi million-dollar work at auction, pledging another work in her collection to the auction house in order to finance the purchase. She forgot, however, that the promised work had already been collateralized months earlier when she needed liquidity. Days after the purchase, the collector, her banker, and a financial services representative from the auction house found themselves desperately seeking a solution. Fortunately, the collector had a strong reputation and was the owner of other assets that could be substituted. But, as Annie Leibovitz more publicly learned, art financing can also turn out to be a gambit where mistakes are not so easily forgiven.

PART FIVE

PARTING FROM COLLECTIONS

DEACCESSIONING, GIFTING, AND ESTATE PLANNING

There are many reasons that compel collectors to part with an artwork—or an entire collection. Collectors' tastes and interests evolve. Sometimes a piece no longer fits into a collection, and it will be sold to fund new acquisitions. An ardent collector of contemporary art may go the TEFAF art fair in Maastricht and suddenly become passionate about Hans Holbein (c.1497–1543) and Corneille de Lyon (c.1500–75). Or two small works by an artist may be traded to fund the acquisition of a single, larger piece. Especially in cases where there has been considerable appreciation, a work may be sold to satisfy debts or raise capital. For tax, personal, and philanthropic reasons, collectors may also be spurred to gift works of art to family members or institutions as they age and priorities change. In reference to the sizable gifts he has made to museums such as New York's Museum of Modern Art and his college alma mater, the collector Donald Bryant Jr. advises, "Don't give until it hurts. Give until it feels good."[215]

In the art collection management and legal spheres, the process of parting with an artwork is known as deaccessioning.[216] Closely related to deaccessioning is estate planning, the process of planning the administration and disposition of property—in this case, artworks—according to one's wishes before or after one's death.

This chapter will consider the various motivations and means for parting with works of art, and outline basic issues to consider. As the disposition of estate property is governed by complicated tax laws and every situation is unique, collectors are urged to consult their tax advisors or estate planners when considering how to best part with their artworks. The principles and opinions offered below are further limited in that they are based on the current US system. While there are many parallels in the UK and continental Europe with respect to matters such as capital gains taxes, there are also significant differences, particularly when it comes to charitable donations of artworks.[217]

PREREQUISITES: INFORMATION, VALUATION—AND SOME PLANNING

When selling or transferring ownership of a work of art, all relevant information is needed in order to make informed decisions. The collection management system, no matter how modest or sophisticated, and all related documentation are thus crucial to the process.

As collectors must know the current value of what they are giving up, the first step in ceding a work of art is thus valuation. For all of the approaches that follow, the importance of having a current appraisal cannot be overstated. In some situations, a qualified appraisal is even required by law.

Where many works of art or an entire collection are involved, a collector should use this information to develop a deaccessioning strategy or plan. Each relevant sector of the market should be analyzed and the best possible vendor for every individual piece should be considered. It may be that one group of art is best suited for auction sale and another for sale through a dealer, with less valuable works consigned to smaller, local auction houses. For certain material, it may be best to wait and sell when the corresponding market picks up, if possible. Capital gains, selling expenses, and tax considerations must also be taken into account and may in part dictate when certain works should be sold or gifted.

In developing such strategies, a collector should be cautious not to flood the market by selling a large number of similar works by one artist at the same time. Sellers also need to avoid having the work shopped around—meaning, trying to sell a work privately through various dealers or allowing one dealer to offer it to several different parties without success. Such works, if then consigned to auction, will often fail to conjure buyer excitement.

SELLING ART

When the decision is made to sell a work of art, the key issues are how to sell the work and when. Should an artwork be sold through a gallery or a private dealer? And when is the best moment to sell (if one has a choice)? To start, a collector should look at the kind of material in which an auction house or dealer specializes. Additionally, since some works sell better in certain geographic markets, location and any related sale expenses should also be considered. In one case, a New York collector knew that the strongest market for his German Neo-Expressionist painting was Berlin, but had to weigh consigning it for auction there with the considerable costs of shipping a large-scale work from New York. Since the painting was not terribly valuable (under $20,000), it was determined to be not

worth the shipping fee and eventually sold at auction in New York (but disappointingly, it only reached its reserve).

Auction houses and dealers will only want to take works on consignment for which they believe there is a market. Not all works are easy to sell, and some works don't have much of a market to speak of at all. In such cases, the collector may want to consider donating or gifting the work to offset income taxes (see discussion below).

Selling at Auction

Some works of art should be sold at auction; others should not. An advantage of selling at auction is that the seller may have the attention of several prospective buyers at one moment, which can fuel bidding and drive prices up. The auction cycle for major sales also allows for extensive marketing campaigns including ads and exhibitions which can stoke interest in the material. Finally, the auction marketplace is relatively transparent; sellers know when their work will be sold and can even observe the sale.

The disadvantage of selling at auction is that the seller must adhere to the auction calendar, which is not always convenient. A work consigned in the summer may not hit the auction block until November. (In the case of smaller, more regional auction houses, the process of selling is usually much more expedient since the production—catalogue, marketing, exhibition, etc.—is not so elaborate.) Payment is typically made 35 days after a sale, but there have been cases where the funds have not been forthcoming and the seller has had to follow up.

Selling works at auction is also not without risk. As auctions are public forums, some collectors fear exposure. If their piece is recognized, people may wonder why they are selling (have they fallen on hard times?). If a work fails to sell, that, too, is public; the bought-in work will be considered "burned" and will be difficult to sell—at least in the immediate future—at the anticipated price. In order to re-introduce such a bought-in work back into the market, the seller will need to "rehabilitate" it: keep it off the market for some time and lend it to respectable shows where possible. This takes time.

In certain circumstances, when weighing whether or not to sell a work through an auction house, collectors should consider any agreements they may have made with the dealer from whom they originally purchased the work. It's important to note that, in the primary market, as dealers like to control the markets of the artists they represent, even if the collector did not grant an actual right of first refusal in writing, a dealer may harbor an *expectation* that a work will be later sold through the gallery. And ignoring this expectation may have consequences.

In one case, an important collector consigned a work of moderate value by a second-tier contemporary artist to Christie's. When the dealer from

whom he had purchased the work five years earlier saw the sales catalogue on the eve of the auction, he was incensed. The collector was baffled. He regularly purchased significant artworks by major artists from the dealer and it was not as if he had consigned one of *those* works. The dealer nonetheless not only insisted that the collector withdraw the work from the sale, but expected the collector to pay the 25 percent penalty on the estimate for doing so. The collector thus found himself in a terrible position: should he alienate the dealer and risk no longer having access to the works he most desired? Or should he take the loss and anger the responsible auction-house specialist who already had buyers lined up to purchase the work and with whom he also enjoyed a close relationship? Either way, the simple act of consigning this work to auction proved to be problematic for the collector.

Similarly, when members of the informal European art club mentioned in Chapter 1 ("Buying Art with Others") decided they wanted to disband their collecting consortium and liquidate the collection of contemporary art they had built jointly as friends, they hit a roadblock when various dealers from whom they had originally purchased the works objected to their sale at auction. While these collectors would not be needing the dealers for future art purchases, the prospect of ruffling feathers by following the most expedient path to achieve their goals presented a quandary they had not anticipated.

A collector who plans to sell a work at auction should obtain competing offers from different auction houses. What kind of estimate would they place on the work? What fees will be charged and how will the sale be marketed? The rollout of an auction sale is a tactical operation, and a consigning collector should ask whether comparable works will be sold at the same time (too many may undermine the work), and discuss placement within the sales catalogue. For major sales at the big auction houses, consigning early is key and offers the collector more bargaining power with respect to both logistics and strategy. If a sale is to take place in May, then the collector will want to start talking to auction specialists in January or February at the latest. Although, in a down market when consignments are slim and auction houses are desperate for material, consigning late in the sales cycle may work to a collector's advantage.

Unless the work is highly sought after by an auction house, the collector can expect to pay a seller's fee in the range of 10 percent which is usually taken off the hammer price. On top of that, there will be fees for shipping, catalogue illustration, and insurance, and possibly buy-in fees and return shipping costs if the work fails to sell. Restoration, authentication, or title insurance may also be required, and all these expenses will be borne by the seller. It is thus important for consignors to read the consignment agreement carefully in order to have a full understanding of the conditions imposed and fees charged.

The seller and the auction house will also have to agree on a reserve price—the lowest price at which the work can be sold. Typically, the auction house will want a lower reserve than the seller. In all cases, a collector should ensure that the consignment contract stipulate that any work sold will not be released to the buyer until the auction house has received payment in full; otherwise, the buyer could be left with only a legal claim. Once a work has been consigned, it is helpful to have an advocate within the auction house, an expert who can shepherd the property throughout the auction process and solicit interest before the sale.

Private Treaty Sales

To the chagrin of many dealers, auction houses have now taken on private treaty sales in addition to their public sales, essentially acting as dealers. Private treaty sales are private sales conducted by auction houses of secondary-market material whereby the seller receives a specified price. These sales offer consignors the wide client-base net of the international auction business (which also includes underbidders for similar works) while affording privacy and flexibility of timing. As an example, Ronald Lauder purchased Gustav Klimt's *Portrait of Adele Bloch-Bauer I* (1907), discussed in Chapter 5, by private treaty sale. In selling their works, collectors should consider who can make them the best offer and use their relationships of trust to guide them.

Selling Through a Dealer

Selling an artwork through a dealer (or art advisor) affords more privacy than selling at auction and allows for a work to be sold at any time. For collectors selling a cherished artwork, private sales can offer a greater degree of control over the work's fate as a work can be offered to a "suitable" buyer. However, sometimes it can take many months, even years, for a dealer to find a willing buyer at the desired price. If the work is offered to a museum, the institutional acquisition process alone could take up to a year or more. In some cases, it may be in the collector's interest to make an outright sale to a willing dealer, take the money, and be done with it.

It is more common, however, for a seller to place a work with a dealer on consignment. Most dealers who take work on consignment will offer the consignor a net price, agreeing to pay the seller a fixed amount. The rest of the proceeds—an amount typically unknown to the collector—will go to the dealer. This may be 20 to 25 percent, but it also may be 50 percent or even 100 percent of the net price promised to the consignor. While this arrangement presents less risk for the consigning collector—who is guaranteed, say, $200,000, even if the dealer can only sell the work for $210,000—the collector really has no way of knowing how much the

dealer is earning through the artwork. This arrangement thus raises issues of transparency and can be unsettling or lead to mistrust.

Dealers and art advisors generally have more market knowledge, and stories abound of such experts profiteering at collectors' expense. In the lawsuit filed by the collector Jan Cowles against one dealer in January 2012, for example, it was revealed that the dealer made $1 million on a painting that was sold for $2 million.[218] When agreeing on a net-price fee structure, the seller should thus insist on a cap on the amount the dealer or advisor can take from the proceeds. If art advisors are involved, the consignment contract should stipulate that the advisor is not taking a commission from anyone else, (e.g., the buyer).

An approach that generally serves the collector better is the percentage model whereby the dealer receives a set percentage of the proceeds. Typically, the dealer would be paid 20 to 25 percent, but possibly less if the work is very valuable. A less common arrangement is a split-price model where there is an agreed value and any sum obtained above that is split evenly.

Dealer consignment contracts should also specify a consignment term, whether that be three months or a year. The parties may want to reassess or renegotiate the consignment terms if the work has not sold or if the market for the work is volatile. The more volatile the market, the shorter the consignment period should be. The dealer needs enough time to have a fair shot at selling a work, and yet the consignor should be able to reclaim the work after a reasonable period.

Consignment Agreements

Whatever the agreement between the consignor and dealer or auction house, it is important to get all the terms clearly expressed in writing. The days of handshake deals in the art world when parties were supposed to rely on trust are ending. With the high stakes and the increasing professionalization of the art world, collectors should demand the same level of clarity and security they would expect in any other business transaction.

There are auction consignment terms mandated by regulation, but others are open to negotiation, depending on the seller and the time in the season. Some auction consignment agreements are relatively simple, outlining the terms of sale and seller warranties, but others can be quite complex, particularly where complicated financials such as guarantees are involved.

In addition to the many points mentioned above, the consignment agreement should identify the work to be sold and outline payment timelines and procedures in detail. In the case of private sales, discounts that might be offered to potential buyers should be addressed. Consignment agreements should also stipulate that no changes—such as

framing or conservation—may be made to the consigned artwork without the consignor's prior written consent.

Consignment agreements should further spell out who is responsible for expenses such as shipping and insurance. Dealers' insurance policies should cover consigned works while they are in their "care, custody and control." The dealer or consignee is responsible for insurance from the time it leaves the collector's possession through the sale and transfer of ownership, and a certificate of insurance should be included with the agreement. Any changes to a consignment agreement should be in writing.

UCC-1

As illustrated by the Salander O'Reilly and Berry-Hill cases (see Chapter 4, "Bad Business Transactions"), galleries have been known to sell an artwork without paying the consignor. US consignors are thus urged to file a UCC-1 form, which affirms the consignor's security interest in the work (see discussion with respect to loans on p.157). This form should be filed in the state where the consigned work is located as well as the state where the dealer or auction house is doing business, if they are not the same. The cost of filing a UCC-1 form agreement is nominal, and filing services exist for those who don't want to be bothered themselves. As no pictures are included in such filings, collectors have to be very precise about the description of the piece. Collectors who value anonymity and are averse to filing a public record about their artworks must therefore balance the need for confidentiality with their security interest in the work.

Even if a UCC-1 Form has been filed, however, it does not mean the consignor will be able to recover the work or guarantee payment; it just creates a priority position as a creditor.

Expenses and Other Considerations

Before putting a work on the market, a collector should also consider the significant expenses involved, which can reach as much as 40 percent. On top of transaction fees and the dealer and auction-house commissions mentioned above, US federal capital gains tax of 28 percent and possibly state capital gains tax will be due when the work is sold. If artworks are sold when owned for less than a year, the art is treated as ordinary income and will be taxed at a marginal rate of around 40 percent. (Under Section 1031 of the Internal Revenue Code, capital gains tax can be deferred on business or investment property where there is a "like-kind" exchange; see discussion in Chapter 8, "Tax Implications: Like-Kind Exchanges".)

In light of these considerable expenses, there are certain situations where it might make sense to sell an artwork outside of the

auction-house–gallery system. In some circumstances, it may be possible to sell work directly to another party. One European collector who owned a large group of important works of French Art Deco design including Pierre Chareau, Jean Dunand, Jacques-Émile Ruhlmann, Jean Puiforcat, and Armand-Albert Rateau was able to sell his works to another prominent collector he knew through his social circle. Over the course of several months, a $1.5-million deal was negotiated, with both parties benefitting from not having to pay a commission. In such cases, it is nonetheless recommended that the seller consult with experts about price to be sure he is asking full value.

In another case, a woman wanted to sell an original silk-screened scarf by Andy Warhol, inscribed to her by the artist during her younger days frequenting The Factory. Smaller auction houses were interested in including it in their day sales, but she chose to sell it on eBay to avoid the considerable auction-house transaction costs. It is important to note, however, that the seller still owes tax in these alternative situations. And, as discussed in the previous chapter, for collectors with valuable secondary-market works in need of cash flow, it may even make sense not to sell the works at all, but to use them as collateral for a loan (see Chapter 8, "Art Financing").

Divorce

Sometimes art is deaccessioned as part of the division of assets in divorce. In such cases, it is important first to establish which of the partners may have title, keeping in mind that the name(s) on the original purchase invoice may be controlling—even if they do not represent true legal ownership—when there is no other proof.[219] In making the decisions of who-gets-what when it comes to jointly owned artworks, emotional value and other psychological factors will likely come into play. Perhaps one party had the money to purchase the artworks, but it was the other party who had the passion and expertise to source them. While selling all the jointly owned art and dividing the proceeds may seem the simplest option, the aforementioned high transaction costs and taxes involved may not make this the best solution for the parties.

The divorcing pair will also have to agree on the value of the works in question and should decide on a neutral party to provide valuations if their assessments differ. Since art is unlike other assets to be divided, however, the parties should account for the costs associated with maintaining possession, such as insurance and maintenance, as well as the taxes and high transaction costs if the work is to be sold in the future. A painting valued at $100,000 would thus not have the same "value" as $100,000 worth of bonds which require no maintenance and can be sold instantaneously at a negligible cost.

GIFTS AND ESTATE PLANNING

Most collectors feel a strong connection to their artworks; some have lived with their art for many years or all of their lives. Thinking about parting with art can thus be painful and it is not entirely surprising that so many collectors put estate planning off. Asset-rich individuals who assiduously plan for the conveyance of their homes, securities, and business interests tend to put their heads in the sand when it comes to the prospect of letting go of their art. Sound art collection management nonetheless requires that collectors make the time to consider the ultimate disposition of their artworks. Decisions have to be made not only about where collections will go in the imminent future, but also what the implications might be for the long term.

As this book seeks to underscore, owning art is a responsibility—and not everyone is disposed to take on that responsibility. A parent may want the artworks to remain in the family, but the children may not always be the most appropriate heirs. Since collecting is such an individual, personal endeavor, children often do not share their parents' tastes and enthusiasm for art. Or they may be interested in a few select pieces, but not others. It is thus important to have frank discussions with family members and other potential heirs or gift recipients about whether they actually desire the works and whether they will be positioned to maintain them. It may be also necessary to educate these individuals about the provenance and values of the works, as well as the potential burdens of art ownership.

In one instance, two daughters inherited their parents' collection of modern art, each receiving half. The youngest sold as much as she could almost immediately after her parents' passing, losing out on the steep appreciation these works would gain over the next decade. She knew her parents' collection had value, yet she knew little about the art market and could not know that the value of the works she had suddenly come to possess would soon begin to soar.

The older daughter, more sentimental, was resolute that she would not sell anything from her parents' collection; she was determined to pass her half on to her own four children and maintain the family legacy. After enduring a battle with the Internal Revenue Service (IRS) on how much estate tax was due on the works (the estate appraisals had been done by an enterprising auction house and were flagged by the tax authorities), many of the works— both important and not so important—were kept stacked in all the closets throughout the house over the decades to come; there was only so much room on the walls and the family had their own pictures. The four children, growing up in a different emotional and experiential sphere than the mother had, felt little connection to the "stuff" that filled their attic and their closets, the very family legacy their mother was determined to cultivate.

The moral of the story is that neither of these situations was optimal for the beneficiaries or for the artworks. While no one can be sure of

future markets or predict the changing inclinations of their children, some planning with good counsel and open discussions could have made for a better outcome in both scenarios.

The objectives of sound estate planning are (1) to ensure that the disposition of the artworks meets the collector's wishes, and (2) to minimize the estate tax burden. Ideally, this planning is done in collaboration with the tax advisors, financial planners, trust and estate lawyers, insurance brokers, and collection managers. The process is not always straightforward, however. Unlike conventional liquid assets, art presents unique nuances and challenges which many professionals are ill-equipped to deal with, and conflicts can occur between those on the financial side and those managing the collection. It is thus advisable to seek specialists who have experience dealing with art.

Every US resident has a federal estate tax exemption of $5 million which is indexed for inflation. Under the American Taxpayer Relief Act of 2012 (implemented the following year), the exemption for 2013 was thus $5,250,000.[220] (Also under this law, a surviving spouse may use any of a deceased spouse's unused exemption upon the surviving spouse's death.) At the time of death, federal estate tax at a rate up to 40 percent will be due on anything that exceeds that amount in the estate after taking account of other applicable exemptions and deductions like the marital deduction. This tax must be paid by the estate's executor within nine months of the date of death. State estate and inheritance tax laws vary and may also have to be taken into account. As the aim is to protect beneficiaries from undue burden, it therefore behooves the collector to consider all strategies well in advance and to take advantage of beneficial tax approaches.

For disposition at death, the value of a work of art is not the original purchase price (the collector's "basis"), but is "stepped up" to the fair market value at the date of death. Here again, valuation will be crucial for the outcome.[221] Sometimes, particularly where art in the estate has greatly appreciated, inherited works may have to be sold in order to satisfy the estate tax debt at death. In the Sonnabend case mentioned in Chapter 1 ("Restrictions"), the art dealer's heirs were forced to sell $600 million of art in order to pay the $471 million due in state and federal estate taxes.[222] In such cases, not only will the estate incur the significant transaction costs,[223] but the works may be sold in less-than-ideal market conditions. If the art market were to crash during this period, the consequences for the heirs could be dire.

Lifetime Gifts: Annual Gift Tax Exclusion

Making gifts during one's lifetime is generally wise in that any appreciation of the artworks won't augment the estate's value. As of 2013, individuals

in the US can gift up to $14,000 each year to an unlimited number of beneficiaries without paying gift tax. This is known as the "annual gift tax exclusion." Spouses can combine their annual exclusions to double the exclusions, amounting to gifts of $28,000 per year to an unlimited number of beneficiaries. Such gifts can also be held in trust. At death, any gifts that exceed the tax-free gift allowances will be subtracted from the estate tax exemption of $5 million as adjusted for inflation. For a collector with more modest artworks likely to appreciate, such tax-free lifetime transfers can be a very good strategy.

Collectors must, however, be careful about maintaining possession and control of gifted artworks. Collectors who gift paintings to their children, but keep them hanging in their own living rooms, should be aware that the property may be included in their taxable estate at their death. In other words, formalities of gifting should be observed. This includes proper documentation (a deed of gift) and removal from the collector's insurance policy. Also, while undervaluing works of art in such transactions may be tempting, gifts of artworks—unlike gifts of cash—may be audited and the consequences can be substantial.

Furthermore, the recipient of such gifts assumes the donor's existing tax basis, which means greater capital gains taxes when the recipient sells the work. The collector should weigh this against the estate tax saved by removing the art from the estate.

Charitable Donations

One of the most effective ways to reduce the burden on an estate and to preserve a legacy is to make charitable gifts during one's lifetime. Here, the law in the US has traditionally been very generous, and this in part explains why 92 percent of the Metropolitan Museum of Art collection is made up of private donations from collectors.[224]

The US Internal Revenue Code permits individuals who donate a work of art to a public charity to deduct the fair market value of the work at the time of donation from their income tax, without having to include any appreciation of that work in their taxable income.[225] This means that if a collector purchased a work for $10,000 and it has appreciated to $50,000, a charitable deduction of $50,000 will be allowed. Such a collector in the 35-percent tax bracket will thus save $17,500 in federal income taxes, realizing $7,500 in profit from the initial $10,000 purchase, while having enjoyed ownership of the work for years.[226]

However, certain requirements exist, and the law, having been developed and altered over many decades, is a complicated one. There are many rules, and it's important to stay abreast of any changes that Congress might enact. (In fact, as this allowance is so favorable to donors, imminent

tax reform is always feared.) Generally speaking, the following conditions need to be met when making a charitable transfer of an artwork:

- Related Use Rule

 To satisfy this rule, any art gifted must be related to the purpose of the receiving organization. Deductions can thus be taken for art donated to art museums or 501(c)(3) (non-profit) organizations whose central mission is art-related. (Where the use is non-related, the deduction would be the lesser of the cost basis and fair market value). To satisfy this related use rule, the museum may not sell the work within three years.

- Public Charity

 The gift must be made to a public charity and not a private foundation. For the latter, deductions will only be allowed for cost—$10,000 in the case above.

- Qualified Appraisal

 For works of art being claimed in excess of $5,000, the donation, in the form of a "Deed of Gift," signed by both the donor and donee, must be accompanied by a qualified appraisal (see Chapter 3, "Valuation v. Appraisal") dated within 60 days of the date of the donation. The importance of a qualified appraisal cannot be stressed enough, as the IRS has not hesitated to litigate questions of value, and the entire deduction can be lost if the appraiser is not deemed qualified.[227] In one case, an appraiser who performed the appraisal of his own donation lost $20 million in deductions because he was not a disinterested party and hence not a qualified appraiser in the eyes of the IRS.[228]

- Capital Gain Property

 In order to receive such a deduction, the property must be considered long-term capital gain property and not ordinary income property. This means that the collector must have owned the work for more than a year before the donation (otherwise it would be considered short-term capital gain) and that it would not produce a loss if sold.

- Form 8283

 For charitable donations of works of art valued at $5,000 or more, IRS Form 8283, "Noncash Charitable Contribution" must be filed with the tax return. For donations of art valued at $20,000 or more, a signed appraisal must be attached to the tax return.

As consequences for not adhering to these conditions is substantial, it is important than an accountant or attorney review the paperwork for any such donations, making sure that the records are thorough, and that the

appraisal is complete and contains all the necessary components including comparable prices in the proper marketplace.

Exceptions to FMV Deductions

There are certain situations where a charitable gift will not entitle the donor to a fair market-value deduction.

If the artwork to be donated was received as a gift from an artist, the collector will only be entitled to a cost deduction—in this case, the cost of the artist's materials. Instead of receiving a gift from an artist, a collector should thus always pay *something* and buy the work—and ask the artist for a receipt.

Gifts to non-US charities (unless at death in a will) will be limited to the cost basis deduction as well. However, if a gift is made to a US-based "friends of" charity, the full market-value deduction will be allowed. Likewise, donations of artworks to charity auctions are only entitled to cost-basis deductions.

Lastly, where the donor's tax status is that of an investor or someone who holds art as inventory for profit (e.g., a dealer), the deduction will also be the cost basis.

Fractional Gifts

US collectors can also make fractional gifts to a museum or public charity, essentially sharing the artwork with a museum on a pro-rata basis while enjoying a tax deduction, provided the related use rule and the other conditions outlined above are met. The collector receives a deduction for the fair market value of the fraction donated and must donate the entire work within 10 years of the fractional donation, at which time the remainder of the fair market value may be deducted.

With recent limitations on fractional gifts, however,[229] most collectors are no longer making fractional gifts. Unlike in the past, any appreciation in fair market value from the time of the original donation may not be accounted for later on; the donor may only take a deduction for the remainder of the original fair market value at the time of the initial donation. Moreover, if the work is not donated in its entirety within 10 years of the initial gift, the donor will be required to pay back the previous deductions to the IRS with interest and penalties. Another requirement is that the receiving institution must have "substantial possession" of the work related to its share. That is, if a collector donates 50 percent of an artwork, presumably the donee should have possession of the work for 50 percent of the time.[230]

Issues to Consider When Making Gifts

In addition to considering tax incentives, collectors should give serious thought to what would be the best home for the art. Where would the

art fit best? What institution has the greatest need for such a work or group of works? Will the museum be able to care for the works and display them as the collector wishes? For the American collector Harry C. Sigman, there was only one place to donate his collection of German and Austrian decorative arts: New York's Neue Galerie, the single museum in the country dedicated solely to German and Austrian art of the same period.[231] Other cases are not so simple, and museums are not always amenable to receiving gifts. Moreover, if it does accept a gift, a museum may not fulfill the donor's particular wishes, such as that the works be displayed together—or at all. (On average, an estimated 80 percent of a museum's collection is kept in storage.)[232]

To take an example, after the influential art dealer and collector Heinz Berggruen donated 90 career-spanning works by Paul Klee (1879–1940) to the Metropolitan Museum of Art in 1988, he expressed regret when the works were not all displayed, stating "I gave the works without conditions, and I learned my lesson."[233] Berggruen felt that his special works were lost in such an encyclopedic museum, and this surely affected his subsequent philanthropic approach. As seen with the many museum deaccessioning cases that have made the press, institutions may even sell donated works from their collection over the years to come.[234]

It is important to keep in mind, however, that any restrictions a collector might want to put on his gift may result in a rejection of the gift. The Museum of Modern Art in New York, for example, does not accept bequests with deaccessioning restrictions due to the expectation that not all of its contemporary-art acquisitions will be considered viable in the future.[235]

Given all these variables, a collector should allow time for the donation process and consider what is personally most important. Is it essential that the works be kept together? Or that there be education programs related to the collection? How will the works be cared for? It is up to the collector to negotiate his or her wishes. The alternatives should also be considered, keeping in mind that smaller regional museums and college museums with teaching collections may be more receptive to certain gifts. Collectors should ask themselves, "Where will my work make a difference?"

Bargain Sales to Museums

For important works of high value, the collector may want to consider a sale to a museum for a reduced price. This allows cash-strapped museums to acquire desirable works while providing the collector with funds to enjoy or to defray estate costs, as well as a tax deduction for the discounted amount. When a museum was established to display Heinz Berggruen's collection in

Berlin, for example, the city's State Museums acquired the works for €129 million, about one-tenth of the market value (see color plate section). This arrangement, a useful tax-planning technique known as a "bargain sale," benefited all, preserving the legacy of the collector while providing cash, and greatly enhancing the city's collections.

Disposition at Death

Some collectors choose to part with their collections at death, bequeathing their artworks to heirs, an institution, or another entity. Distribution of property at death happens through a will or a trust. As mentioned, individuals in the US can make gifts from their estates during their lifetime or at death tax-free for a total inflation-adjusted rate of $5.25 million ("basic estate tax exclusion"), with the estate being subject to federal taxes if, after taking account of other applicable exemptions and deductions, the allowance is exceeded.

However, if the collection is left to a charitable organization— whether that be a public charity or a private foundation—a charitable deduction equal to the full market value of the artwork will be allowed.[236] Unlike lifetime gifts, there is no related use requirement, and transfers to foreign-based charitable organizations are allowed. The IRS requires appraisals for collectibles with a value in excess of $3,000 or a collection with a value which exceeds $10,000.

Identification of Estate Contents

To facilitate the disposition of one estate, artworks distributed during one's lifetime or at death need to be clearly identified. The best way to do that is to attach an illustrated collection management system report or an appraisal document to any instruments that transfer ownership in an artwork including wills, trusts, and gift deeds. All records related to the artworks should also be included with the transfer, and collectors should ensure that they are comprehensible to all parties (see Chapter 2).

Trusts, Foundations, and Limited-Liability Companies

Another option for the collector is to transfer his or her collection to a trust or foundation, the choice often depending on state laws and the nature of the reporting requirements, some of which can be onerous. Such arrangements may permit the collector to avoid estate taxes and maintain some control over the assets. While a discussion of the various foundation and trust possibilities (e.g., Crummey Trusts, Grantor Retained Annuity Trusts ("GRATs"), etc.) and implications is beyond the scope of this chapter, trusts and foundations can offer viable, creative solutions for collectors concerned about the fate of their artworks.

To take an example, Don and Doris Fisher, founders of the Gap clothing retailer, put together an outstanding collection of contemporary art through the years. When their dream of creating a museum in San Francisco's Presidio Park was foiled, they created a trust through which their collection would be loaned to the San Francisco Museum of Modern Art for a period of 100 years (renewable for another 25) as if absorbed into the permanent collection. The museum would build a special wing to showcase the Fisher collection and would maintain and exhibit the art with the help of funds from the Fishers. The Fisher heirs would maintain control of the collection with a trust that stipulated: (1) 75 percent of works displayed in the new wing must be Fisher works; (2) the most important works must be shown every five years; and (3) the work can be deaccessioned only to upgrade the collection and in consultation with the collection curator, who has veto power over certain pieces.[237] This creative arrangement was a win for all, preserving the collectors' vital legacy and catapulting an average museum into a premier position.

Other collectors, like the Rubells and Martin Z. Margulies (discussed in Chapter 7, "Public and Semi-Public Display"), have established private-operating foundations which, by sharing their collections with the public, provide certain tax deductions while allowing them to maintain control of their collections during their lifetimes.

An additional tax strategy employed by collectors is to convey the artworks to a limited-liability company (LLC) and transfer interests in the entity to family members or trusts. This allows the collector, through the entity, to maintain a degree of control over the collection while discounting the value of the collector's estate at death. The caveat here is that the entity needs to have a legitimate business purpose and the collector should not retain too much control.[238]

The IRS and Valuation

Estate lawyers marvel at how many law-abiding citizens are willing, if not eager, to commit tax fraud when it comes to artworks in their estate. Collectors—or those who have inherited from collectors—often assume that they can hide works of art in the estate from the IRS, particularly if there is no known public paper trail such as an insurance schedule. Not claiming artworks in an estate is a risky gamble, however. There is no statute of limitations on tax fraud, which means heirs can be held accountable for taxes—plus substantial interest and penalties—for future generations.

Not surprisingly, as mentioned in Chapter 3, a common battle fought with the IRS is over valuation of artworks, whether that be for lifetime gifts and charitable-donation purposes or for estate tax at the date of death.[239] The IRS's Art Advisory Panel, which meets twice a year, is charged with

making assessments about artwork or cultural property with a claimed value of $50,000 or more. Made up of selected dealers, curators, auction-house experts, etc., the Art Advisory Panel "assists the Internal Revenue Service by reviewing and evaluating the acceptability of property appraisals submitted by taxpayers in support of fair market value claims on works of art involved in Federal Income, Estate and Gift taxes in accordance with the Internal Revenue Code."[240] Decisions of the IRS are final (although one can go to Tax Court to fight the IRS, as the Sonnabend heirs did), and penalties may be imposed for valuations that are deemed improper.

If the Panel review leads to audit, the result will most likely be painful. In cases of audit, there is about a 50 percent chance that money will be owed. In the year 2012, for example, the Panel accepted 51 percent of the appraisals submitted and recommended adjustments for the remaining 49 percent. Of that 49 percent, there was a net 52 percent reduction on charitable-contribution claims deemed overvalued and a net 47 percent increase on undervalued estate and gift appraisals.[241]

Collectors should also consider the implications of possible IRS valuations with respect to the lifetime basic estate tax exemptions. If a collector's estate includes an artwork valued at $5 million, it would seem to make sense that no tax will be due on that artwork under the $5.25 million inflation-adjusted allowance. But what if the IRS subsequently decides that the value of the work is actually $7 millon? The collector's estate may be accountable for taxes owed on $1.75 million plus interest and penalties, and there may be no funds left to cover it. For works in sizable estates that might attract the attention of tax authorities, it is thus best to err on the modest side with respect to valuations.

Art collections reflect the work and passions of a lifetime. Just as maintaining a collection requires time and attention, determining a collection's destiny demands careful and thoughtful planning. Those collectors who have effectively managed their collections over the years will have a meaningful advantage when it comes to the difficult task of parting with their treasured works of art.

CONCLUSION

Collecting art is often described as a journey. This journey begins with looking and continues through acquisition, ownership, and—eventually—relinquishment. At all of these stages, for the sake of a collection's integrity and value, its management and care should not be overlooked.

There would be no art market without collectors—and with the worldwide art market estimated somewhere around $60 billion, there are many types of collectors entering this market for different reasons. Concurrently, globalization, advances in technology, and the concomitant professionalization of the industry are transforming the structures of the art world as well as approaches to building, maintaining, and utilizing collections. Moreover, rising values of artworks persist in making the stakes ever higher, demanding that collectors pay closer attention to the works they are acquiring as well as how they hold and part with them.

Owning art is a responsibility. That responsibility starts with gathering and housing all information related to each and every work of art in a collection, from provenance data to values to condition, and keeping this information updated throughout the years. Whether deciding how to safely and expeditiously move an artwork from Point A to Point B; how to display it; how best to protect it from deterioration; or whether (and how) to insure it, collection management requires ongoing investment and engagement.

Having made such commitments of resources and energy, collectors are now seeking to share their art more than ever before. They are using online platforms, taking advantage of new publishing means, opening their private doors to the community, and establishing public and semi-public spaces—some quite novel—expressly for the purpose of sharing their collections. In doing so, they gain intellectual, social, and sometimes economic benefits.

As art values climb and financial markets prove fallible, collectors and other art buyers have found they can actually make a profit from investing in art, whether that be incidental or very much intentional. For some, art collections have also become a viable source of liquidity,

potentially providing a valuable monetary resource when required. This also means, however, there are more entities seeking to prey on collectors' assets and vulnerabilities—making full awareness of the market and every aspect of one's collection all the more essential.

This appreciation is perhaps most vital when it comes to the task of eventually parting with one's art collection. Finding the optimal method to sell at the right price at the right time requires an understanding of the art business, while gifting works of art to individuals or institutions and including one's art in estate planning involves a great deal of foresight and consultation with professionals. Those who have been active stewards of their collections throughout the years are best positioned to let go of their art to their advantage as well.

The journey of owning art is, most often, one filled with continued pleasure, delight, and even transformation—all the more so, if it is a hands-on experience. Being conversant in the subjects surveyed in this book should make the journey easier and all the richer.

Collectors are strongly encouraged to get to know each of the artworks they own: examine them, research them, document them, install them, follow their markets, protect them, employ them, plan for them, and quietly revel in them all the while.

NOTES

Preface

1. This expression references Werner Muensterberger's classic psychological study on collecting, *Collecting: An Unruly Passion*, Princeton University Press, Princeton, 1994.

2. It must be said that not everyone who buys art is a collector. There are many who purchase art purely for decorative purposes or even for recreation.

3. Tara Loader-Wilkinson, "How Art Expenses Stack Up," *Wall Street Journal*, September 19, 2010, http://online.wsj.com/article/SB10001424052748703959704575453162597091330.html.

4. Marie C. Malaro, *A Legal Primer on Managing Museum Collections*, Smithsonian Books, Washington, D.C., 1998 (2nd ed.) is a classic work. See also: John Simmons, *Things Great and Small: Collections Management Policies*, American Alliance of Museums Press, Washington, D.C., 2006. It should also be noted that "collections management" seems to be museum terminology, reflecting the multiple kinds of collections (e.g., art, ethnological artifacts, historical objects, etc.) any given museum might have.

Chapter 1

5. Jesse Price speaking at ADAA Collectors' Forum "Collecting Across the Centuries: Old Masters in 21st Century Collections," The Frick Collection, January 19, 2011, available at www.artdealers.org/events.forum28v.html.

6. Elizabeth Szancer Kujawski, "From Wish List to in Collection," *The Ronald S. Lauder Collection: Selections from the 3rd Century BC to the 20th Century—Germany, Austria, and France*, Neue Galerie and Prestel, Munich, London and New York, 2011.

7. *Herb & Dorothy: You Don't Have to be a Rockefeller to Collect Art*, dir. Megumi Sasaki, Arthouse Films, Curiously Bright Entertainment and LM Media, 2009.

8. Email with Tasha Seren Lawton, collection manager, July 31, 2013.

9. Gareth Harris, "Crossover Collecting: Ancient Meets Modern," *Art Newspaper*, vol. 22, no. 239, October 2012, p. 17.

10. "Gallerist" is often the preferred term in Europe where "dealer" is deemed a touch too literal, too commercial—even though the activity and general rules are virtually identical.

11. Amy J. Goldrich, "Is a Right of First Refusal an Offer You Can't Refuse? If It's In Writing, Most Probably," in *Spencer's Art Law Journal*, Ronald D. Spencer (ed.), vol. 2, no. 1, Spring 2011, pp. 5–9, www.clm.com/docs/6790694_1.pdf.

12. Randy Kennedy, "Lawsuit Describes Art 'Blacklist' to Keep Some Collectors Away," *New York Times*, p. C1, 17 April 2010.

13. S. N. Behrman, *Duveen: The Story of the Most Spectacular Art Dealer of All Time*, The Little Bookroom, New York, 2003 [1959].

14. UCC 2.401(2).

15. Georgina Adam, "Fair or foul: more art fairs and bigger brand galleries, but is the model sustainable?" *Art*

Newspaper, vol. 21, no. 236, June 2012, p. 89.

16. The 2008 Damien Hirst sale "Beautiful Inside My Head Forever" at Sotheby's London was notable, among other reasons, because an individual artist's works were sold directly at a dedicated auction, leaving the dealer out of the primary-market equation.

17. As of March 2013, Christie's auction house charges 25 percent for the first $75,000; 20 percent on the next $75,001 to $1.5 million; and 12 percent on the remainder. Sotheby's auction house charges 25 percent on the first $100,000 of hammer price; 20 percent on the portion of hammer price above $100,000 up to and including $2 million; and 12 percent on any remaining amount above $2 million.

18. Scott Reyburn, "Billionaires lured to TEFAF Maastricht 2013 by 'reasonably priced' $14 million Velazquez," *ArtDaily.org*, March 14, 2013.

19. In what has been coined as a "bombshell" for the auction world, a New York Supreme Court held in late 2012 that, according to a medieval English law that states that a vendor's name (and not just a seller number) must be included on a sales contract, New York auction houses must disclose the names of consignors. This decision has been appealed and the results are still pending. Tom Mashberg, "Lawyers Fight to Keep Auction Sellers Anonymous," *New York Times*, February 4, 2013, p. C1.

20. Clare McAndrew, *The International Art Market in 2011: Observations on the Art Trade Over 25 Years*, The European Fine Art Foundation, Maastricht, 2012, p. 13. The volume is listed as €46.1 billion and is regularly referenced at approximately $60 billion with currency conversion.

21. Aditya Julka, co-founder of Paddle8, lecture at Sotheby's Institute of Art, New York, September 12, 2012.

22. Allison Malafronte, "Amazon Makes Splash in the Online Art Sales Space With the Announcement of Amazon Art," *Fine Art Connoisseur* online, www.fineartconnoisseur.com/ Amazon-Makes-Splash-in-the-Online-Art-Sales-Space/17063231.

23. Hiscox's Online Art Trade Report 2013, March 2013, p. 3.

24. Patricia Cohen, "Art's Sale Value? Zero. The Tax Bill? $29 Million," *New York Times*, July 22, 2012, p. A1.

25. See discussion on the distinctions between "collectors" and "investors" for tax purposes in Ralph Lerner, "Art and Taxation in the United States," in Clare McAndrew (ed.), *Fine Art and High Finance: Expert Advice on the Economics of Ownership*, Bloomberg Press, New York, 2010, pp. 213–14,

26. Lerner, p. 217.

27. Andrew Jacobs and Clare Pennington, "Two Arrests in China Unnerve Artworld," *New York Times*, July 17, 2012, p. C1.

28. Charlotte Burns and Charmaine Picard, "Is the Coffee Economy Grinding to a Halt?," *Art Newspaper*, vol. 22, no. 240, November 2012, p. 9.

29. Donn Zaretsky, "Kozlowski Sales Tax Deal," *The Art Law Blog*, May 14, 2006, http://theartlawblog.blogspot.com/2006/05/kozlowski-sales-tax-deal.html.

30. www.sothebys.com/content/dam/ sothebys/PDFs/Droit%20de%20 Suite.pdf.

31. There has been much discussion about the lack of transparency in the art world. Professionals are discussing the topic at events such as "Transparency in the market," Art Industry Summit, presented by the *Art Newspaper* in association with the Art Dealers Association of America, New York, March 3, 2011 (www.artdealers.org/events.forum30.html). Relevant articles include: Charlotte Burns, "Court Battle Fuels Calls for Less Art Market Secrecy," *Art Newspaper*, vol. 18, no. 213, May 2010, pp 1 & 8; Melanie Gerlis, "Art Fund Calls for Greater Transparency," *Art Newspaper*, no. 246, May 2013, published online at www.theartnewspaper.com/articles/ Art-fund-calls-for-greater-transparency/29439; and Robin Pogrebin and Kevin Flynn, "As Art Values Rise, So Do Concerns About Market's Oversight," *New York Times*, January 27, 2013, p. A1.

32. Judith Prowda, *Visual Arts and the Law: A Handbook for Professionals*,

Lund Humphries, Farnham, Surrey, and Sotheby's Institute of Art, London and New York, 2013, pp. 171–82.

33. www.collegeart.org/guidelines/ histethics, Section IV.

34. Joshua Hammer, "The Greatest Fake-Art Scam in History?," *Vanity Fair* web exclusive, October 10, 2012, www.vanityfair.com/ culture/2012/10/wolfgang-beltracchi-helene-art-scam.

35. David Barboza, Graham Bowley and Amanda Cox, "A Culture of Bidding: Forging an Art Market in China," *New York Times*, October 28, 2103, www.nytimes.com/projects/2013/ china-art-fraud/.

36. As designated by Michael Shnayerson in "A Question of Provenance," *Vanity Fair*, May 2012, online edition, www. vanityfair.com/culture/2012/05/ knoedler-gallery-forgery-scandal-investigation.

37. Ibid.

38. Judith Pearson, President and co-founder of ARIS Insurance, speaking at the panel discussion "Authenticity Issues and the Law," Art Law Day, *NYU SCPS and Appraisers Association*, November 9, 2012.

39. Patricia Cohen, "In Art, Freedom of Expression Doesn't Extend to 'Is It Real?'," *New York Times*, June 19, 2012, p. A1, provides a thorough examination of this issue.

40. Susan Hapgood and Cornelia Lauf, exhibition text from "In Deed: Certificates of Authenticity in Art," exhibition at KHOJ Studios at New Delhi, India, November 18–December 16, 2011, accessed at http:// khojworkshop.org/project/12157.

41. The Leopold Museum eventually agreed to pay $19 million to Bondi's heirs in July 2010. For a good synopsis of this important case along with an interesting online exchange of some parties involved, see: Judith Dobrzynski, "What Makes the Portrait of Wally Case So Significant?," *Art Newspaper* (online edition only), April 24, 2012, www. theartnewspaper.com/articles/ What-makes-the-Portrait-of-Wally-case-so-significant/26309. As will be discussed in Chapter 4, given the spate of title issues that can arise with respect to an artwork, specialized insurance has recently been introduced to the market to protect buyers from losses due to defective title.

42. Christopher A. Marinello, General Counsel, Art Loss Register, "Art Financing and the Law," *NYU-SCPS/AAA Art Law Day*, New York University, November 9, 2012.

43. For a full discussion, see Prowda, pp. 222–38.

44. "Met Museum Enters Legal Beef Over Its Mark Tansey Cow Painting, Unwittingly Sold by Gagosian," *Blouin Art Info*, May 11, 2011, www. blouinartinfo.com/museums/ article/37658-met-museum-enters-legal-beef-over-its-mark-tansey-cow-painting-unwittingly-sold-by-gagosian.

45. Prowda, p.109. For a full discussion, see also pp. 101–17.

46. Jancou Fine Art, Ltd. v. Sotheby's and Noland, New York Supreme Court, November 13, 2012, www.ifar.org/case_summary. php?docid=1355364926.

Chapter 2

47. When handling fragile documents, it is not recommended to wear white conservation gloves (see Chapter 6, "Collection Care Challenges" for more information).

48. ArtBase clients include the dealers David Zwirner and Matthew Marks, the collections of The Gap and Tishman Speyer (New York's largest real-estate developer) and *New York Times*, whose archive of over 150,000 cartoons is stored in the database.

49. www.artbase.com.

50. Some companies such as ArtBinder, "the leading mobile solution for galleries" founded by a former employee of the gallery Gavin Brown's Enterprise, have jumped on the market for Apps as tools to present artworks. These Apps are not management systems and are to be distinguished from CMS.

51. A VPN is defined as a network that uses the Internet to enable remote offices or traveling users to access a central organizational network with secure data once authenticated. Expensive and difficult to implement, VPNs may soon be antiquated.

Other options for remote access have included GoToMyPC (www.gotomypc.com).

52. www.artlogic.net.

Chapter 3

53. Elizabeth Von Habsburg, Rachel Goodman, and Clare McAndrew, "Art Appraisals, Prices, and Valuations," in Clare McAndrew (ed.), *Fine Art and High Finance: Expert Advice on the Economics of Ownership*, Bloomberg Press, New York, 2010, p. 36.

54. Pension Protection Act, Pub. L. No. 109–280 , 120 Stat. 780 (2006), IRS Notice 2006-96, www.irs.gov/pub/irs-drop/n-06-96.pdf.

55. Under the IRS Pension Protection Act of 2006, qualified appraisers can be penalized by the IRS for incorrectly prepared appraisals. Part 20 Penalty and Interest, Chapter 1 Penalty Handbook, Section 12 Penalties Applicable to Incorrect Appraisals, www.irs.gov/irm/part20/irm_20-001-012.html.

56. James Martin, "What Materials Tell Us about the Age and Attribution of The Matter Paintings," *IFAR Journal*, vol. 10, no. 1, 2008, pp. 25–35.

57. Picasso's 1969 *Mousquetaire à la pipe* sold for $30.9 million (estimate $12 million to $18 million) on November 6, 2013—a record price for a late Picasso.

58. Carol Vogel, "The Met Makes its Biggest Purchase Ever," *New York Times*, November 10, 2004, p. E1, www.nytimes.com/2004/11/10/arts/design/10pain.html

59. The case was ultimately dismissed. Julia Halperin, "Sizing Up the Curious New William Eggleston Lawsuit: Can a Collector Really Stop Him From Making More Art?," *Blouin Art Info*, April 8, 2012, www.blouinartinfo.com/news/story/797986/sizing-up-the-curious-new-william-eggleston-lawsuit-can-a-collector-really-stop-him-from-making-more-art.

60. Dorit Straus, Vice President and Worldwide Fine Art Manager, Chubb Personal Insurance, "Accidents Happen," *NYU-SCPS/AAA Art Law Day*, New York University, November 12, 2010.

61. For an entertaining account of this accident, see Nick Paumgarten, "The $40-Million Elbow," *New Yorker*, October 23, 2006, www.newyorker.com/archive/2006/10/23/061023ta_talk_paumgarten.

62. The print sold for $302,500 at Christie's in January 2011 against an estimate of $20,000–$30,000. Mark Brown, "Dennis Hopper's Bullet-Scarred Warhol Screen Print on Sale," *Guardian* (online version), January 5, 2011, www.guardian.co.uk/film/2011/jan/05/dennis-hopper-andy-warhol-print.

63. "Hugh Grant: 'I was drunk when I bought Elizabeth Taylor painting that made £11m profit,'" *Daily Mail Online*, December 13, 2009, www.dailymail.co.uk/tvshowbiz/article-1235452/Hugh-Grant-I-drunk-I-bought-Elizabeth-Taylor-painting-11m-profit.html.

64. Dan Duray, "Wunderkind Kassay Takes Phillips, Again," *Observer* (online edition), May 13, 2011, http://observer.com/2011/05/wunderkind-kassay-takes-phillips-again.

65. Shane Ferro and Rachel Corbett, "10 Former Art Sensations That the Market Has Left Behind", *Blouin Art Info*, January 30, 2013, www.blouinartinfo.com/news/story/861621/10-former-art-sensations-that-the-market-has-left-behind.

66. Von Habsburg, Goodman, and McAndrew, 2010, p. 36.

67. Christiane Fischer, President and CEO of AXA Art Americas, speaking at Sotheby's Institute of Art, New York, March 1, 2012.

68. Richard Polsky, "A Dealer Looks Back," *artnet Magazine*, August 27, 2008, www.artnet.com/magazineus/features/polsky/polsky8-27-08.asp.

69. For a full list of these factors, see *The Experts' Guide to Collecting*, Appraisers Association of America, Withers Bergman LLP, 2010, p. 21.

70. Collectors' enjoyment is usually referred to as the "psychic return" on fine-art investment in the professional literature. For an overview, see: Bruno S. Frey and Reiner Eichenberger, "On the Return of Art Investment Return Analyses," *Journal of Cultural Economics*, vol. 19, 1995, pp. 207–20.

Chapter 4

71. Allan Kozinn, "Art Insurance Losses from Hurrican Sandy May Reach $500 Million," *New York Times*, December 31, 2012, p. C3.

72. "A Museum in the Sky," *The Economist*, October 11, 2001, www.economist.com/node/814452.

73. Christiane Fischer, President and CEO of AXA ART Insurance, speaking at Sotheby's Institute of Art, New York, March 1, 2012.

74. The champagne incident was reported by Dorit Straus, Vice President and Worldwide Fine Art Manager, Chubb Personal Insurance, "Accidents Happen," *NYU-SCPS/AAA Art Law Day*, New York University, November 12, 2010.

75. Fischer, Sotheby's Institute, March 1, 2012.

76. Straus, New York University, November 12, 2010.

77. Ibid.

78. A.M. Best Co. rates insurance companies using letter grades. Christiane Fischer and Jill Arnold, "Insurance and the Art Market," in Clare McAndrew (ed.), *Fine Art and High Finance: Expert Advice on the Economics of Ownership*, Bloomberg Press, New York, 2010, p. 200.

79. Ibid., p. 199.

80. AXA ART is the only specialized art insurer.

81. Christiane Fischer, President and CEO of AXA Art Insurance, speaking at Sotheby's Institute of Art, New York, April 23, 2013.

82. Christiane Fischer, as cited in Brian Boucher, "Will Insurance Companies Cover Chelsea After Sandy?," *Art in America*, November 7, 2012, www.artinamerica.com/news-features/news/sandy-insurance.

83. M. P. McQueen, "Perishable Art: Investing In Works That May Not Last," *Wall Street Journal*, May 16, 2007, http://online.wsj.com/news/articles/SB117927768289404269

84. Betsy Dorfman, "What You Should Know About 'Inherent Vice'," *Fine Art Shipping Blog*, April 16, 2009, www.fineartship.com/2009/04/what-you-should-know-about-inherent-vice/.

85. In the 2007 Frigon v. Pacific Indemnity case, a federal judge in Illinois held that an "all-risk" insurance policy covered conversion by a gallery of consigned works. Elizabeth C. Black, "Entrustment, the Hidden Title Risk of Leaving your Artwork in the Care or Possession of Others—Will your Fine Art Insurance Cover your Loss? Probably Not," in Ronald D. Spencer (ed.), *Spencer's Art Law Journal*, vol. 1, no. 3, Winter 2010/2011, p. 3, www.clm.com/docs/6706004_1.pdf.

86. Eileen Kinsella, "Untangling the Salander Mess," *ArtNews*, July 1, 2010, www.artnews.com/2010/07/01/untangling-the-salander-mess/.

87. Martha Lufkin, "Berry-Hill Stacks Up Lawsuits," *Art Newspaper*, no. 222, March 14, 2011, www.theartnewspaper.com/articles/Berry-Hill+stacks+up+lawsuits/23311.

88. Only 25 percent of title claims are related to provenance. Judith Pearson, ARIS Title Insurance, "Best Practices in the Chain of Custody," panel discussion, *Understanding Art as an Asset*, Artelligence symposium, New York Athletic Club, April 13, 2011.

89. Fischer, Sotheby's Institute, New York, April 23, 2013.

90. Ralph Lerner, "Art and Taxation in the United States," in McAndrew (ed.), 2010, p. 216.

91. Ibid., pp. 215–16.

Chapter 5

92. Andrew Faintych, "Fine Art Shipping and Storage," *IFAR Journal*, vol. 9, nos. 3 & 4, 2007, p. 56.

93. Jonathan Schwartz, Co-founder and CEO, Atelier 4, Long Island City, New York, on-site conversation, February 26, 2013.

94. Schwartz, in conversation, April 27, 2012.

95. IFAR 58. Faintych, p. 56.

96. ICEFAT, for example, has an international network of some 70 members in 40 countries at the time of writing.

97. Email with Andrew Faintych, Co-founder and Executive Vice President, Atelier 4, Long Island City, New York, June 17, 2013. According to Faintych, most theft occurs on loading docks.

98. "Request a Quote," Cadogan Tate Fine Art, www.cadogantate.com/fineart/request-a-quote.html.

99. Cristina Ruiz, "Momart Dispute Reveals Hazards of Shipping Art," *Art Newspaper*, no. 229, November 2011, www.theartnewspaper.com/articles/ Momart-dispute-reveals-hazards-of-shipping-art/24929.

100. Meredith Mendelsohn, "The Price You Pay," *Art + Auction*, vol. 33, no. 11, July/August 2010, p. 44.

101. "Art and Museum Transportation Services," FedEx Service Guide, http://customcritical.fedex.com/us/ services/market-industry/art.shtml.

102. According to Ida Ng, CEO, Artmove Helu-Trans(S) Pte. Ltd., Singapore, email, June 27, 2013. Ms. Ng notes that these calculations are not entirely straightforward.

103. See "Works of Art, Collectors' Pieces and Antiques," *Harmonized Tariff Schedule of the United States*, Chapter 97, Section XXI, 2010, http://usitc. gov/publications/docs/tata/hts/ bychapter/1000C97.pdf.

104. Brancusi v. The United States, T.D. 43063, 54 Treas. Dec. 428 (1928).

105. Georgina Adam, "Flavin and Viola works ruled 'not art'," *Art Newspaper*, no. 219, December 2010, p. 59.

106. Louisa Buck and Judith Greer, *Owning Art: The Contemporary Art Collector's Handbook*, Cultureshock Media, London, 2007, p. 191.

107. See discussion of German art handler's imprisonment in Chapter 1, p. 36. Email evidence seemed to indicate that the art handlers were complicit. Andrew Jacobs and Clare Pennington, "Two Arrests in China Unnerve Artworld," *New York Times*, July 17, 2012, p. C1.

108. www.singaporefreeport.com/.

109. David Segal, "Swiss Freeports Are Home for a Growing Treasury of Art," *New York Times*, online, July 21, 2012, www.nytimes.com/2012/07/22/ business/swiss-freeports-are-home-for-a-growing-treasury-of-art.html?_ r=0.

110. Gareth Harris, "Beijing to get Freeport to Challenge Hong Kong's Supremacy," *Art Newspaper* (online edition only), July 26, 2012, www. theartnewspaper.com/articles Beijing+freeport+to+challenge+ Hong+Kong%E2%80%99s +supremacy+as+Asia's+- art+centre/26942.

111. These ideas are in part gleaned from James K. Reeve, *The Art of Showing Art*, Council Oak Books, Tulsa, AZ, 1986, 1992 (2nd ed.), pp. 82–5. Mr. Reeve also offers extensive instructions for packing artworks oneself. While dated in parts, this book is an excellent resource for collectors and was recommended by the art handler Tom Zoufaly, who spoke at Sotheby's Institute of Art on April 19, 2012.

112. As recounted by the responsible art handler, Tom Zoufaly, Sotheby's Institute of Art, New York, April 19, 2012.

113. In a *New York Times* article about the acquisition, Ronald Lauder stated, "This is our Mona Lisa." Carol Vogel, "Lauder Pays $135 Million, a Record, for a Klimt Portrait," *New York Times*, June 19, 2006, www. nytimes.com/2006/06/19/arts/ design/19klim.html.

114. www.chenue.com/english/our_ expertise/storage.html.

115. James Mee, "Art into Ashes," *Guardian*, September 22, 2004, www.theguardian.com/ artanddesign/2004/sep/23/art. britartfire.

116. GRASP (Global Risk Assessment Platform), AXA ART Insurance Corporation, 2013, www.axa-art-usa. com/artprotect/grasp.html.

117. Faintych, p. 56.

118. Fred Leeman quotation in "The Art of Framing," *Christie's International Magazine*, March–April 1990, as cited in Jared Bark, "Framing Van Gogh's *The Night Café*," *IFAR Journal*, vol. 13, no. 4, 2012–13, p. 30.

119. This practice is described in actor/ collector Steve Martin's novel, *An Object of Beauty*. The young Sotheby's employee protagonist races to have a Milton Avery painting—which had been consigned in a "frame so ghastly that [her boss] Cherry Finch looked at the painting with her fingers squared so as to screen it out,"—reframed at Lowy, "the Upper East Side framer to the magnificent," before the sale. Steve Martin, *An Object of Beauty*, Hachette Book Group, New York, 2010, pp. 22–5.

120. Elaine Louie, "Trade Secrets; Frames are Worth at least 500 Words," *New York Times*, March 25, 1999. Reprinted online at

www.nytimes.com/1999/03/25/garden/trade-secrets-frames-are-worth-at-least-500-words.html?pagewanted=all&src=pm.

121. Panel discussion at the IFAR Evening Panel "What Frames Can Tell Us," Christie's New York, May 17, 2011. Panelists included George Bisacca, Conservator at the Metropolitan Museum of Art, Laurence B. Kanter, Curator of Early European Art at Yale University Art Gallery, and Eli Wilner, CEO and founder of Eli Wilner & Company.

122. Jared Bark, "Framing Van Gogh's *The Night Café*", *IFAR Journal*, vol. 13, no. 4, 2012–13, p. 30.

123. Telephone conversation with Bas Mühren, Research Department, Kröller-Müller Museum, Otterlo, Netherlands, September 25, 2013.

124. Bark, p. 32.

125. The heated discussion took place during the *IFAR Evening* entitled "What Frames Can Tell Us," on May 17, 2011, held at Christie's New York.

126. www.eliwilner.com/.

127. Kelly Crow, "Out Size Art," *Wall Street Journal Magazine*, September 9, 2009, p. 2 of 4.

128. Telephone conversation with Katherine Hinds, Curator, Margulies Collection, October 8, 2013. The installation has since been de-installed on two occasions, with the curatorial team using a template system with numbered boxes.

129. In such situations, D-rings are usually fixed to the frame sides for attaching the work directly to the wall. This method requires greater precision (the work cannot be shifted a little as is the case with a wire). The first step is to measure the distance between the D-rings and mark the corresponding desired points on the wall. The points should then be checked with a level before a hook is nailed to the wall. Professional art-hanging hooks such as an OOK 3-hole hook should be used (the weight limit is noted on the packaging).

130. Pac Pobric, "US Fails to Tackle Art Crime," *Art Newspaper*, vol. 22, no. 245, April 2013, p. 5.

131. Joseph Berger, "House Painter Is Charged in Long Island Art Thefts," *New York Times*, May 7, 2013, p. A18.

132. "Detroit Art Theft: 19 Works Worth Millions, One by Andy Warhol, Stolen From Private Collection," *HuffPost Detroit*, May 22, 2012, www.huffingtonpost.com/2012/05/22/detroit-art-theft-andy-warhol-rube-goldberg-works-worth-millions-stolen-from-collector_n_1536544.html.

133. In 2004, armed robbers stole another version of *The Scream* along with Munch's *Madonna* in broad daylight from the Munch Museum in Oslo. It was recovered two years later. Ten years earlier, yet another version of *The Scream* was stolen from Oslo's National Gallery and recovered three months later.

Chapter 6

134. Thomas Wessel, quoted in Nazanin Lankarani, "Contemporary art boom brings opportunities, and challenges, for insurers," *New York Times*, May 30, 2008, www.nytimes.com/2008/05/30/arts/30iht-rcartaxa.1.13337568.html?pagewanted=all.

135. Glenn Wharton, lecture at Sotheby's Institute of Art, New York, April 1, 2011.

136. See Elaine Sciolino, "Leonardo Painting's Restoration Bitterly Divides Art Experts," *New York Times*, January 4, 2012, p. C1.

137. Registrars, being the guardians and caretakers of artworks who oversee their intake, handling, and movement within museums, are becoming increasingly involved in the documentation process for conservation matters.

138. The contemporary-art conservator, Christian Scheidemann, took on the challenge of trying to find a way to conserve Robert Gober's *Bag of Donuts* (1989). In a four-day treatment that included placing the donuts in a low-pressure tank with acetone (found also in nail-polish remover), Scheidemann was able to remove the grease from the donuts. The actual weight of the donuts, however, changed significantly; they were therefore refilled with a resin solution to "bring them back" to their original size. There were eight versions of *Bag of Donuts*, one of

which sold at auction for $240,000. See Rebecca Mead, "The Art Doctor: Onward and Upward with the Arts," *New Yorker*, vol. 85, no. 13, May 11, 2009, p. 58.

139. Both New York and California moral rights statutes create the right of paternity (also called right of authorship or right of attribution) by giving the artist the right to claim or disclaim authorship. For further discussion, see Judith Prowda, *Visual Arts and the Law: A Handbook for Professionals*, Lund Humphries, Farnham, Surrey, and Sotheby's Institute of Art, London and New York, 2013, pp. 101–17.

140. Conversation with Suzanne Siano, chief conservator and founder of Modern Art Conservation (MAC) in New York, MAC studio, October 18, 2011.

141. "Atomic Oxygen Restoration System Restores Artwork," Glenn Research Center, National Aeronautics and Space Administration, July 24, 2007, https://rt.grc.nasa.gov/2007/atomic-oxygen-restoration/.

142. See Emily Sharpe, "Preserving a Work by Starving it of Air," *Art Newspaper* (online edition only), Conservation no. 227, September 14, 2011, www. theartnewspaper.com/articles/ Preserving-a-work-by-starving-it-of-air/24507.

143. Such filters should be changed every 10 years or so.

144. Helen Pidd, "Overzealous Cleaner Ruins £690,000 Artwork that she Thought was Dirty," *Guardian*, November 2, 2011. www.theguardian.com/ artanddesign/2011/nov/03/ overzealous-cleaner-ruins-artwork.

145. Emily Sharpe, "Caring for What the Camera Saw," *Art Newspaper*, Art Basel Daily Edition June 17–19, 2011, p. 4.

146. Cristina Ruiz, "C-prints Fade into the Light," *Art Newspaper*, vol. 18, no. 212, April 2010, p. 36.

147. Andreas Gursky's *Rhine II* reached $4.3 million in 2011, making it the most expensive photograph sold to date.

148. "Projet AXA-Art soutient le CRCC sur la conservation du patrimoine photographique," *Centre de recherche sur la conservation des collections*, www.axa-art-usa.com/partnerships/ crcc-paris.html

149. Recent literature and discussion on the challenges of conserving contemporary art include: ADAA collectors' forum, "Conserving the New: Preserving and Restoring Contemporary Artworks," New York, January 23, 2010, www.artdealers. org/events.forum24v.html; Glenn Wharton, "The Challenges of Conserving Contemporary Art," in Bruce Altshuler (ed.), *Collecting the New: Museums and Contemporary Art*, Princeton University Press, Princeton and Oxford, 2007; Cristina Biaggi, *Caring for Contemporary Art: Towards A Collaborative Approach to Conservation in Art Business*, MA Thesis, Sotheby's Institute of Art, New York, 2010; IJsbrand Hummelen, and Dionne Sillé (eds.), *Modern Art: Who Cares? An Interdisciplinary Research Project and an International Symposium on the Conservation of Modern and Contemporary Art*, Archetype Publications, London, 1999; Randy Kennedy, "Giving the Artists a Voice in Preserving Their Work," *New York Times*, June 29, 2006, www.nytimes.com/2006/06/29/ arts/design/29cons.html; Pip Laurenson, "The Management of Display Equipment in Time-based Media Installations," *Tate Papers*, Issue 3, Spring 2005,www.tate. org.uk/download/file/fid/7344; and M. P. McQueen, "Perishable Art: Investing In Works That May Not Last," *Wall Street Journal*, May 16, 2007, http://online.wsj.com/ article/SB117927768289404269-search.html?KEYWORDS=-damien+hirst&COLLECTION-=wsjie/6month.

150. Carol Vogel, "Swimming with Famous Dead Sharks," *New York Times*, October 1, 2006, www. nytimes.com/2006/10/01/ arts/design/01voge. html?pagewanted=all

151. Dan Flavin's *Four Red Horizontals (To Sonja)* (1963) sold for $1,706,500 on November 9, 2011, at Sotheby's New York.

152. Conversation with Blythe Projects

dealer Hillary Metz at PULSE MIAMI, December 3, 2011.

153. As recounted by Christiane Fischer, the President and CEO of AXA ART Insurance, lecture at Sotheby's Institute of Art, New York, March 1, 2012.

154. Sara Roffino, "Hurricane Sandy Leaves Greenpoint Studios Wrecked, Destroying Years of Work," *Blouinartinfo.com*, November 1, 2012, www.blouinartinfo.com/news/story/837972/hurricane-sandy-leaves-greenpoint-studios-wrecked-destroying.

155. Andrew Faintych, "Fine Art Shipping and Storage," *IFAR Journal*, vol. 9, nos. 3 & 4, 2007, p. 56.

Chapter 7

156. Donald Bryant, Jr. talk at Sotheby's Institute of Art, February 8, 2011.

157. Introduction, *Max Ernst Hanging*, film by François de Menil and John de Menil, Menil Foundation, Houston, 2010.

158. Jana Hyner (ed.), Silvia Anna Barrilà, Nicole Büsing, Heiko Klaas, and Christiane Meixner, *BMW Art Guide by Independent Collectors: The Global Guide to Private and Publicly Accessible Collections of Contemporary Art*, Hatje Cantz, Ostfildern, 2013.

159. Mary Rozell Hopkins, "Profile: Collectors Erika and Rolf Hoffman," *Art Newspaper*, vol. 74, October 1997, p. 25. Mr. Hoffmann passed away in 2006.

160. "About the Rubell Family Collection and Contemporary Arts Foundation," Rubell Family Collection/Contemporary Arts Foundation, 2009, http://rfc.museum/about-us.

161. The terms "cultural capital" and "social capital" were coined by the sociologist Pierre Bourdieu in his seminal work *The Forms of Capital* (1986). According to Bourdieu, the third form of capital is economic.

162. David Kocieniewski, "A Family's Billions, Artfully Sheltered," *New York Times*, November 28, 2011, p. A1.

163. Andrew Faintych, "Fine Art Shipping and Storage," *IFAR Journal*, vol. 9, nos. 3 & 4, 2007, p. 56.

164. US Statute Executive Order 12047, March 27, 1978, 43 F.R. 13359, as amended by Executive Order 12388, October 14, 1982, 47 F.R. 46245.

165. "Sample Introductory Paragraphs for Immunity Application," US Department of State, www.state.gov/s/l/3197.htm.

166. Lindsay Pollock, "U.S. Marshals seize Degas, Miro Works at Miami Fair," Bloomberg, December 3, 2009, www.bloomberg.com/apps/news?pid=newsarchive&sid-=aX82sXGnDW4Y.

167. See, for example: Carol Vogel, "The Art World, Blurred," *New York Times*, October 26, 2012, p. 25.

168. Lee Boltin, William S. Lieberman, and Dorothy Canning Miller, *The Nelson A. Rockefeller Collection: Masterpieces of Modern Art*, Hudson Hills Press, New York, 1981, p. 20.

169. Nelson A. Rockefeller and Richard Marcus, *The Nelson Rockefeller Collection—Compliments of Neiman-Marcus*, Nelson Rockefeller Collection, Dallas, 1970s.

170. www.independent-collectors.com/about/.

171. In the US, for works created on or before January 1, 1978, copyright runs from the date of creation through the life of the artist plus 70 years. For a full discussion on copyright, see Judith Prowda, *Visual Arts and the Law: A Handbook for Professionals*, Lund Humphries, Farnham, Surrey, and Sotheby's Institute of Art, London and New York, 2013, pp. 55–78.

172. Deborah Sontag and Robin Pogrebin, "Some Object as Museum Shows Its Trustee's Art," *New York Times*, November 10, 2009, p. A1.

173. David Barboza, "An Auction of New Chinese Art Leaves Disjointed Noses in its Wake," *New York Times*, May 7, 2008.

174. There is an abundance of literature, both commercial and scholarly, which dissects the ins and outs of this controversy. See, for example: Steven C. Dubin, "How 'Sensation' became a scandal," *Art in America*, vol. 88, no. 1, January 2000, pp. 53–5, 57, 59; Patricia Failing, "Following the Money," *ARTnews*, vol. 99, no. 1, January 2000, pp. 150–53; and Roger Kimball, "The Elephant in the Gallery, or the Lessons of 'Sensation'," *New*

Criterion (U.S.A.), vol. 18, no. 3, November 1999, pp. 4–8.

175. Sontag and Pogrebin, p. A1.

Chapter 8

176. Quotation taken from Jeremy Eckstein, "Investing in Art: Art as an Asset Class," in Iain Robertson and Derrick Chong, *The Art Business*, Routledge, Abingdon, Oxon, 2008, p. 70.

177. www.aexchange.net/.

178. Commentary by Sergey Skaterschikov, founder of Skate's, at "Matters of Art Finance: Exploration of Art Loans & Art Investment Funds," Entertainment, Art and Sports Law Section of the New York State Bar Association, Herrick, Feinstein LLP, September 13, 2012. Skaterschikov recounted that the first edition of Skate's was banned from museum bookstores.

179. See, for example, Clare McAndrew, *The Art Economy: An Investor's Guide to the Art Market*, Liffey Press, Dublin, 2008, and Noah Horowitz, *Art of the Deal: Contemporary Art in a Global Financial Market*, Princeton University Press, Princeton, 2011.

180. Carol Vogel, "Landmark de Kooning Crowns Collection," *New York Times*, November 18, 2006, www.nytimes.com/2006/11/18/arts/design/18pain.html.

181. Michael Plummer and Jeff Rabin, *The Truth About Art Funds*, Eurekahedge, January 2012, p. 1, www.eurekahedge.com/news/january_2012_alternative_investments_Artvest_The_Truth_About_Art_Funds.asp.

182. Walter Robinson, "A Tale of an Art World Lawsuit," *Artnet news*, January 18, 2005, provides a good account of the background of this story.

183. Plummer and Rabin. The reality is that few funds have succeeded in attracting capital in excess of $50 million, and this explains why art funds have yet to succeed in attracting institutional investors and look rather to billion-dollar funds with more transparent underlying assets.

184. "Chinese Art Funds on a Risky Road to Maturity," *Art Newspaper*, vol. 21, no. 237, p. 47, July/August 2012. Art funds in China have shorter maturity dates, and most of the investment vehicles available are loosely regulated, if regulated at all. This has resulted in remarkable activity estimated at $900 million. However, it is still not on the level of private-equity funds where many billions of dollars are invested. Furthermore, this investment market could be diminished anytime if the art market crashes or the government suddenly steps in and imposes regulation, as was the case in India where unregistered funds were abruptly shut down.

185. Clare McAndrew, *The International Art Market in 2011: Observations on the Art Trade Over 25 Years*, The European Fine Art Foundation, Maastricht, 2012, p. 13.

186. Marcus Barum, "Art Funds Starved for Investors," *Wall Street Journal*, August 22, 2005, http://online.wsj.com/news/articles/SB112467158168319234.

187. Other art funds in various forms followed during that period, but none endured. For an excellent discussion on the history of art funds, see Noah Horowitz, "Art Investment Funds," *Art of the Deal: Contemporary Art in a Global Financial Market*, Princeton University Press, Princeton, 2011, pp. 151–6.

188. The Art Vantage fund started with the personal collection of its founder Serge Tiroche. See Serge Tiroche, "Art Funds, Art Investment," ArtTactic podcast, October 5, 2012, www.arttactic.com/item/512-serge-tiroche-art-vantage.html.

189. Homepage, The Fine Art Fund Group, www.thefineartfund.com/.

190. Noah Horowitz provides a comprehensive table of art-investment funds—many of which are no longer in existence. "Art Investment Fund Universe," Appendix C, in *Art of the Deal: Contemporary Art in a Global Financial Market*, Princeton University Press, Princeton, 2011, pp. 151–6.

191. Daniel Grant, "Secrets of the Fine Art Funds," *Artnet*, November

22, 2011, www.artnet.com/magazine/features/grant/fine-art-funds-11-22-11.asp# provides a good discussion of the Fine Art Fund and other funds.

192. However, some insiders say that, in practice, these loans rarely happen as they cause a drag on the ability to sell quickly. Also, loaning artworks to museums and thereby enhancing their value generally benefits the fund more than any rental fees obtained from its members. "Art Funds: The Key to Success," panel discussion, *Understanding Art as an Asset,* Artelligence symposium, New York Athletic Club, April 13, 2011.

193. See Boris Groysberg, Joel Podolny, and Tim Keller, *Fernwood Art Investments: Leading in an Imperfect Marketplace*, Harvard Business School, Boston, September 27, 2004.

194. It should be noted that the art-insurance industry finds art funds challenging to underwrite due to the lack of data and transparency of these still-emerging enterprises. Christiane Fischer and Jill Arnold, "Insurance and the Art Market," in Clare McAndrew (ed.), *Fine Art and High Finance*, Bloomberg Press, New York, 2010, p. 209.

195. Medium seems to be of particular importance with respect to this tax strategy. An 18th-century American painting exchanged for a 20th-century European painting would probably qualify as "like-kind," but an 18th-century Chinese watercolor would probably not be considered similar in nature and character to an 18th-century porcelain vase.

196. "Like-Kind Exchanges Under IRC Code Section 1031," Internal Revenue Service, updated August 3, 2012, www.irs.gov/uac/Like-Kind-Exchanges-Under-IRC-Code-Section-1031.

197. The total amount of all auction guarantees issued by Sotheby's amounted to $626 million in 2008 and dropped to a mere $7 million in 2009. Judd Tully, "Assurance Policies: Third-Party Guarantees May Reduce Risk and Yield Rewards," *Art + Auction*, September 2011, p. 37.

198. See Georgina Adam and Charlotte Burns, "Guaranteed Outcome: Insurance for Sellers or Market Manipulation? Why Auction Guarantees are Dividing the Art Trade," *Art Newspaper*, Armory Show Edition, March 2–3, 2011, p. 9; and Robin Pogrebin and Kevin Flynn, "As Art Values Rise, So Do Concerns About Market's Oversight," *New York Times*, January 27, 2013, p. A1.

199. Tully, p. 37. At the time of writing, Sotheby's does not offer discounts on buyer's premiums.

200. Pogrebin and Flynn, p. A1.

201. For a discussion of the origins of art finance, see Suzanne Gyorgy, in McAndrew, 2010, pp.118–21..

202. Michael Plummer, "The Truth About Art Financing—A Two-Tier System," *Artvest* blog post, April 2, 2012, http://artvest.com/the-truth-about-art-financing-%E2%80%93-a-two-tier-system/.

203. It is also becoming more common for art lenders to register their security interest in the artworks with the Art Loss Register, a public record, according to Christopher A. Marinello, speaking on the panel "Art Financing and the Law," *NYU-SCPS/AAA Art Law Day*, New York University, November 9, 2012.

204. See Melanie Gerlis, "Banks Cash In on 'Spend and Lend' Strategy," *Art Newspaper*, Art Basel Daily Edition (digital version), June 13, 2012.

205. Citi, for example, requires a minimum of four pieces of art from various artists of international standing. Gyorgy, p. 125.

206. Benjamin Genocchio, "Conversation with … Trinh Doan of U.S. Trust on the ins and outs of borrowing against art," "What You Need to Know Before You Take Out an Art Loan: A Q & A with Trinh Doan," *Art + Auction*, vol. 36, no. 3, November, p. 93, 2012 or www.blouinartinfo.com/news/story/836467/what-you-need-to-know-before-you-take-out-an-art-loan-a-qa.

207. According to Nicola Walter of J. P. Morgan Securities, who stated that she was not familiar with any defaults on art loans at her bank during the panel "Art Financing and the Law," *NYU-SCPS/AAA Art*

Law Day, New York University, November 9, 2012.

208. According to attorney Amy Goldrich, speaking on the panel "Art Financing and the Law," *NYU-SCPS/AAA Art Law Day*, New York University, November 9, 2012.

209. Shane Ferro, "Navigating the Art Loan Biz, A Surge in Industry Attracting Both Big Banks and 'Loan-to-Own' Sharks," *Blouin ArtInfo*, April 4, 2012, www.blouinartinfo.com/news/story/797602/navigating-the-art-loan-biz-a-surging-industry-attracting-both-big-banks-and-loan-to-own-sharks.

210. Ibid.

211. Art Capital Group, www.artcapitalgroup.com.

212. For a thorough account of this debacle, see Andrew Goldman, "How Could This Happen to Annie Leibovitz?," *New York Magazine*, August 24, 2009, pp. 50–57, 161–2. See also Felix Salmon, "Art Capital Made at least $16 million off Annie Leibovitz," *blogs.reuters.com*, April 6, 2010.

213. Allen Salkin, "That Old Master? It's at the Pawn Shop," *New York Times*, February 24, 2009, p. A1.

214. "Sotheby's Financial Services," www.sothebys.com/en/inside/services/financial-services/overview.html.

Chapter 9

215. Donald Bryant, Jr. talk at Sotheby's Institute of Art, February 8, 2011. Mr. Bryant's quote comes from his father.

216. This term is most often used in connection with museums that—not without controversy—sell works that no longer fit the institution's mission in order to raise cash for operating expenses.

217. See Pierre Valentin, Philip Munro, and Samantha Morgan, "Art and Taxation in the United Kingdom and Beyond", in Clare McAndrew (ed.), *Fine Art and High Finance: Expert Advice on the Economics of Ownership*, Bloomberg Press, New York, 2010, pp. 249–62.

218. Randy Kennedy, "Gagosian Suit Offers Rare Look at Art Dealing,"

219. This underscores the importance of checking the bill of sale for accuracy. Where there is a standing relationship between a dealer and a client, for example, names on invoices may be automatically generated by the dealer's system and not correctly reflect which spouse is actually gaining title to a work if using separate funds.

220. American Taxpayer Relief Act of 2013, www.finance.senate.gov/legislation/details/?id=acd8d505-5056-a032-5213-d4c3ac0bb7b0.

221. Heirs should receive a copy of any estate appraisals in order to establish their own basis for income-tax purposes in case of sale down the road, as their own basis will be "stepped up" to the appraised estate value. If they do not receive a copy, they will need to have the works appraised at the time of the bequest on their own.

222. Patricia Cohen, "Art's Sale Value? Zero. The Tax Bill? $29 Million," *New York Times*, July 22, 2012, p. A1.

223. If a will specifically dictates that works be sold, the sale expenses may be deducted. If there is no specific direction, US courts are split on whether expenses may be deducted.

224. Philippe de Montebello, former Director of the Metropolitan Museum of Art, New York, speaking at "Collecting Across the Centuries: Old Masters in 21st Century Collections," *ADAA Collectors' Forum*, January 19, 2011, Frick Collection, www.artdealers.org/events.forum28v.html.

225. The deduction may not exceed 30 percent of the donor's contribution base (yearly salary or income), but any amount in excess may be carried over for up to five years.

226. For a full discussion of taxation issues on which this example is based, see Ralph Lerner, "Art and Taxation in the United States," in McAndrew, pp. 211–48.

227. Lerner, pp. 219–29.

228. According to Karin Gross, IRS Office of Chief Counsel, speaking on the panel "Philanthropy and the Law," *The Appraisers Association* and *NYU-*

SCPS/AAA Art Law Day, New York University, November 9, 2012.

229. The Pension Protection Act of 2006 essentially ended fractional giving in the US. Elizabeth Dillinger, *A Not So Starry Night: The Pension Protection Act's Destruction of Fractional Giving*, 76 UMKC L. REV. 1045, 1046 (2008).

230. The exact definition of "substantial possession," however, seems to be unclear. See Lerner in McAndrew, p. 235.

231. Talk with the collector, Neue Galerie, New York, February 6, 2013.

232. According to Holland Dunn, Aurora Advisory Group, speaking on the panel "Philanthropy and the Law," *The Appraisers Association* and *NYU-SCPS/AAA Art Law Day*, New York University, November 9, 2012.

233. As quoted in Berggruen's obituary: Alan Riding, "Heinz Berggruen, Influential Picasso Collector, Dies at 93," *New York Times*, February 27, 2007, www.nytimes.com/2007/02/27/arts/design/27berggruen.html.

234. See, for example, James Panero, "Another Museum Puts its Collection on the Block," *Wall Street Journal* (online version), April 15, 2009, http://online.wsj.com/newsarticles/SB123974676917018355.html.

235. According to Henry A. Lanman, Associate General Counsel, the Museum of Modern Art, speaking at "Successful Art Succession: Estate Planning and Practical Issues for Collectors," *New York City Bar Association*, January 24, 2012.

236. If the donor is married, the art designated for charity should be left to the spouse who will then complete the transfer upon his or her death or during his or her lifetime, thus avoiding the estate tax on the deceased spouse's estate. The advantage of transferring property tax-free to a spouse is known as the Marital Tax Deduction, part of the Economic Recovery Tax Act (ERTA) of 1981. Lerner, p. 239.

237. Carol Kino, "Private Collection Becomes Very Public," *New York Times*, June 6, 2010, p. A23.

238. Michael S. Arlein, "Estate Planning Techniques for the Art Collector," materials submitted for panel of the same title at the *Understanding Art as an Asset,* Artelligence symposium, New York Athletic Club, April 13, 2011.

239. For an outline of illuminating cases, see Lerner, in McAndrew pp. 224–6.

240. "Art Appraisal Services," *Internal Revenue Service*, updated February 22, 2013, www.irs.gov/Individuals/Art-Appraisal-Services.

241. "Annual Summary Report for Fiscal Year 2012," *The Art Advisory Panel of the Commissioner of Internal Revenue*, www.irs.gov/pub/irs-utl/annrep2012.pdf.

BIBLIOGRAPHY

Books and Articles

Aldrich, Megan, and Hackforth-Jones, Jos (eds.), *Art and Authenticity*, Lund Humphries, Farnham, Surrey, and Sotheby's Institute of Art, London and New York, 2013

Benjamin, Walter, "Unpacking my Library: A Talk About Book Collecting," in *Illuminations*, translated by Harry Zohn, edited by Hannah Arendt, Schocken, New York, 1968 (an important essay on the nature and essence of collecting)

Behrman, S. N., *Duveen: The Story of the Most Spectacular Art Dealer of All Time*, The Little Bookroom, New York, 2003 [1959]

Buck, Louisa, and Greer, Judith, *Owning Art: The Contemporary Art Collector's Handbook*, Cultureshock Media, London, 2007

Davis, Deborah, *The Secret Lives of Frames: One Hundred Years of Art and Artistry*, Filipacchi Publishing, New York, 2006

Findlay, Michael, *The Value of Art: Money, Power, Beauty*, Prestel, Munich, London and New York, 2012

Frey, Bruno S. and Eichenberger, Reiner, "On the Return of Art Investment Return Analyses," *Journal of Cultural Economics*, vol. 19, 1995, pp. 207–20

Godfrey, Tony et al., *Understanding Art Objects: Thinking Through the Eye*, Lund Humphries, Farnham, Surrey, 2009

Horowitz, Noah, *Art of the Deal: Contemporary Art in a Global Financial Market*, Princeton University Press, Princeton, 2011

Lavédrine, Bertrand, *A Guide to the Preventive Conservation of Photograph Collections*, Getty Conservation Institute, Los Angeles, 2003 (1st ed.)

Lavédrine, Bertrand, McElhone, John P., Frizot, Michel, Gandolfo, Jean-Paul and Monod, Sibylle, *Photographs of the Past: Process and Preservation*, Getty Conservation Institute, Los Angeles, 2009

Lerner, Ralph E., and Bresler, Judith, *Art Law: The Guide for Collectors, Investors, Dealers, and Artists*, Practising Law Institute, New York, 2013 (4th ed.)

Lindemann, Adam, *Collecting Contemporary*, Taschen, Cologne, 2010

McAndrew, Clare (ed.), *Fine Art and High Finance: Expert Advice on the Economics of Ownership*, Bloomberg Press, New York, 2010

Mead, Rebecca, "The Art Doctor: Onward and Upward with the Arts," *New Yorker*, vol. 85, no. 13, May 11, 2009, p. 58

Muensterberger, Werner, *Collecting: An Unruly Passion*, Princeton University Press, Princeton, 1994

Neue Galerie, *The Ronald S. Lauder Collection: Selections from the 3rd Century BC to the 20th Century—Germany, Austria, and France*, Prestel, Munich, London and New York, 2011

Newhouse, Victoria, *Art and the Power of Placement*, The Monacelli Press, New York, 2005

Nicolas, Lynn, *The Rape of Europa: The Fate of Europe's Treasures in the Third Reich and the Second World War*, Knopf, New York, 1994

Prowda, Judith, *Visual Arts and the Law: A Handbook for Professionals*, Lund Humphries, Farnham, Surrey, and Sotheby's Institute of Art, London and New York, 2013

Reeve, James K., *The Art of Showing Art*, Council Oak Books, Tulsa, AZ, 1986, 1992 (2nd ed.)

Robertson, Iain and Chong, Derrick, *The Art Business*, Routledge, Abingdon, Oxon, 2008

Spencer, Ronald D. (ed.), *The Expert versus the Object: Judging Fakes and False Attributions in the Visual Arts*, Oxford University Press, New York, 2004

Studying and Conserving Paintings: Occasional Papers on the Samuel H. Kress Collection, Archetype Publications, London, 2006

Thornton, Sarah, *Seven Days in the Art World*, W. W. Norton, New York, 2008

Wagner, Ethan and Westreich Wagner, Thea, *Collecting Art for Love, Money and More*, Phaidon Press, London, 2013

Wharton, Glenn, "The Challenges of Conserving Contemporary Art," in Altshuler, Bruce (ed.), *Collecting the New: Museums and Contemporary Art*, Princeton University Press, Princeton and Oxford, 2005, pp. 163–78

Wilner, Eli, *The Gilded Edge: The Art of the Frame*, Chronicle Books, San Francisco, 2011

Winkleman, Edward, *How to Start and Run a Commercial Art Gallery*, Allworth Press, New York, 2009 (knowing how a gallery works can be very beneficial to collectors; this book offers the best inside look)

Yeide, Nancy et al., *American Association of Museums Guide to Provenance and Research*, AAM, Washington, D.C., 2001

Online Resources

General Collecting and Cataloging
Art Dealers Association of America Collector's Guide
www.artdealers.org/collectorsguide.html
A gallery-oriented guide for collectors in PDF form

The Art Law Blog
http://theartlawblog.com

Frick Art Reference Library Center for the History of Collecting
www.frick.org/research/center
Information on the formation of collections of fine and decorative arts, both public and private, in Europe and the United States from the Renaissance to the present day

Getty Provenance Index Databases
www.getty.edu/research/tools/provenance/search.html

Getty Research Guidelines
www.getty.edu/research/tools/vocabularies/intro_to_cco_cdwa.pdf
The Getty's guide to cataloguing cultural objects

IFAR Collectors' Corner
www.ifar.org/collectors_corner.php
Information on a range of topics of interest to the collector

IFAR Catalogues Raisonnés
www.ifar.org/cat_rais.php
Search database for artists' catalogues raisonnés.

IFAR Provenance Guide
www.ifar.org/provenance_guide.php
Provenance guidance with links to key organizations and a thorough bibliography

Independent Collectors
www.independent-collectors.com/
A global network for collectors of contemporary art

The Printed Picture, Museum of Modern Art, New York
www.benson.readandnote.com/
Helpful information from Richard Benson for those interested in collecting prints

Insurance, Storage and Disaster Recovery
A.M. Best Ratings Company
www.ambest.com/ratings/guide.asp
An agency which rates a carrier's financial solvency

GRASP (Global Risk Assessment Platform), AXA ART Insurance Corporation
www.axa-art-usa.com/artprotect/grasp.html
A risk-assessment system which evaluates storage facilities, providing a list of approved facilities in the US and Canada

AXA ART Caring for Collections
www.axa-art-usa.com/artprotect/caring-for-collections.html
General advice for collectors on collection care, hurricane preparation, and preventative measures

MoMA Emergency Guidelines for Disaster Recovery
www.moma.org/docs/explore/emergency_guidelines_for_art_disasters.pdf?utm_source=cmail&utm_medium=email&utm_campaign=e110312_gdl
Published in the wake of Hurricane Sandy, these guidelines offer valuable instructions for disaster recovery, particularly with respect to water damage

Conservation
American Institute for Conservation of Historic and Artistic Works (AIC)
www.conservation-us.org/
US-based professional organization of conservators which provides information on conservation and a conservator search tool.

The Institute of Conservation (Icon)
www.icon.org.uk/
UK-based professional organization of conservators which provides information on conservation and a conservator search tool

International Network for the Conservation of Contemporary Art (INCCA)
www.incca.org
A valuable resource for any collector of contemporary art who is confronted with a challenging conservation question

Tate Conservation
www.tate.org.uk/conservation/
A learning resource for those collectors interested in learning more about conservation and some of the latest developments in the field

Art Market and Investing
Arts Economics
www.artseconomics.com/
A research and consulting firm which also produces important analytical publications on the global art market

ArtTactic
www.arttactic.com/
A market analysis firm which also offers market news and interviews (podcasts)

Skate's Art Market Review
www.skatesartinvestment.com/
"An Open Forum Covering Today's Global Art Market"

Art Market Monitor
www.artmarketmonitor.com/
A website which follows reporting in the art market

INDEX

IMAGE CREDITS

Integrated images

p. 20 photo © Everett Collection / Rex Features
p.39 Author photo
p.40 courtesy of Sotheby's
p.55 courtesy of Collector Systems
p.83 photo: Katya Kazakina / Bloomberg / Getty Images
p.100 Author photo
p.106 Author photo
p.110 photos courtesy of Le Freeport | Singapore
p.120 Author photo
p.127 courtesy of Modern Art Conservation, New York
p.139 courtesy of the Artist (also on front cover)
p.149 © The Willem de Kooning Foundation, New York / ARS, NY and DACS, London 2014. Photo © Rebecca McAlpin

Color plate images

p.1 © The Metropolitan Museum of Art
p.2 (top) © 2014 The Andy Warhol Foundation for the Visual Arts, Inc. / Artists Rights Society (ARS), New York and DACS, London. Photo: Private Collection/ Photo © Christie's Images/The Bridgeman Art Library
p.2 (bottom) photo: Reuters / Shannon Stapleton
p.3 © DACS 2014. Photo courtesy AXA Art Americas Corporation.
p.4 (bottom) © 2014. Banco de México Diego Rivera Frida Kahlo Museums Trust, México, D.F. / DACS. Photo: © 2014 Art Resource / Bob Schalkwijk / Scala, Florence
p.5 (top) Photo: Amit Lennon.
p.5 (bottom) © Félix González-Torres Foundation, image courtesy of Andrea Rosen Gallery, New York
p.6–7 © DACS 2014. Courtesy of Hoffman collection. Photo: Peter Harholdt
p.8 (top) Photo: Collection Martin Z. Margulies (on cover: author photo)
 (bottom) © Succession Picasso / DACS, London 2014. Photo: EPA/Sophie Tummescheit